CHINESE
CALLIGRAPHY

EDOARDO FAZZIOLI

CHINESE CALLIGRAPHY

*From Pictograph to Ideogram:
The History of 214 essential
Chinese/Japanese Characters*

Calligraphy by
Rebecca Hon Ko

ABBEVILLE PRESS · PUBLISHERS
NEW YORK · LONDON

To my wife
Eileen Chan
Mei Ling (beautiful little bell)
the most charming and intriguing
Chinese character I have ever known.

The publisher gratefully acknowledges the contribution
of the Italo-Chinese Institute for Economic and
Cultural Exchange.

Printed Chinese characters by Huang Suching

Translated by Geoffrey Culverwell

First American hardcover edition
10 9 8

First American paperback edition
10 9 8 7 6 5 4 3 2 1

Library of Congress Cataloging-in-Publication Data
Fazzioli, Edoardo
 Chinese calligraphy.
 Translation of: Caratteri cinesi.
 Bibliography: P.
 Includes index.
1. Chinese language—Etymology. I. Title.
PL1281.F3413 1987 495.1'2 87-1203
Hardcover ISBN 0-89659-774-1
Paperback ISBN 0-7892-0870-9

For bulk and premium sales and for text adoption
procedures, write to Customer Service Manager,
Abbeville Press, 137 Varick Street, Suite 504, New York,
NY 10013 or call 1-800-ARTBOOK.

Contents

The idea for this book was born during the early 1960s, when I was working as a correspondent in the Far East. The impact of the Chinese world, my university studies, my encounter and struggle with a language of such extraordinary complexity and diversity – possessing no alphabetical script and readable only by memorizing its more than 40,000 characters – fired my interest in a culture that is as admired as it is little known. From the very first moment I came across Chinese characters I began to ask myself whether perhaps there was not a story, a portrayal of some reality, lying behind those graphically beautiful symbols.

As the years went by I became increasingly interested in Chinese calligraphy, one of the oldest still in use: many people were intrigued by my theory because of its originality, its subject, and the way in which I planned to tackle it, but nobody dared follow it up. One day, however, the Istituto Italo Cinese per Scambi Economici e Culturali (Italo-Chinese Institute for Economic and Cultural Exchange), with which I had collaborated for more than ten years with articles, conferences and trips abroad, asked me to submit my project for this title to a publisher. I am particularly indebted to the Institute's president and board for the confidence and trust they placed in me. My dream, nurtured over the years, had suddenly become reality.

But why write a book that is perhaps without precedent in the West, on a subject that would appear to be the exclusive domain of a select few? First, because I am convinced that it is possible to derive intellectual entertainment from just reading Chinese characters; second, because it provides a ready opportunity for gaining a deeper insight into a people who now number more than a thousand million; third, because it allows us to gain a measure of familiarity with the most widely spoken language of the modern world by recognizing its basic signs, its graphic structure, its original meaning, the richness of its content; and finally, because it is not a subject solely of interest to the specialist, but one that is accessible to any reader with a thirst for knowledge and a taste for achievement. Behind those basic signs, the radicals, which may at first sight seem hard to understand, there is often a message, a piece of history, a universal truth, an echo of past customs.

Although this book is the result of lengthy research, extensive reading and a great deal of hard work, I have tried throughout to write in simple terms, without in any way diminishing its scholarly validity. I leave it to the reader to judge whether I have succeeded. There are a great many people to whom I am indebted for having made this work possible, and I should like to take this opportunity to mention just a few.

7

My thanks go to my Sinology masters, L. Wieger, B. Karlgren, Wei Chu-hsien, T.C. Lai, V.R. Burkhardt and Joseph Needham, of whom some are personal acquaintances, some were my teachers and others I met through their writings; to the many friends with whom I have visited China during the past 25 years, eagerly attended lectures and conferences and read articles on Chinese characters; to my Chinese friends, from simple peasants to university professors, who all enriched my store of knowledge with the same patience, willingness and hospitality.

My special thanks go to three ladies. To Madame Rebecca Hon Ko, the calligrapher and artist, who was responsible for the large characters drawn in the Song style and also the drawings in each section, every one of which was discussed with her, based on models from the classic Chinese work on painting, The Mustard Seed Garden. *Apart from giving visual form to the image contained in each pictograph, they provide a pictorial document of ancient China. The illustrations of the characters' sequential evolution and organic formation also flowed from her skilful brush. To my editor, Marisa Melis, who took particular care and interest in supervising the correction and printing of these unusual and difficult pages, combining her considerable experience with an inordinate amount of hard work. Finally, there is my wife Eileen Chán Mei Líng, who supported me character by character and helped me to define and write the sequences, to study the different strokes and to interpret difficult classical texts in the original language. I went through every entry in the book with her; with her assistance I overcame many problems; but, most important of all, she was constantly at my side during the difficult months spent creating the final draft, displaying enthusiasm, an iron will, a critical sense and the sort of patience only the Chinese possess. Without her contribution this book would never have been written.*

Because of its unusual content and layout, and the informative way in which the subject has been dealt with, this book will inevitably contain mistakes, despite every effort to the contrary. For these I beg the reader's forgiveness and assume total responsibility. During my lifetime I have spent much time and money trying to familiarize myself with Chinese culture; I have spent ten years in the Far East, living among Chinese people; and I can honestly say that I have received a great deal in return. The knowledge of their civilization, together with its written and spoken language, has enriched me intellectually, heightened my awareness and made me realize that Heaven, Man and Nature are three interdependent realities and that happiness comes from the balanced relationship of these three. I hope that this volume will allow the reader to make the same exciting discovery. A final word: this is a book to savour like a good cup of coffee, in small sips, enjoying its aroma and bouquet in moments of tranquillity. In this way it will become a first step forward toward a civilization that is still little known, but that has much to offer contemporary man.

Edoardo Fazzioli

A living language, six thousand years old

Many great civilizations have punctuated man's presence on earth, but only the Chinese civilization has survived into modern times with its principal characteristics intact. Also – and this makes it unique – it retains a language more than 6,000 years old. This is undoubtedly the outcome of a series of happy coincidences but, first and foremost, it results from the Chinese system of writing: those fascinating, mysterious characters, each of which hides a snatch of history, literature, art and popular wisdom.

Never has the word calligraphy been so aptly used as here, even though it is still difficult for the Western eye to appreciate the full beauty and depth of this writing or to understand the aesthetic message contained in its lines. The nature of the written language and the use of the same instruments, brush and ink, have ensured that the writing of characters has formed an integral part of the history of Chinese painting.

Wáng Xī Zhī (321–379), the "calligrapher sage" who lived under the Eastern Jīn (317–420), is regarded as the greatest master of all time and the model for all those wishing to become engaged in the art of character-writing. His rich poetical and imaginative style is conveyed in his portrayal of writing as a real battle. In his work *The Calligraphic Strategy of the Lady Wèi*, he writes: "The sheet of paper is a battleground; the brush: the lances and swords; the ink: the mind, the commander-in-chief; ability and dexterity: the deputies; the composition: the strategy. By grasping the brush the outcome of the battle is decided: the strokes and lines are the commanders' orders; the curves and returns are the mortal blows." An exciting battle, but fortunately a bloodless one: one of the few that mankind can enjoy and be proud of.

The first characters were incised, using wooden sticks, pointed stones, jade knives or bronze styli. These are the marks we find on ceramics, on bones, inside vases and on bronze artefacts. The graphic transformation of characters was caused by changes in the implements used for writing or the introduction of new writing surfaces such as wood, silk and paper. On a

Shāng bronze (16th–11th century B.C.) we find a design for a pen with a reservoir; it takes the form of a cup-shaped container attached to one end of a hollow straw which deposited the colouring liquid on strips of bamboo. The result was a thick, uniform line. Around 213 B.C. widespread use appears to have been made of brushes with a fibrous tip suitable for writing on silk: these worked faster, but were still too rigid and gave a thick, square line.

During the same period a further advance was made by replacing the fibrous tip with one made of leather, which was softer and more flexible. It is to a general in the imperial army of the Qín dynasty (229–206 B.C.), however, that we owe a marked improvement in the quality of writing instruments. Méng Tián, who wielded the sword as skilfully as the brush, replaced the leather tip with a tuft of soft animal hairs. His intuitive innovation was linked to the discovery of a new writing material: paper. This quickly absorbed the water, making it possible to create lines of varying intensity. He maintained that the brush, with its very soft, pliable tip, could create every sort of effect when placed in the hands of a skilled calligrapher: everything from a thin, thread-like line to a thick one; from a full, rich stroke to a broken, fading one; from a squared line to a rounded one with either a sharp or blunted point. This moment marked the birth of calligraphy, which now entered the history of Chinese painting and was treated with the same honour and dignity accorded to figurative works.

Apart from the instrument and the writing surface, another important element was India ink, in fact a Chinese discovery, obtained from soot, or lampblack, mixed into a paste with glue and perfumed with camphor and musk. Shaped into tablets or small sticks, it was decorated with figures or extracts from famous calligraphers written in gold characters. It is one of the "treasures of the literate," together with the brush, the paper and the "ink-stone" (a type of Chinese ink-pot). These stones were carefully selected, then carved and finely decorated, with two wells hollowed out in their surface: one to act as a container for water; the other, larger, in which to rub the ink tablet to produce a fine black powder. This would then be diluted with water. Using the best stones, and skilfully mixing the powder with water, it is possible to obtain the shades known to the Chinese as "the five shades of black."

The history and mythology of a script

Knots tied in lengths of vegetable fiber, which represented a sort of calendar, marked the first attempts by Chinese man to establish records. Later on, notches scored on wooden laths acted as a means of recording harvests and other events; later still, sticks, stones and bones were used to

make marks on clay objects. The Neolithic village of Bànpō, more than 6,000 years old – discovered in 1953 near Xiān and the largest and most complete human settlement so far excavated – represents one of the most important sources of information on ancient Chinese writing. Two types of signs appear on red clay pots found there: the simplest ones are probably numerals, while other, more complex ones indicate names of clans and tribes (see page 12).

These are the forerunners of the characters as they are known today, even though they anticipate pictographs by several millennia; the latter require a degree of skill and manual dexterity those early Neolithic Chinese appear not to have possessed. The development of Chinese characters can be loosely subdivided into four chronological stages: the *primitive period* (8000–3000 B.C.), during which man expressed himself first in conventional signs that had a mnemonic function and later in designs that reproduced the world around him: pictographs. The *archaic period* (3000–*c*.1600 B.C.) includes the pre-dynastic period and the Xià dynasty, during which there was a transition from pictographs to ideograms, from direct to indirect symbols, thus filling the gap left by early Chinese man when faced with abstract concepts. The *historic period* spanned 18 centuries – beginning with the Shāng or Yīn dynasty and ending with the fall of the Eastern Hàn (A.D. 220) – during which writing completed its evolution and took on its definitive form: the determinative characters and phonetics were born, the main styles were developed and form and meaning were established. Over the centuries that followed, the Chinese merely made use of what had already been invented and codified during the earlier period. Finally we come to the *contemporary period*, which began in 1949 with the founding of the People's Republic of China. This is an important age for the changes made to the writing and structure of characters, the result of a campaign to eradicate illiteracy. These modifications had three main aims: to simplify characters that were difficult but in common use; to achieve a common national pronunciation by means of the *Pŭtònghuà* (common language); to be able to transcribe the characters in alphabetical letters in accordance with a system known as *Pīnyīn*, that is, combining the sounds with syllables, which gave uniformity to the earlier differences in transliteration. This programme of intensive "alphabetization" has clearly favoured a quantitative rather than qualitative knowledge of the written language, which is regarded as an inalienable part of the Chinese national heritage.

The mythological account is altogether more romantic and mysterious. This tells how the notion of progressing from knots tied in a piece of rope to drawings of words and ideas to a quicker and easier graphic sign belongs to the mythical Fú Xī, the first of the Five Emperors of the legendary period. Living 5,000 years ago, he is credited with the invention of rope,

THE FIRST CHARACTERS

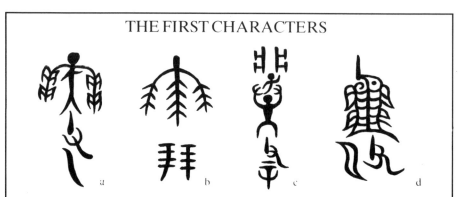

Four examples of pictographs taken from ritual bronzes of the Shāng dynasty (c. 1300 B.C.).
a) Poured wine (a tongue below), cooked meat (a hand, smoke rising) and offerings of money (a man carrying two strings of shells on a pole).
b) Offerings of money, portrayed in a stylized form that is the forerunner of characters.
c) Ritual vessel with wine and cooked meat, and a man presenting his son to his ancestors through the pillars of the temple.
d) Ritual sacrifice of wine, cooked meat and fresh meat (represented by the fish).

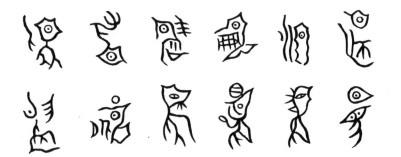

The bronze strip from which these 12 signs are taken dates from c. 2000 B.C.: it is the earliest calligraphic discovery made so far. They are stylized drawings of animals killed during the hunt. The process of stylization that leads ultimately to modern writing has already begun.

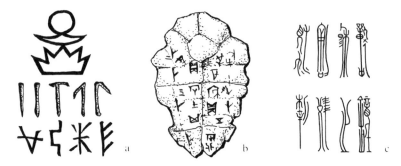

a) Signs found on pottery vases or sherds. They date from c. 6000 B.C. and probably represent numbers and names of tribes or clans.
b) Oracular incisions on the undershell of a tortoise dating from the Shāng dynasty (16th–11th century B.C.). Some of these signs are still legible today.
c) Fascinating and highly imaginative characters incised on a bronze ritual wine-vessel from the Warring States period (475–221 B.C.) found in the grave of the noble Zēng at Síuxiàn in 1978.

fishing- and hunting-nets, musical instruments and the eight trigrams. He taught man how to use fire to cook food and how to raise and tend livestock, becoming the protective deity of nomadic life. Legends clearly pay little heed to archaeology.

In a commentary to the *Book of Changes* (*Yì Jīng*), one of the world's oldest books, there is a passage that reads as follows: "When Fú Xī governed everything under the sky, he looked upward and admired the splendid designs in the heavens, and looking down he observed the structure of the earth. He noted the elegance of the shapes of birds and animals and the balanced variety of their territories. He studied his own body and the distant realities and afterwards invented the eight trigrams in order to be able to reveal the transformations of nature and understand the essence of things." In this way, it was alleged, characters were born.

But Fú Xī is not alone; Huáng Dì, who lived 4,700 years ago, is also believed to have been the father of writing. The legendary Yellow Emperor is said to have been given the characters by a dragon that emerged from the waters of the Huáng Ghé, the Yellow River. Another legend attributes the invention of the characters to Cāng Jié, a learned minister of the Yellow Emperor. He was struck by the tracks left by animals on the ground, particularly those of birds, whose claw marks gave him the idea for the lines that make up the characters. Two thousand years later, a style of writing was born known as *niǎo zhuàn*, bird character. Finally, there is talk of a third claimant, who was given the characters as a token of gratitude by a tortoise saved from drowning. He was the third of the Five Emperors, the Great Yǔ, founder of the Xià dynasty (21st–16th century B.C.), the same person who taught man how to channel water and cultivate the land, the patron of farming life.

Classification and radical characters

Learning how to recognize Chinese characters and how to write them correctly has never been easy. Ancient scribes often filled spaces with incorrect or even invented characters: such lexical monstrosities, the fruits of ignorance or fantasy, cause philologists considerable trouble.

In order to put a stop to this, the great emperor Qín ordered his prime minister Lǐ Sī to compile a catalogue of the characters to be used in official documents and literary works. And so the first Chinese dictionary was born, the *Sān Chāng*, containing 3,300 characters, some of them so-called "monster-characters" (*Jī zì*), which were thus assured a place in history. For the first time, the shape and meaning of words were officially defined.

Three centuries later, the scholar Xú Shěn composed the first carefully researched lexicon, complete with definitions and commentaries. Its 15

volumes, published in A.D. 121 under the name *Shuō wén jiě zì*, extended and updated Lǐ Sī's dictionary. It was an imposing work that brought the number of characters up to 10,516, grouped under 540 radicals.

A further 1,600 years were to elapse before the appearance of another dictionary as innovative and important as Xú Shěn's work. Under the final imperial dynasty, the Qīng, (1644–1911), the last dictionary of the classical language was compiled. In 1717 the second emperor of the dynasty, Kāng Xī (1661–1722), published the *Kāng Xī zì diǎn*. This dictionary, which bears his name, contains 40,000 characters arranged under 214 radicals, less than half the number in Xú Shěn's lexicon.

Finally, in 1967, the *Xīnhuá zì diǎn* (Dictionary of New China) was published, a work that has been used as the basis for many bilingual dictionaries. The radicals were modified and some of them doubled, their number rising to 227; simplified characters were introduced to replace 2,252 others considered "difficult." Although this publication is by no means a literary work, and although many of its points are debatable, it nevertheless marks the first step toward a scientifically modern written language through the establishment of an up-to-date lexicon. It also marks the first use in transcription of *Pīn yīn*, the newest system of transliterating Chinese writing into alphabetical form, which has effectively superseded all earlier methods, the most common of which was the Wade-Giles system.

The official classification, the most scholarly so far – despite its understandable shortcomings – will always be that of the Kāng Xī period, which is the source of the 214 radicals illustrated in this volume.

Having made their first historical appearance in the *Shuō wén*, where they numbered 540, and having been reduced to 214 in the *Kāng Xī* and then raised to 227 in modern dictionaries, these radicals hold the key to reading Chinese and give the phonetic compositions their meaning.

All the characters are grouped under their radicals. It is the radicals that allow us to locate characters in the dictionary because Chinese, not being an alphabetical language, does not permit the arrangement of words in any alphabetical order: in order to find a character you must first discover the radical from which it is composed. The progressive number that identifies a character refers back to the radical with a list of all its relevant composites. By counting all the strokes that occur in the character, excluding the radical, you will arrive at the subgroup that encompasses the same number of strokes and thence at the character you are seeking. It is not easy, but neither is it impossible.

Of the 214 radicals in the *Kāng Xī*, 49 can be written in different ways. For some this is just a matter of slight modification, for others there is a simplified form of script and for one small group there exists a reduced

EVOLUTION OF CHARACTERS

	on bone	on bronze	seal	official	normal	cursive	running hand	simplified
sun (*rì*)								
moon (*yuè*)								
mountain (*shān*)								
water (*shuǐ*)								
fire (*huǒ*)								
rain (*yǔ*)								
follower (*cōng*)								从
cart (*chē*)								车
choose (*cǎi*)								
to act (*wéi*)								为
son (*zǐ*)								
ox (*niú*)								
horse (*mǎ*)								马
fish (*yú*)								鱼
sheep (*yáng*)								
stag (*lù*)								
tiger (*hǔ*)								
elephant (*xiàng*)								
tortoise (*guī*)								龟
step (*bù*)								

Twenty characters in common use and their evolution over the years: from the pictograph representing reality as seen through the eyes of primitive man to the different forms that the sign assumed over the centuries, dictated either by aesthetic reasons or practical necessity. For many people this evolutionary process has distorted certain characters to such a degree as to make them unrecognizable. Recalling their original roots may be of great assistance in understanding the meaning of these signs, which remains one of the basic keys to understanding Chinese civilization.

form used in composite characters (see below). The radical therefore serves a dual purpose: it allows a character to be located in the dictionary and, normally, it indicates its meaning.

However, the author's decision to illustrate and explain the 214 radicals is not the outcome of any desire to educate his readers but rather to involve them in a game of wits, to lead them down the bizarre yet stimulating road that leads back to the roots of the Chinese language and so to introduce them to its spirit, its philosophy and its riches.

Styles of calligraphy

Although preserving the basic formal characteristics that allow us to grasp its meaning, every character can be written in a variety of ways. Its

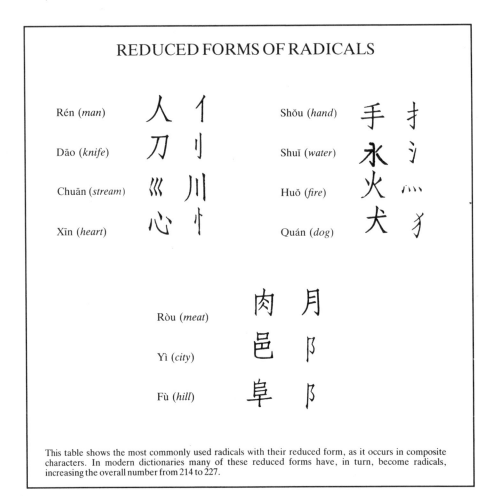

REDUCED FORMS OF RADICALS

Rén (*man*)	人	亻	Shŏu (*hand*)	手	扌
Dāo (*knife*)	刀	刂	Shuĭ (*water*)	永	氵
Chuān (*stream*)	巛	川	Huŏ (*fire*)	火	灬
Xīn (*heart*)	心	忄	Quán (*dog*)	犬	犭

Ròu (*meat*)	肉	月
Yì (*city*)	邑	阝
Fù (*hill*)	阜	阝

This table shows the most commonly used radicals with their reduced form, as it occurs in composite characters. In modern dictionaries many of these reduced forms have, in turn, become radicals, increasing the overall number from 214 to 227.

appearance is linked to the instrument with which it is written, to the material on which it is inscribed and, above all, to the technical ability and artistic sense of the individual calligrapher. Every Chinese knows that calligraphy is a key to reading the scribe; each character reveals not only the style but also the background, the skill, the mind and the passions of the person who produces it. There are styles with narrow, thick, regular, irregular, intense or light lines; others are squared, fine, elongated, horizontal, soft, stiff or sinuous. All this and more determines calligraphic style. Precisely because they are linked to the personality of the writer, many different styles of calligraphy have emerged over the centuries and still continue to develop today; they represent the individual touch, the artistic genius of certain men. Every Chinese calligrapher must be familiar with, and know how to write in, the six classic styles, aiming to achieve perfection in those which best suit his means and his talent (see below).

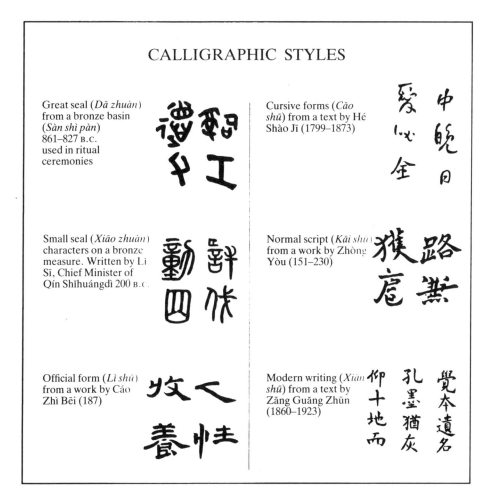

CALLIGRAPHIC STYLES

Great seal (*Dà zhuàn*) from a bronze basin (*Sàn shì pàn*) 861–827 B.C. used in ritual ceremonies

Cursive forms (*Cǎo shū*) from a text by Hé Shào Jī (1799–1873)

Small seal (*Xiǎo zhuàn*) characters on a bronze measure. Written by Lǐ Sī, Chief Minister of Qín Shǐhuángdì 200 B.C.

Normal script (*Kǎi shū*) from a work by Zhòng Yòu (151–230)

Official form (*Lì shū*) from a work by Cáo Zhì Bēi (187)

Modern writing (*Xiàn shū*) from a text by Zāng Guǎng Zhūn (1860–1923)

THE FAMILIES OF CHARACTERS

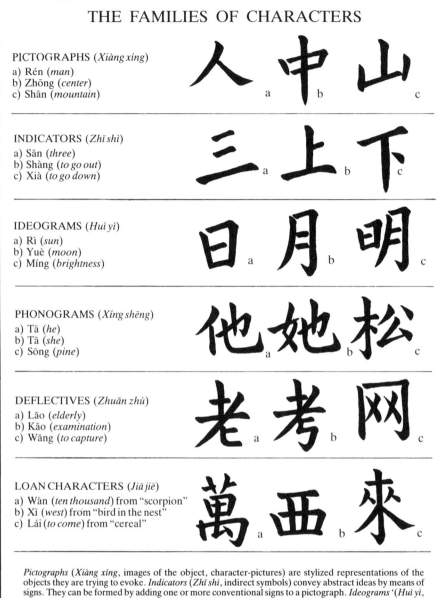

PICTOGRAPHS (*Xiàng xíng*)
a) Rén (*man*)
b) Zhōng (*center*)
c) Shān (*mountain*)

INDICATORS (*Zhǐ shì*)
a) Sān (*three*)
b) Shàng (*to go out*)
c) Xià (*to go down*)

IDEOGRAMS (*Huì yì*)
a) Rì (*sun*)
b) Yuè (*moon*)
c) Míng (*brightness*)

PHONOGRAMS (*Xíng shēng*)
a) Tā (*he*)
b) Tā (*she*)
c) Sōng (*pine*)

DEFLECTIVES (*Zhuăn zhù*)
a) Lăo (*elderly*)
b) Kăo (*examination*)
c) Wăng (*to capture*)

LOAN CHARACTERS (*Jiă jiè*)
a) Wàn (*ten thousand*) from "scorpion"
b) Xī (*west*) from "bird in the nest"
c) Lái (*to come*) from "cereal"

Pictographs (*Xiàng xíng*, images of the object, character-pictures) are stylized representations of the objects they are trying to evoke. *Indicators* (*Zhǐ shì*, indirect symbols) convey abstract ideas by means of signs. They can be formed by adding one or more conventional signs to a pictograph. *Ideograms* '(*Huì yì*, associatives, logical composites) are the result of combining one or more pictographs to form characters with different meanings (above: sun + moon = brightness). *Phonograms* (*Xíng shēng*, phonetic determinatives, phonetic aggregates) represent almost 90% of existing characters. They comprise characters formed of two parts, one of which suggests the meaning, while the other determines the pronunciation (above: *tā*, "he," is distinguished by a phonetic sign from *tā*, "she." In example (c), the character of *mú*, "tree," linked to a phonetic sign that establishes the pronunciation, forms the word *sōng*). *Deflectives* (*Zhuăn zhù*, symbols of reciprocal interpretation) are characters that are interlinked. (The character *kăo* (b), which means "examination," is thought to derive from *lăo* (a), "elderly," because according to Confucian logic only elders can examine; in example (c), the character for *wăng*, "to capture," derives from the one for "net." *Loan characters* (*Jiă jiè*, phonetic characters on loan) have no effect on either meaning or pronunciation, deriving solely from often etymologically inexplicable usage, and are the bane of philologists: they generally result from the transference of meaning to a homophone.

The Six Families

Nobody knows exactly how many Chinese characters there are. The most recent dictionary lists more than 48,000, but it is not a specialist dictionary and thus omits many classical, scientific and technical terms. Chinese is, after all, a living language that is constantly growing and therefore needing new characters the whole time.

This problem was already preoccupying two scholars who lived during the Eastern Hàn dynasty (25–220), Liú Xīn and Xǔ Shèn. The latter, having analyzed and grouped all the characters into six categories, codified in meticulously detailed form the technique for creating new ones, transliterating neologisms in graphic form but preserving the same peculiarities found in ancient characters. And so the Six Families (*Liù shū*) of characters were born: pictographs, indicators, ideographs, phonograms, deflectives and borrowed forms (see page 18).

The strokes

Every Chinese character, from the simplest to the most complex, is formed of one or more strokes in a variety of combinations.

There are six basic strokes; all the others are modifications, variants and developments and therefore all reducible to the original six. Nevertheless, in the various writings on Chinese characters you will find tables of strokes ranging from a minimum of six to a maximum of 32. In this volume we have used 24, in accordance with the method adopted in China for teaching the language. Each stroke is identifiable by means of a distinguishing number (see page 20).

There are precise rules governing the writing of a character: the strokes must go from left to right, downward and inward. These rules must always be respected, apart from a small number of exceptions, in order to achieve a correct, graceful, harmonious, swift and, above all, legible writing.

THE STROKES THAT FORM THE CHARACTER

Strokes	Names	Examples
1　`	Dot	不
2　一	Horizontal	不
3　丨	Perpendicular	不
4　丿	Downstroke to the left	八
5　乀	Downstroke to the right	八
6　丷	Tick	汉
7　一	Horizontal hook	你
8　亅	Perpendicular hook	小
9　乀	Oblique hook	我
10　亅	Perpendicular with tick	很
11　乛	Perpendicular with fold	口
12　乚	Perpendicular with fold	画

Strokes	Names	Examples
13　く	Downstroke to the left with dot	好
14　ㄥ	Downstroke to the left with fold	去
15　フ	Horizontal with downstroke to the left	汉
16　ㄴ	Perpendicular with turn	忙
17　ㄱ	Horizontal with fold and hook	习
18　乁	Horizontal with fold and hook (variant)	也
19　ㄴ	Perpendicular with turn and hook	儿
20　ㄅ	Horizontal with fold and tick	语
21　ㄅ	Perpendicular with fold and turn with tick	吗
22　ㄋ	Horizontal with fold and turned downstroke to the left	这
23　ㄗ	Horizontal with fold and turned hook	那
24　乙	Horizontal with fold and turned hook (variant)	九

The strokes are in the left hand column; in the right hand column they are shown as a component of a complete character. The relevant numbers (1-24) are given in red on each page from p.24 to p.247, to denote the strokes employed in writing the radical (from *Elementary Chinese Readers* Book One *Chinese Character Exercise Book*, Foreign Languages Press, Beijing, 1980).

Notes on how to read this book

The following pages provide the key to reading Chinese radicals: more specifically, the 214 radicals of the Kāng Xī. *One page is devoted to each radical.*

The radicals have been subdivided into eight groups on the basis of analogies in form or meaning, in accordance with a classification system favoured by ancient writers, classical texts on Chinese characters and modern scholars.

Rather than following the numbering system used by modern dictionaries to identify individual characters, which works from the simplest to the most complicated, we have chosen the classical method, as this will allow the reader to discover graphic and etymological affinities by drawing attention to similarities of line and meaning.

Each of the eight groups opens with a guide-character: those for man, body, to journey, village, paintbrush, dragon, jade *and* yellow, *which have been selected not so much for their beauty as for their importance in Chinese culture.*

Every page follows the same layout, opening with the radical in black, painted by the calligrapher in the style of the Sòng dynasty (960–1279), which has been chosen for its classical clarity. This is accompanied by the character's English meaning and the Pīn yīn transliteration. The reader should remember that one character often has several, sometimes unconnected meanings: this wide variety of meaning explains why the same character can often be translated in several different ways.

Below the radical, a naturalistic drawing in red, in the classic Chinese style, represents the element (object, part of body, etc.) from which the character's pictograph is ultimately derived. To the right of the drawing, starting with the pictograph, appear the sequential changes undergone by the character over the years.

Immediately below these variants are the strokes that make up each character, individually and in the correct writing sequence, numbered in red with their identifying number (see page 20).

The box below is divided into nine sections containing the radical painted in red; this is intended to emphasize the perfect proportional balance that must exist between its different constituent elements. To the right of this box is another containing the modern simplification, where applicable.

Finally, a few examples of the radical's use in the construction of a character are given, or examples of composite words in which the radical plays a part, again followed by the Pīn yīn transliteration and English translation. In these examples the simplified form is often given, which is in current use in China.

The left-hand column contains a brief text outlining the radical's origin, history and etymology, and sometimes the meanings that go beyond the literal sense but are used idiomatically in the language.

The tones. *In order to read a Chinese character exactly, three elements are used: the sign, the sound and the tone. Together they reveal the meaning of the word. In transliterations, the tone is indicated by four conventional accents, placed above the syllable, which are included throughout this book:*

¯ *high even tone*	ˇ *low dipping tone*
´ *rising tone*	` *short falling tone*

A fifth, natural tone is not distinguished by any accent.

Man

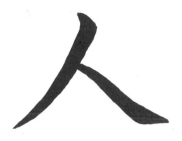

If it is true that characters, with all their fascination and contradictions, are the mirror of the Chinese people, then those grouped around the word man *provide the most eloquent and significant images. The notion of man (rén) is the fundamental element of Confucian thought. It can be summed up in the following statement: man gains fulfilment through his relationship with other men and with the natural world around him. This is why, when embarking on this examination of radicals, our starting point had to be* man, *followed by the words that relate to it:* woman, son, *etc.*

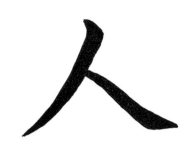

人

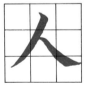

4 5

人

From its earliest pictographic represen-
tation to its present appearance, the charac-
ter indicating "man" emphasizes the main
human characteristic: an erect stance. The
evolution of the signs shows how – starting
with the man shown in profile, with his
head, hands and legs clearly visible – it
developed into its present form, in which
the man appears head-on, his legs apart.

This stance, common to countless other
cultures and still often used nowadays in
the theater, expresses power, superiority,
command, self-confidence and dignity.

There is a Chinese proverb that says: "A
man is judged by his clothes, a horse by its
saddle." This character makes us realize
how important shape and position are to the
Chinese. If, for example, we find a charac-
ter showing "man" next to a rice field, it
means that he intends to rent it. If,
however, our character occurs next to the
one meaning "to stand," it indicates
"pride," "dignity," "social position." When
juxtaposed with the character for "dog," it
means "to prostrate oneself," "to lie
down," "to hide." Put a lance next to the
sign for man and he is ready to attack.

佃	Diàn	*to rent*
位	Wèi	*social position*
伏	Fú	*to prostrate oneself*
伐	Fá	*to attack*

FÙ
FATHER

父

月 才 殳 父 父

ノ 丶 八
4 1 4 5
ノ 八 少 父

Some people believe that this represents a hand holding a rod, which would make it a symbol of paternal authority. It is the father who must instruct the members of his family and make them respect order: he is its head. His role in the economy of the society in which he lives is extremely important. According to the classic work *The Three Characters*, "if a man is not properly educated, he will gradually become evil-natured." It is for this reason that a father has to educate his son, even if it means using the rod, because "man must be formed by man as the blade is sharpened by the stone."

According to other scholars, the design of the character for father shows a hand grasping an axe: a symbol of working ability and thus of the economic security that a father should provide. There are several proverbs on the subject of paternal authority: "Better to be harsh first and understanding later." "The son may be virtuous, but without the guidance of a father he will not know truth." But education is a difficult skill, as is acknowledged by the proverb "it is easy to rule a kingdom, harder to lead one's own family."

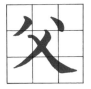

爸　Bà　*daddy*

斧　Fū　*axe*

爷　Yé　*uncle*

爹　Diē　*parent*

NŬ
WOMAN

女

冉 electrodynamics 甩 也 女 女

Officially, at least, woman did not occupy an important place in society, even though in reality she played a fundamental role and enjoyed considerable prestige. The pictograph shows her in a submissive position typical of Chinese women, her hands clasped in front of her and hidden by her sleeves, bowing, with her head inclined. Later, for reasons of speed, the character shows the woman in profile but in an even humbler position: kneeling. Such a lowly role was not always to be assigned to women, since the proverb "man is head of the family" was ironically completed by the words "and woman is the neck that moves the head as and when it wants."

The idea of goodness, of something one loves, is represented by the character for "woman" beside that for "son." If we place "woman" beneath "roof" we get "peace," "tranquillity," "serenity." By writing the character for "take" above the radical, we have the word "marry," meaning to take the woman to be one's wife. Put a broom in the woman's hand and we have the character for "wife."

$$\underset{13}{\zeta} \quad \underset{4}{\text{丿}} \quad \underset{2}{\text{一}}$$

$$\zeta \quad \text{乆} \quad \text{女}$$

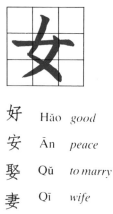

好	Hǎo	*good*
安	Ān	*peace*
娶	Qǔ	*to marry*
妻	Qī	*wife*

26

ZǏ
SON

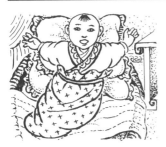

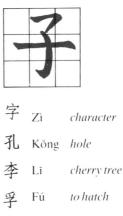

"Raise sons for old age, pile up grain for times of famine," says one writer – reflecting, at least in part, the mentality of the ancient Chinese, who saw sons as the continuation of the family, the safeguarding of the clan name, the survival of ritual custom, and also as economic security in old age. The earliest character represents a man with a very large head and short arms and legs. Then the frontal stance becomes a profile, showing just one leg, as though the body were wrapped in swaddling bands. The character forms part of many combinations with a great diversity of meaning. Placing it under the roof of a house meant "to raise," "to feed," whereas today it means "word" or "character": the children of thinking and writing. Written next to the character for "swallow" (the bird) it becomes "hole" or "opening." If, however, the character for "son" appears under that for "tree," it means "cherry tree," the fruits of which are a favourite of children. When two bird's legs are placed above the character it means "to hatch," "to protect," like the broody hen who gathers her eggs beneath her.

字	Zì	character
孔	Kǒng	hole
李	Lǐ	cherry tree
孚	Fú	to hatch

SHÌ
FAMILY

氏

The pictograph resembles a plant bobbing up and down on the water; one that grows and multiplies like the countless water lilies found in China. These start with a floating seed and grow surprisingly fast once they have found somewhere to put down roots. They bring to mind those nomadic groups that wander across the land trying to find a suitable place in which to settle, thus giving rise to the clan or family.

In modern usage this character has lost its original meaning and acquired the role of a patronymic, as has happened with many other radicals. In classical language it was also used in the sense of development or multiplication.

The sign for "family" combined with the simplified character for "man" and a small stroke along the base means "low." The same sign preceded by a hand becomes "support" or "prop." However, by placing the sun, symbol of light, below the character we obtain "sunset" or "darkness." The character for "people" very probably developed from the image of a plant growing out of the primordial waters of creation.

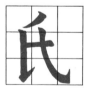

低　Dī　*low*
抵　Dī　*to sustain*
昏　Hūn　*sunset*
民　Mín　*people*

ZÌ
ONESELF

自

自 自 自 自 自

```
ノ 丿 フ ー ー ー
4  3  11 2  2  2
ノ 亻 白 白 自 自
```

A child wanting to indicate himself will point to his nose. This is probably the origin of this character. There is also a hint of embryology in the pictograph: the Chinese believed that the nose was the starting point for the human body's development in the womb and therefore the origin of the individual.

By placing two wings above the character the word for "exercise" or "practice" is formed: think of a small bird flapping its wings, trying again and again to learn how to fly. And yet the character has only one wing. By drawing a heart beneath it, however, we form the word meaning "to breathe." The ancient Chinese believed that breath came from the heart and emerged out of the nose, completing the cycle of life by returning through the nose to the heart. If you place yourself on top of a tree the resulting character means "target." If you draw yourself above a dog, an animal with a very acute sense of smell, you have the word meaning "unpleasant smell" or "stench." Freedom is indicated by two characters: an individual (oneself) and germinating corn, one's own land.

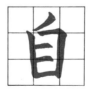

习	Xí	exercise
息	Xī	to breathe
臬	Niè	target
臭	Chòu	unpleasant smell

SHÌ
LITERATE

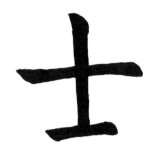

This ideogram, which originally meant "ten," comprises one vertical stroke indicating all the fingers of one hand and another, horizontal one indicating those on the other. A base was later added to symbolize the number "one." This was intended to represent everything contained between one and ten, the beginning and end of numbering, and therefore all the knowledge available to man. As a result the character came to mean "literate" (in the old sense of "lettered"), "cultured" or "wise." Other sinologists, however, maintain that the character represents a man at the head of ten others, which gives the word the meaning of "deacon" or "official."

In the character meaning "fortunate" or "propitious," we find the character for "wise" with the one for "mouth" underneath. The wise, cultured person knows how to give sound advice. By repeating the character for "wise" twice, one on top of the other, we obtain the name for the jade tablet that imperial officials were obliged to clasp in their hands when presenting themselves to the emperor: a symbol of their great wisdom.

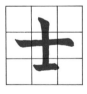

吉	Jí	*fortunate*
圭	Guī	*jade tablet*
志	Zhì	*to wish*
坐	Zuò	*to sit down*

CHÉN
MINISTER

臣

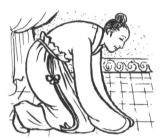

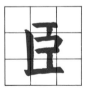

一 丨 丁 一 丨 し
2　3　11　2　3　16
一 丁 굿 굼 쿠 臣

Kneeling, with head cast down and hands pressed to the floor: this is the picture of a minister before his king in ancient China. Officials lived in great splendour and owed their power to the prestigious offices they held in the palace or in the great cities of the empire. From them the emperor demanded fidelity, humility and devotion. In the book *The Three Characters*, a classical text, we find the words: "The sovereign must hold in esteem his courtiers, but they must, in turn, be loyal to him."

The character for "just" or "good" is composed of three signs: to the left a bamboo strip, at the center the minister and to the right a weapon formed of a lance and a battle-axe or halberd. The meaning is clear: the authorities administer justice, the emperor is represented by his minister, an official who knows the law (the tablet) and has the power needed to enforce it (the halberd). The character for "minister," when placed beneath the one for "roof," means "officer," "court official" or "eunuch"; the latter worked among the wives and concubines of the Son of Heaven.

藏	Zāng	*just*
宦	Huàn	*eunuch*
臥	Wò	*to lie*
坚	Jiān	*strong*

GUǏ
SPIRIT

鬼

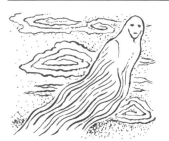

鬼 鬼 鬼 鬼 鬼

ノ 丨 フ 一 丨 一 ノ レ し
4　3　11　2　3　2　4　19　14

ノ 亻 宀 白 甶 甶 鬼 鬼

丶 ⺄

鬼

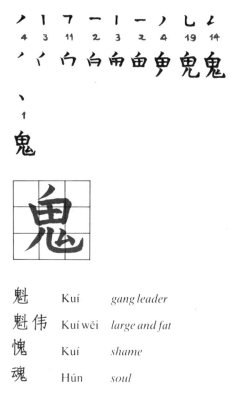

A human form floating through the air after leaving the body suggests the idea of a spirit, weightless and free as a bird. The curved "tail" we find in the early characters is the vortex of air caused by the spirit's movement. Only later does the character take on the meaning of "ghost" or "demon" and then "horrible," "repugnant."

Another interpretation attributes the character's origins to a sketchy drawing of a scarecrow. It is difficult, however, to substantiate such a derivation on the basis of the earliest graphic signs: in fact, one of the least-used words in Chinese is "ghost." When combined with the one for "fists," the character means "head of a band of criminals," "gang leader." Linked to the character for "great," this composite means "large" or "fat": a person who is physically imposing. "Shame," however, derives from the fact that the mind is disturbed by passion, indicated by the character for "heart"; this is a relatively recent concept because the Chinese people used to regard the heart as being the seat of intelligence and thought, whereas emotions derived from the kidneys.

魁	Kuí	gang leader
魁伟	Kuí wěi	large and fat
愧	Kuí	shame
魂	Hún	soul

SHÓU
LEADER

首

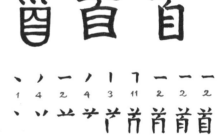

It may seem strange, but all the ancient Chinese needed to make the ideogram for "head" or "leader" was a rather prominent nose and two topknots of hair. In modern Chinese, however, the word "leader" is expressed by two characters, the one we are dealing with here and the one for "neck," thus emphasizing the fact that to be a leader nowadays it is not enough to have just a head: you need support as well.

Another important meaning is obtained by combining "head" with "to walk," which produces "road," "way," "rule": the famous *dào*. In fact, Taoism has its roots in the *Dàodéjīng*, *the Book of the Way and of Virtue*, written by Lǎozǐ (570–490 B.C.), a contemporary of Confucius (551–479 B.C.): he condensed the text of China's most popular philosophy into 81 chapters containing 5,000 characters, even though it has been pointed out that "believing in *Dào* is easy, the difficulty lies in living it." The radical combined with the character for "order" or "sequence" produces "the first time." A guide is the person who knows the road and the distance, and thus the time needed to cover it.

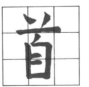

首领		Shǒu lǐng	*leader*
道		Dào	*way*
首次		Shǒu cì	*the first time*
导		Dǎo	*guide*

JǏ
PERSONAL

己

 毛 玉 己 己 己

Originally this character represented the warp and weft of a loom. In fact, it is possible to distinguish two threads running transversely and another running lengthwise, while at the base of the character we can see the thread attached to the bobbin. It was later simplified and used as one of the cyclical characters that make up the Chinese lunar calendar. Even later on it acquired the meaning of "personal" or "own," perhaps because the product of weaving always had a personal quality: it was the fruit of individual creation.

Combining this character with the one for "word" produces the "spoken word," the narration of facts in chronological order: the spinning of a yarn. However, by placing "woman" next to this character, which recalls the loom and weaving, we obtain the word for "concubine" or "secondary wife," the woman who, while waiting for her master, could well be weaving something more than cloth. Place a "heart" beneath the loom and its network of threads and we have "jealous." Arranging marriages was at one time known as "knotting silk threads."

フ 一 し
11 2 19
フ コ 己

记 Jì *to recount*

妃 Fēi *imperial concubine*

忌 Jì *jealous*

纪 Jì *to arrange marriages*

Body

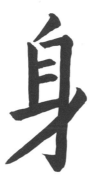

For the Chinese, the human body *is an integral part of nature; it should move amidst nature in perfect harmony. The character is linked to the ancient cult of ancestor worship, which is still alive in China today. The focal point of the body is the heart, where intellect and feeling coexist in indissoluble form. The radical for* heart *may be written in two different composite forms. Some of the radicals in this chapter no longer appear in modern dictionaries; others, such as those for* tooth *and* hand, *are used only in their simplified form and are very hard to trace back to their original ideograms.*

SHĒN
BODY

身

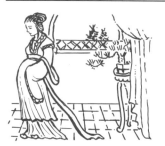

It is not hard to discern a human body with a very pronounced belly in the earliest drawings. Originally, the character meant "pregnant woman," but today it refers to either the male or the female body. Sometimes it is also used in the sense of "life span." The Chinese have proclaimed and exalted the beauty of the human body in both literature and art, although in the latter there has always been a deep sense of modesty. Even Confucius bewailed: "I have yet to find a man as much in love with virtue as with female beauty."

Writing this character next to the one for "heart" gives it the meaning of "body and soul," the human being in its totality. However, by juxtaposing it with the character for "conception," which has the sign for "milk" in its upper part and that for "son" in the lower, the word for "pregnant woman" is created. Next to the character for "bow," a weapon of war, it means "personally." Next to the word "measure" it becomes "to hit": a man must calculate the correct distance before reaching his target.

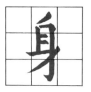

身心	Shēn xīn	*body and soul*
身孕	Shēn yùn	*pregnant woman*
躬	Gōng	*personally*
射	Shè	*to hit*

YÈ
HEAD

頁

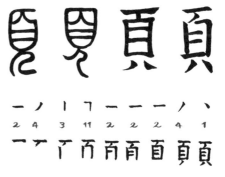

In keeping with the layout typically found in the earliest signs involving facial characteristics, here the nose is clearly visible, and what a nose! At the base of the sign we can see the neck, with the nose at the center and a horizontal line above enclosing the drawing: the result is the character for "head." Because it is portrayed frontally, like an open book, the character often comes to be used in the sense of "leaf," either of a book or of a tree. If the character for "head" is preceded by the one for "nail," we get "crown," as worn by kings and emperors, and thence the meaning "top" or "summit." However, if we replace "nail" with the sign for "stream," identifiable by the small lines indicating flowing water, the character assumes the meaning of "to go in the same direction," to swim with the current: this is emphasized by the head that appears in the character, which is turned in the same direction as the water.

顶 Dīng *summit*
顺 Shùn *to follow*
预 Yù *to anticipate*
颐 Yí *cheek*

37

MIÀN
FACE

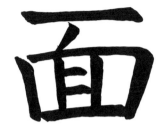

The structure of the radical seems to frame a human face: a head in which the eyes are clearly visible. There is also a modern version containing a quadrilateral to signify the mouth, but this is an erroneous interpretation of the early character, even though it is officially included in dictionaries.

The face is very important for the Chinese. The saying "to present your face to someone" means to recognize their social status, to acknowledge their merits: the character for "reputation" means literally "daughter of the face." "Losing face" means dishonour, contempt, shame. The man who loses face in business, among friends or at work is a failure, a worthless person. "To expose face and head" means to risk too much, especially with regard to the opposite sex. The character for "flour" derives from milled grain, grain that has been flattened like a leaf by the millstone. "Face" together with the character for "silk," one of the most ancient Chinese products, means "very distant." Something on the face becomes "mask."

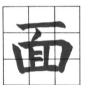

面子	Miàn zī	*reputation*
面粉	Miàn fēn	*flour*
缅	Miǎn	*very distant*
面具	Miàn jù	*mask*

BĀO
HAIR

髟

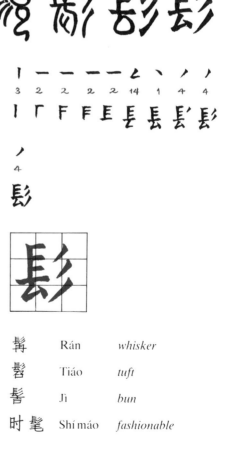

This character is no longer used in modern Chinese by itself; it does, however, occur in different combinations with meanings often linked to its early sense of "hair." Three hairs next to the character for "long" make the generic word "hair." The Chinese have very strong, smooth and shiny hair; it is rare to find a bald person in China.

There are many sayings and proverbs linked to this subject: "horns on a hare and hair on a tortoise" means something that does not exist. It can be said of a man full of malice that "his hair may be short [a sign of youth and inexperience], but his heart is long." For Westerners, fear makes hair curl, but not so in China, where people can be "so enraged their hair straightens." A fastidious person, someone who splits hairs, is one "who blows through hair to discover a mole." The symbol of avarice and selfishness is "a person who would not tear out a single hair." Another proverb says: "Tear out one hair and your whole body will suffer."

髯	Rán	whisker
髫	Tiáo	tuft
髻	Jì	bun
时髦	Shí máo	fashionable

ĚR
EAR

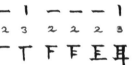

"A good speaker is not worth as much as a good listener." This old saying underlines the importance of the ear as an instrument of knowledge. The basic sign takes the form of a very lifelike portrayal of the organ, with particular emphasis laid on the outer ear. The characters that develop from this radical have a wide variety of meanings: combined with the character for "eye" it means "informant," someone who looks and listens.

If we join this character to the one for "heart," it means "to blush," "to feel uneasy," "to feel ashamed"; when a person's heart is in turmoil his ears redden. If the character for "ear" is drawn inside the one for "door," the meaning is obviously the age-old one of "to eavesdrop," but for the Chinese it also means "to gather information," "to get to know." By placing the character for "hand" next to it, the result is the word meaning "to grasp" and thence "to withhold" or "choose." If we join the characters for "ear" and "ring" together, we get "earring."

耳目	Ěr mù	informant
闻	Wén	to listen
取	Qǔ	to grasp
耳环	Ěr húan	earring

40

MÙ
EYE

目

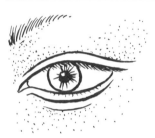

Originally a conventional drawing of an eye, with the pupil at the center, this character was later portrayed vertically for practical reasons and also to distinguish it from the number "four." "To examine" or "to inspect" is composed of the characters "tree" and "eye." There are two possible explanations for this: the idea of watching something while hidden behind a tree or the idea of keeping one's eyes peeled when walking through a wood.

When we smile our eyes are half-closed, which is why the character for "eye," when combined with the one for "rice" (whose grain is small and oval), produces the word for "to smile." The word meaning "vision" or "view" is also composed of two characters, "eye" and "light" or "luminosity." To express the idea of sight two distinct characters are used, as is generally the case with modern Chinese: one is "eye," while the other shows a man with an eye where his head should be, as though he were trying to raise his "point of view" in order to see farther. The Chinese way of saying that it is hard to admit one's own limitations is "the eye cannot see its own eyebrows."

丨 𠃌 一 一 一
3 11 2 2 2
丨 冂 冂 月 目

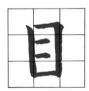

相	Xiāng	*to examine*
眯	Mī	*to smile*
目光	Mù guāng	*view*
目见	Mù jiàn	*to see*

BÍ
NOSE

鼻

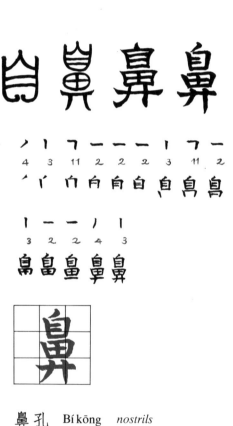

The oldest characters contain a fairly realistic drawing of a nose: then other signs were added to distinguish this from another character with the same initial design, the one denoting "oneself." Today it is one of the most complex radicals, with fourteen strokes. In modern script it is possible to identify, within the stylized and conventional graphic format of the characters, the sign denoting the neck that supports the mouth, in this case a rectangle divided into four parts, and, further up, the nose.

We have already mentioned how the Chinese considered this part of the human body to be the first to develop within the womb: they therefore believed that not only were a person's external characteristics determined by the nose, but also his actual personality. The radical, followed by the character for "hole," produces "nostrils," while combined with the radical for "sound" it forms "nasal voice"; with the character for "smoke," however, it gives us "to take snuff." "To snore" is written with the character for "nose" next to the one for "tree," perhaps by association with the noise produced by sawing a tree trunk.

鼻孔	Bí kōng	nostrils
鼻音	Bí yīn	nasal voice
鼻烟	Bí yān	to take snuff
鼾	Hān	to snore

KŎU
MOUTH

The initial pictograph depicts a smiling mouth: it is the best way to introduce this character, which forms part of no fewer than 239 combinations. It is one of the simplest and easiest to recognize.

A mouth beside a nail means "to prick," but if we place "mouth" next to the character for "dog" it means "to bark." The character for "man" next to "mouth" indicates a plural, a certain number of people to feed, and forms the word "population," something that has always been regarded by those who exploit it as a mass of mouths to feed rather than as a productive force. When combined with the sign for "water," however, it means "saliva." A character in modern usage places four food containers round "dog": besides recalling the first known dishwasher, this gives "kitchen utensil." In China, in order to keep quiet, you have to "seal your mouth and tie your tongue." It was said of Guō Xiàng (A.D. 253–312), the greatest of the Taoist writers and author of the *Notes on Zhuāng Zī*: "words fell from his mouth like a river from the top of a waterfall."

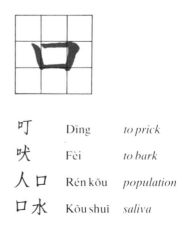

叮	Dīng	*to prick*
吠	Fèi	*to bark*
人口	Rén kǒu	*population*
口水	Kǒu shuī	*saliva*

SHÉ
TONGUE

舌 舌 舌 舌

ノ 一 丨 丨 フ 一
4 2 3 3 11 2

ノ 二 千 千 舌 舌

The Chinese have always had a very low opinion of the tongue, which they believed to be "as sharp as a blade, able to kill without spilling a drop of blood." The Egyptians held similar views, as revealed by a papyrus bearing the legend "the tongue is the ruin of mankind." This may explain why the character began in the form of a mouth from which there darts a forked tongue.

"Tongue" plus "knife" gives the word meaning "to scrape." The simplified character of "child" next to "tongue" means "confusion" or "disorder," recalling a child after a meal. Write the character for "pleasing" next to "tongue" and we get "dessert."

If we come across the character for "battle" next to "tongue," we are dealing with a heated discussion, a war of words. "Dry tongue and worn out lips" means to waste time and breath in vain entreaties and useless requests. If you let slip an unguarded word, there is nothing you can do: "four galloping horses cannot beat the speed of a tongue." "Flapping the lips and beating a drum with the tongue" means wasting time on idle gossip.

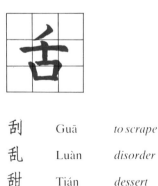

刮	Guā	to scrape
乱	Luàn	disorder
甜	Tián	dessert
舌 战	Shé zhàn	heated discussion

CHǏ
TEETH

齒

Originally drawn in the form of an open mouth with sharp, threatening teeth, this radical evolved by first retaining four square incisors and then four sharp teeth. The final simplification retains a single tooth.

Teeth grow fewer with age, but wisdom increases; in fact, the Chinese say, "many true words are spoken by false teeth." To show how the two facts are strictly correlated, they say: "when the upper lip curls, the exposed teeth suffer the cold." There are very few characters derived from this radical, partly because another, of different form with the same meaning, has replaced it in modern phraseology. By joining "tooth" with the character for "total," we obtain "age": counting the teeth to determine age. With the character for "wheel," the radical gives "gear," thus reflecting the idea of a toothed wheel. The character for "resistant" after the one for "tooth" forms the word "gum," the tissue that surrounds the tooth. Finally, by linking the character for "pain" with it, we get "toothache."

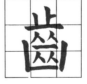

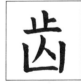

龄	Líng	*age*
齿轮	Chǐ lún	*gear*
齿龈	Chǐ yín	*gum*
齿痛	Chǐ tòng	*toothache*

45

XŪ
BEARD

The radical shows only three hairs, but this is not an allusion to the fact that the Chinese, a race renowned for their lack of body hair, more often than not have no beard. There was a time in China when men, if they were able, would grow a beard shortly before assuming their social responsibilities. Thus the character for "beard" has come to mean "necessary" or "required." In order to understand the "honour of the chin" for the Chinese, all you need do is pay close attention to a few of the characters linked to this radical.

The word "proverb" is written with the characters for "word," "to stand" and "shelter," between which the character for "beard" is inserted: proverbs are the words that emanate from the house of a wise, bearded man. Similarly, the character for "chapter," when placed next to "beard," means "clear," "evident": the bearded man, who has wisdom and age, reads the written word and explains it clearly. This explains why divinities, emperors, generals and great thinkers are always portrayed as bearded, even though we know they were clean-shaven.

须	Xū	beard
谚	Yàn	proverb
彰	Zhāng	clear
形象	Xíng xiàng	figure

XĪN
HEART

心

In modern dictionaries the radical for "heart" appears in two versions, one simplified and the other shown here. This duplication can be explained by the fact that modern dictionaries list 227 radicals rather than 214. However, the official catalogue containing 214, which was published in 1716 under the Qīng dynasty (1644–1911) is not completely free of mistakes.

Seen by the Chinese as the source of thoughts and intelligence, the heart is one of the five organs responsible for feelings and is governed by one of the five elements: fire. When Wáng Chāng, a poet of the Táng dynasty (618–907), wrote: "tell it abroad, my heart is a shining piece of ice, enclosed in jade," he meant that he had remained pure, uncorrupted. By placing the word "to love" next to "heart," we get the word "dear" or "beloved." The sign for "prisoner" above "heart" moves you: it becomes the character for "tenderness," "pity." If, however, "prisoner" is replaced by "slave," then it becomes "passion" ensnaring the heart. Similarly, the character for "psychology" incorporates the radical for the heart, hence "studying the rules of the heart."

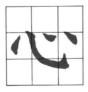

`	し	`	`
1	19	1	1

丿 乀 心 心

心爱 Xīn ài *dear, beloved*

恩 Ēn *pity*

怒 Nù *passion*

心理 Xīn lǐ *psychology*

SHŎU
HAND

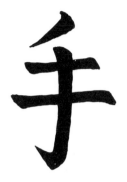

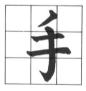

Looking at the pictographs, one gets the impression that the drawing reproduces the lines of the palm rather than those of the fingers.

The characters for "hand," "sword" and "mouth," when joined together, give the words "to press gang," that cruel system of forcible conscription practised in the past. If the character for "receptacle" occurs next to "hand," with the one for "rod" (a horizontal stoke) beneath, the word means "to carry." Even today in the East objects are carried on rods resting on the shoulders. "To grasp" or "to capture" is described by the character for "hand" joined to the one for "foot." The verb "to tie," however, is expressed by the character for "hand" linked to the one for "finished, perfect work." It recalls the extraordinary Chinese way of making packages. "What the heart wants, the hand carries out" means that where there is intelligence there is ability. If, however, a person is blamed or scolded, then he is "marked by ten hands and drilled by ten eyes." "Empty but industrious hands" signifies little money, but great ability.

招	Zhāo	*to press gang*
担	Dān	*to carry*
捉	Zhuō	*to grasp*
拴	Shuān	*to tie*

ZÚ
FOOT

足

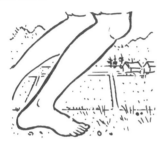

击 足 足 足 足

丨	一	一	丨	一	丿	乀
3	11	2	3	2	4	5

丨 口 口 甲 甼 足 足

The earliest drawing from which the present character is derived shows the lower part of the leg and the foot in a standing position. In the modern character the knee is represented by a rectangle, with the leg below the knee and the heel below to the left, and the sole of the foot and the toes pointing to the right. The graphic sign does not appear to convey the idea of the famous Chinese bound foot, 8 cm (*c.* 3 in) long, which was first inflicted on women and began to obsess men during the Sòng dynasty (960–1279). The "lotus flower" or "golden lotus," as it came to be known, was a powerful sexual stimulant to men and a painful deformity for women.

The radical in the sense of "total," "complete," when combined with the character for "metal," produces "pure gold," meaning gold that is almost free of any alloy. The word for "rest" next to the character means "toes." Combined with the character for a man leaning forward, the radical produces the word "to jump." Linked to the character for "moon" it means "ready," a reference to babies born at the exact time they are due.

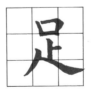

足金	Zú jīn	*pure gold*
趾	Zhī	*toe*
跃	Yuè	*to jump*
足月	Zú yuè	*mature*

SHĪ
BODY

尸

Derived from another earlier sign, which indicated a crouching man or woman, this character has acquired the meaning of "seated man" – a figure that in ancient graphics represented the departed. Other scholars have suggested that it is simply a form invented by early man to represent the ancestor he was no longer able to see.

Combined with the character for "hair" it produces "tail." We know from ancient texts that the prehistoric Chinese used to tie on false tails in order to appear "as beautiful as the animals." By placing the radical for "vapour" after this composite we get the word for "exhaust fumes," the vapours that escape from the tail of cars and motorbikes. By including the character meaning "to arrive" beneath the radical, we get the word "room": the place in which to lay one's body down after reaching one's destination. There is one curious derivation: the word for "dung" is composed of the character for "rice" inside the one for "body." Perhaps this character owes its structure to the realization that rice was the basic foodstuff and therefore the main constituent of animal droppings.

丿 フ 一
4　11　2
丿 尸 尸

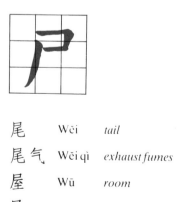

尾	Wěi	tail
尾气	Wěi qì	exhaust fumes
屋	Wū	room
屎	Shī	dung

To Journey

行

To journey on foot, as a means of discovery, progress, knowledge and self-expression and also as a way of meeting other people and seeing the world: these are the meanings contained in the radical for foot, *often recurring in the characters that appear in this chapter.*

One phrase sums up better than any other the idea contained in the sign: "the sound of footsteps in a deserted valley," which for the Chinese means meeting an outstanding man or listening to an extraordinary event.

SHĒNG
TO GIVE BIRTH

生

生 生 生 生 生

ノ 一 一 ｜ 一
4 2 2 3 2

ノ ⼧ ⼧ 牛 生

"Man is a century, grass a spring": these mysterious words encapsulate the origins of this character. In fact its lower part represents the earth, which is giving birth to a small plant, later depicted in a few stylized strokes. For the ancient Chinese the origins of life lay in Mother Earth. The character evolved from the portrayal of a seedling struggling to push its shoots up toward the sunlight. From this there developed the meanings of "to be born," "to grow," "to produce." By placing the simplified form of "heart" in front of the character we obtain "nature," "character," "attitude." Man's temperament, qualities and inclinations are already contained in his heart at the moment of birth. If we place the character for "sun" or "day" next to the radical, we have the word for "birthday": the day on which we were born. Stars are nothing more than the quintessence of earthly things, sublimated and then crystallized in the sky, and so all we have to do is place the sun above the radical to create the character for "star." The sign for "things," placed next to this radical, indicates "living things."

性	Xìng	nature
生日	Shēng rì	birthday
星	Xīng	star
生物	Shēng wù	living things

SHÍ
TO EAT

食

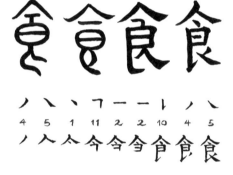

Sitting down to eat is one of the most important activities in the East. The newly born child is welcomed with food; friendships are kept alive, business deals sealed and disputes resolved in restaurants. Marriage is celebrated by sipping tea from the same cup during the wedding feast. This simple, everyday act legitimizes the start of two people's life together.

Beneath the sign for "together" there is the one for "covered pot" and, further down, even a ladle is represented. It signifies gathering in the house of the people cooking the rice in order to share their table or "eat." The famous sinologist Glose, however, interprets the sign for "together" as portraying the mixing of cereals during the preparation of the meal. During the lunar eclipse the moon is eaten by the wicked star Luóhóu Xīng, with evil consequences for man; this is what the Chinese believed when they wrote the character for "moon" next to "to eat." Eating one's word means to break promises. Food is nothing more than the grouping together of everything that can be eaten.

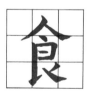

月食	Yuè shí	eclipse
食言	Shí yán	to break one's word
食物	Shí wù	food
饗	Xiǎng	to invite to dine

53

GŌNG
WORK

工

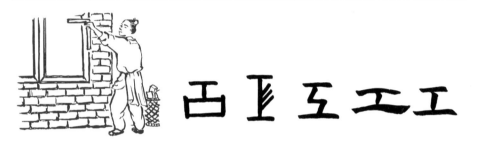

A simple sign that can be interpreted in two different ways. The most likely is that it represents the old carpenter's set square. In the ancient script there were also three parallel lines drawn to the right of the character. Alternatively, the character may show an implement used for breaking up the earth after it has been ploughed.

When combined with the character for "strength" it means "meritorious," a job well done. When it is placed above the character for "shell," nowadays used in its simplified form, the word for "tribute," "tax" or "salary" is created; this refers to the number of shells given either as payment for work or as tax to the local dignitary. The sign for "man" placed after the character for "work" produces "workman." In the character for "wizard" or "witch," two men appear inside the character for "work." They recall the young girls who danced at the shaman's behest in order to make rain during times of drought. From this lengthy and gruelling exercise we pass to the meaning "soothsayer," the person who is able to contact supernatural forces.

一 丨 一
2 3 2
一 丁 工

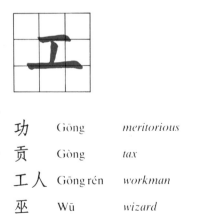

功	Gōng	*meritorious*
贡	Gòng	*tax*
工人	Gōng rén	*workman*
巫	Wū	*wizard*

LÌ
STRENGTH

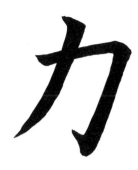

It seems very easy to explain the graphic structure of this character with a modern drawing: it is strength expressed by means of a man's arm with a swelling bicep. In fact, the character derives from a representation of the tendon that joins the muscle to the bone and thus, by extension, means "strength." There are many, however, who believe that its origins lie in the portrayal of a stooping man vigorously working the soil with a spade.

By placing the sign for "little" beneath the one for "strength" we obtain "bad," "weak," or "inferior." However, by placing "rice field" above "strength" we get the word "male," the man who uses his strength to work in the fields. This may seem somewhat unfair, given the fact that large numbers of women still work in the fields, but the original idea is somewhat justified: the man supported his family by working in the fields, while the woman was involved in bringing up the children and looking after the home. The character for "strength," when repeated three times (now reduced to one or two small sidestrokes), forms the sign for "union" or "concord."

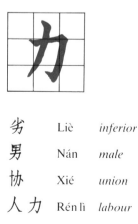

劣	Liè	inferior
男	Nán	male
协	Xié	union
人力	Rén lì	labour

BŌ
TO ASCEND

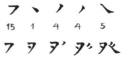

This is another character no longer found today, except in combination with others, and with only three derivatives in modern dictionaries. Originally it was much more extensive and prolific. It began with a graphic sign already seen in the character for "foot." Here it indicates two feet facing in opposite directions: hence its meaning of "separation" or "divergence" in addition to the basic meaning of "to go up," albeit with the assistance of a stool.

Among its few derivatives is the tenth sign of the "heavenly stems." The Chinese lunar calendar, still used by peasants, results from the combination of two cycles: the ten "heavenly stems" and the twelve "earthly branches," all indicated by characters that, when combined with each other, form a perpetual calendar lasting sixty years. The word "to go out" is written nowadays by placing "stool" beneath the character shown here. However, by placing the character for "door" beside "to go out" we obtain the meaning "to go looking for someone": in ancient China all doors had a step. Replace "door" with "mountain" and we get "to scale."

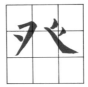

癸	Guī	*tenth heavenly stem*
登	Dēng	*to go out*
登门	Dēng mén	*to go looking for someone*
登山	Dēng shān	*to scale mountains*

RŌU
TO DEPART

内

离 内 内 内

丨 フ 𠃌 丶
3 17 14 1
丨 冂 内 内

This radical has been eliminated from modern dictionaries, but it can be found in combination with other signs. The pictograph describes the tracks made by a quadruped, the only visible part of which is its tail between the shafts of the cart. An animal, harnessed to a cart and impatiently swishing its tail, conveys the idea of departure. In its earliest form it was often part of a composite meaning "golden oriole" and then, by transference, "to depart," "to leave," "to split up." The Chinese golden oriole, a small bird, arrived in the villages at the start of May and stayed for the short duration of the mating season. This was the sign for betrothed girls that the time had come for them to get married and leave for their new families. The name of the founder of the Xià dynasty (21st–16th century B.C.), the emperor Yǔ, who made his capital at Xiàxiān, had this radical in his character. The overall appearance of the composite seems to be that of a long-tailed insect, or perhaps a scorpion. If we join the radical to the character for "marriage" we create "separation": if one or the other leaves, the result is "divorce."

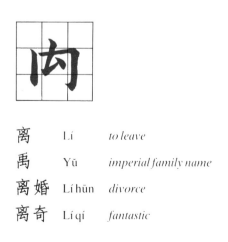

离	Lí	to leave
禹	Yǔ	imperial family name
离婚	Lí hūn	divorce
离奇	Lí qí	fantastic

LÌ
TO GRASP

隶

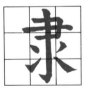

Although of disputed interpretation, this character can be traced back to two drawings: a hand grasping something and the hairy tail of an animal. These two ideas are clear in the character's ancient form, but incomprehensible in modern script. One plausible hypothesis is that when monarchs of the Zhōu dynasty (1066–256 B.C.) had to ask some favour of Heaven or their ancestors, they sacrificed animals. The priests conducting the ceremony would take the victims to the altar holding on to their tails; hence the meaning "to beseech," "to ask for favours." From the obvious original meaning of "to hold," "to grasp," "to reach," it now came to signify the opening element of the liturgy. In modern dictionaries the character has taken on the meaning of "subordinate," "submissive." "A tail too fat to wag" refers to someone who has become too powerful to remain submissive, whereas to "humble oneself" or "ask for favours" becomes "to move the head and wag the tail." In modern usage "to reach" is written by joining the radical for "to grasp" with the one for "to walk quickly."

隶	Lì	subordinate
隶书	Lì shū	a style of calligraphy
奴隶	Nú lì	slave
逮	Dài	to reach

BĀO
TO EMBRACE

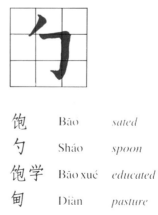

The oldest form of this radical represents a man bowing down to embrace or to gather up an object. When combined with the character for "food" (in its simplified form), it has the meaning of "sated" or "satisfied." There are no fewer than three characters in this composite: "foetus," "to envelop" and "food." The baby in its mother's womb is enveloped in the amniotic sac; it is properly fed, it is completely satisfied. To clasp a newborn child in one's arms means to embrace. A small stroke within the radical produces "spoon," the china utensil used by the Chinese to eat soup. A man filled with what he has learned and studied at school is "educated." The character for "rice field," when combined with this radical, gives the idea of a carefully protected and well defined area of land: a pasture. If, however, we place the sign for "rice" inside this radical, the new character means "handful," the amount that can be held in the hollow of the hand, which was a unit of measure used by villagers when buying cereals.

饱	Bāo	sated
勺	Sháo	spoon
饱学	Bāo xué	educated
甸	Diàn	pasture

XÍNG
TO TRAVEL

行

井 仆 仕 行 行 行

A step forward with the left foot and then another with the right: this is the action portrayed by the modern character, which is composed of the two signs juxtaposed. The original pictograph showed two intersecting roads. This gave rise to a dual meaning: that of walking, as represented by the footsteps and the crossroads; and that of business, a shop where goods are bought and sold. The sign is found on all Chinese banknotes. By placing this radical, in its sense of "business," next to the character for "house" we obtain the meaning of a place inhabited by someone who is successful in business, "an expert." Replace "house" with "palace" and we have an imperial residence in which the Son of Heaven lived when he was far from his capital. A star that travels through the sky is a planet, as is indicated by the composite character, while placing the sign for "man" next to this radical produces "pedestrian."

ノ ノ 丨 ﹣ ﹣ 亅
4 4 3 2 2 8
ノ ク 千 彳 行 行

行家	Háng jiā	expert
行宮	Xíng gōng	imperial palace
行星	Xíng xīng	planet
行人	Xíng rén	pedestrian

ZŎU
TO MARCH

走

文 往 金 矢 走

一 丨 一 丨 一 丿 乀
2 3 2 3 2 4 5

一 十 土 キ キ 走 走

The sign of a man moving his arms, in combination with the normal character for "foot," gives the idea of a person walking. As the character develops, the man bends forward, emphasizing the decisiveness and rapidity of his step: he is marching.

This radical, when combined with the character for "divination" once used on oracle bones and thus one of the earliest ancestors of modern characters gives rise to the word meaning "to take part in a ceremony," reflecting the idea of marching to a celebration. Placed next to the character for "brush," now simplified, it means "to write fast." Next to the character for "to visit" it means "to interview," which to the Chinese always has the sense of visiting someone with the specific intention of obtaining information. During the European occupation of certain parts of China in the last century, people who collaborated or worked with Europeans in the Concessions were insultingly referred to as "running dogs." The two characters used to define them were this radical and the character for "barking dog."

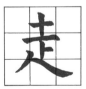

赴	Fù	*to participate*
走笔	Zōu bĭ	*to write fast*
走访	Zōu fǎng	*to interview*
走狗	Zōu gŏu	*"running dogs"*

61

ZHÌ
TO FOLLOW

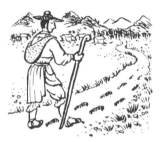

This radical means to walk in someone else's tracks, "to follow." By placing the character for "mouth" beneath it, we obtain its original meaning of to make one's own way without listening to the advice (indicated by the mouth) of others. Today it means "different."

Another character derived from "to follow" has altered its meaning: it now represents "mistake" or "error." This radical combined with the characters for "mouth" and "choice," indicated "to go one's own way," to have a plan and be determined to follow it through. Such a course of action would inevitably lead to their irritating or alienating someone, which explains the meaning of "mistake" or "blame" that one would never be able to deduce from the graphic design of the character's components.

By placing a roof over this radical one obtains the meaning "traveller," but in the sense of "guest," someone who stays for a short time in a house other than his own. When combined with the character for "choice," it means to get on well with someone, to be in agreement with him.

丿 フ ㇏
4 15 5

丿 夂 夂

各 Gè *different*

咎 Jiù *mistake*

客 Kè *traveller*

处 Chŭ *to get on well with someone*

ZHǏ
TO HALT

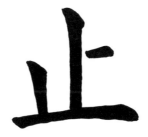

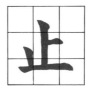

| ㇐ | ㇐ | ㇐ | ㇐ |
| 3 | 2 | 3 | 2 |

丨 ㇏ 止 止

We have already seen the design of this radical when we dealt with "foot." It is this same meaning of a footprint on the ground that the character meaning "to halt" emphasizes. It is not hard to see the difference between the two, however: the earlier radical for "foot," which showed the heel raised off the ground, conveyed an idea of motion, whereas this one underlies the static nature of the foot by portraying it with a flat sole.

It is in its meaning of "to halt" or "to stop" that this radical forms part of many composites. By writing the sign next to "blood" we obtain the word "styptic": anything that staunches bleeding. Next to the character for "cough" it means "to cure a cough," while next to "thirst" or "drought" it means "thirst-quenching" or "to refresh." When placed beneath the radical for "man," in one of its simplified forms not to be confused with the one for "roof" or "covering," it signifies "to stand on tiptoe" or, in its present meaning, "to look far ahead." In fact, the characters suggest a man on tiptoe peering into the distance.

止血	Zhī xuè	*styptic*
止咳	Zhī ké	*to cure a cough*
止渴	Zhī kě	*to refresh*
企	Qī	*to peer*

63

ZHUŌ
TO WALK QUICKLY

辵

This radical is formed from the familiar sign of a foot in motion, but with the addition of footprints on the ground.

By linking this radical with the character for "sprouting grain" we obtain the character that used to mean "intimate": to share the road and food with someone. In my opinion, however, this is an error in transcription: the character was originally the one for "rice field" or "field" and only later did some careless scribe add an extra stroke and change its sense. If this were true, we would have another explanation. In fact, a cultivated field is so precious that only someone very well known to the owner would be allowed to walk across his rice field. It now means "to advance" or "to lead." To move quickly away from a group of houses meant "to flee," whereas today the word means "distant": it is formed by combining the character for an enclosure with houses inside, i.e. a "city," with the radical for "to move quickly." The same radical together with the character for "strength" means "edge" or "shore." Next to the character for "art" it makes the word meaning "to recount": the ability to cover events quickly.

丗 辻 走 辵

ノ ノ ノ ㇐ 一 ノ ㇏
4 4 4 3 2 4 5

ノ 彡 彡 午 乒 乒 辵

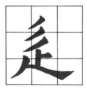

迪	Dī	*to advance*
迥	Jiǒng	*distant*
边	Biān	*shore*
述	Shù	*to recount*

CHÌ
TO GO FOR A WALK

This character shows the print made by the left foot while walking: hence the meaning of "to walk slowly," "to go for a walk." If the walk proceeds with the other foot, and there are two footprints, the new character means "line," "file," "progression," but also "shop" or "business." The union of this radical with the character for "imperial court" creates the word "to try." This has a wealth of meaning: the court, in fact, is represented as the place in which the law flourishes like a tree. "To try" thus means to show moderation in applying the law, administering it fairly but also patiently, step by step.

The word for "virtue" or "goodness" is also derived from this radical plus the signs for "ten," "eye" and "heart." The way to virtue and goodness is controlled by the heart and at least ten eyes. By joining the radical with the one meaning "to march" we obtain "follower," "disciple": the one who progresses slowly, like a shadow, in the footsteps of his master, who walks swiftly and surely. To walk decisively toward a goal means "to travel."

待　Dài　*to try*

德　Dé　*virtue, goodness*

徒　Tú　*disciple*

征　Zhēng　*to travel*

SUĪ
TO DRAG ONESELF
ALONG

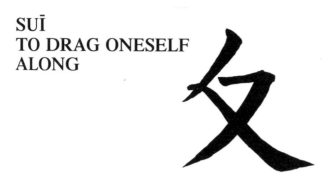

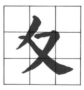

Between 1973 and 1974, a team of archae-
ologists working at Liúlíhé near Beijing, in
Fángshān county, made a macabre dis-
còvery: of the 46 tombs unearthed, no fewer
than seven contained skeletons of slaves,
either sacrificed after the death of their
owner or buried alive with his corpse. The
tombs dated from the period of the Western
Zhōu dynasty (1066–771 B.C.). From infor-
mation provided by historical and literary
sources, as well as carvings and bronzes,
scholars already knew that the sacrificing of
slaves had been practised since the Shāng
dynasty (16th–11th century B.C.), but this
was the first time the remains of children
between the ages of seven and fifteen had
been discovered with chains around their
necks and feet. The radical portrayed above
is graphic proof of this fact. The first
pictograph portrayed the chains tied around
the legs of prisoners. The meaning is "to
drag oneself along," "to walk with dif-
ficulty." Later it acquired the sense of "will"
or "tenacity." The modern composite signi-
fies "to devote oneself," "to dedicate
oneself to a cause." "To retreat," "to refuse
to proceed" are derived from this character.

致	Zhì	*to dedicate oneself*
退	Tuì	*to retreat*
复	Fù	*duplicate*
致力	Zhì lì	*to work for*

JIÉ
TO APPLY THE SEAL 卩

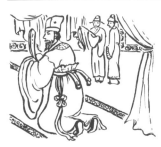

卩 卩 卩 卩 卩

When the emperor entrusted one of his subjects with an official post he had a piece of finely carved jade or wood prepared, which was then divided into two. One part was given to the official, the other kept in the palace as a guarantee of authenticity. It constituted legal proof of the official's mandate and acted as a means of validating his documents. Whenever he had to present himself to his emperor or carry out his mandate, he had to have this seal in his possession. Under the Sòng dynasty (960–1279), the emperor presented even the humblest artisans with a seal with which to mark their work.

This radical once represented a man kneeling before his superior with a seal in his hands. Today it means "dignity," "authority" or "seal," but also "knot," "fragment" or "part of the whole." A man firmly grasping the seal has an official mandate: he is a "defender." Another character formed in conjunction with this radical is part of the Chinese cyclical calendar: the fourth "earthly branch." A day marked in red, the colour of the seal, is a red-letter day or "festival."

⁊　丨
17　3

⁊　卩

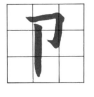

印	Yìn	*seal*
卫	Wèi	*defender*
卯	Mǎo	*fourth earthly branch*
节 日	Jié rì	*festival*

LÌ
TO STAND UPRIGHT

立

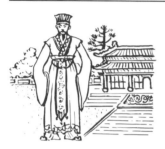

This character is easy to interpret since the pictograph is very close to reality in its portrayal. It shows a man with his feet planted firmly on the ground – a sign of solidity – and with his legs apart (originally, at least) – a sign of power. He is a symbol of independence, ability and a readiness to act. Placing the character for "sun" above it creates the word "day," but by placing "woman" beneath it we obtain "concubine." Apart from the fact that it gives a very accurate idea of the social position of a secondary wife, there is nevertheless a transcription error in the modern character. Originally, the character for "guilt" appeared instead of "to stand upright." According to Confucian ethics, concubinage was the outcome of a woman's guilt or crime and she therefore had no alternative to becoming a slave or servant girl and, by extension, a concubine. The military command "attention!" could be translated "straight and upright." These Chinese characters are, in fact, used for this order. Putting one's feet firmly down where one intends to settle means "to inhabit."

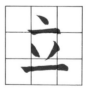

昱	Yù	day
妾	Qiè	concubine
立正	Lì zhèng	attention!
立足	Lì zú	to inhabit

YÍN
TO GO

久

彳 彳 彳 辵 辵

ㄱ ㄱ ㄟ
15 15 5
ㄱ ㄓ 又

Although it has to be admitted that the foot must have played a major part in Chinese life in view of the number of radicals linked to it, this one has a particular use. It shows a man striding along, his step determined by some important and pressing consideration. It is for this reason that it is sometimes used in the sense of "to progress."

Combined with "king" or "lord," this character means "to go to court." It once indicated someone who had to present himself at the imperial court or in front of the person administering justice on the emperor's behalf. Later it acquired the meaning of "seat of the imperial government" or "feudal court." By placing a character composed of a hand and a writing tablet within this radical we obtain the word meaning "to construct." To progress in carrying out projects means "to build." This radical – which has disappeared in the simplification process – when surrounded by a double wall, one inside the other, means "to return," almost in the sense of circling the walls to regain the safety and protection of the village.

廷 Tíng *to go to court*

建 Jiàn *to construct*

回 Huí *to return*

JIÀN
TO SEE

見

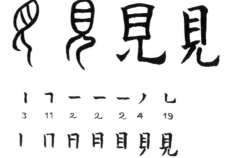

丨	乛	一	一	一	丿	乚
3	11	2	2	2	4	19

丨 冂 冃 冃 目 貝 見

A large eye above two legs conveys the idea of seeing. The size of the eye underlines the importance of personal experience as opposed to what other people say. The old Chinese saying "better one thing seen than a hundred things heard" is attributed to General Zhào Chóng-guó (120–52 B.C.), who lived during the Hàn dynasty; only after having observed the situation on the battlefield was he able to adopt the correct strategy for fighting the Tibetans, who were threatening the southwestern frontiers of the empire.

Together with the character for "spirit," this radical gives the meaning "absurd," "irrational," like the belief in ghosts so firmly rooted among the ancient Chinese. The sign for "roof" above this character means "to sleep": to place one's eye beneath the shelter of the eyelid. "To see," next to the character for "practice," means "to learn a craft," a process that involves watching and copying one's instructor. By placing the sign for negation next to "to see" we obtain the meaning for "lost," "disappeared": something beyond the line of vision.

见 鬼	Jiàn guǐ	*absurd*
觉	Jiào	*to sleep*
见 习	Jiàn xí	*to learn*
不 见	Bù jiàn	*disappeared*

70

YÁN
TO SPEAK

言

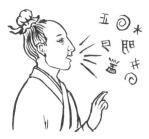 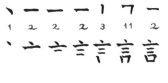

Some scholars have traced the derivation of this radical from the character for "tongue" rather than the one for "mouth." The conclusion is obvious: the tongue moving within the mouth creates language. But what seems logical to us does not always appear so to the Chinese. The pictograph has two clear elements: a mouth from which mistakes emerge. It reflects the old proverb "From a multitude of words there will certainly come forth errors." Another, poetic version has the words emanating from the heart like waves on the sea.

Poetry apart, when we find the character for "man" next to this radical we have the word "faith," "sincerity," "letter." The man who stands by his word guarantees what he says or, according to another interpretation, is ready to put his statements down on paper. "Faith" with the character for "heart" beside it means "confidence," while the man who faithfully follows the word of his master is a "disciple": a historical and deeply human image of Confucianism. Finally, the character for "word" next to the one for "to walk" means "words and deeds."

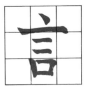

信	Xìn	faith
信 心	Xìn xīn	confidence
信 徒	Xìn tú	disciple
言 行	Yán xíng	words and deeds

YUĒ
TO SAY

日

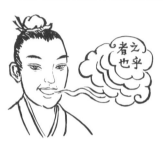

У ビ Ц 日 目 日

\|	7	--	--
3	11	2	2

\| 冂 日 日

The by now familiar sign for the mouth, with a smoke-like spiral emerging from it, provides the character for "to say." For this reason it is sometimes used in the sense of "to emit," "to emanate," "to breathe." Among the many derivatives of this radical is the character for "to shout," "to demand loudly." Its origins are rather strange. It started with the character indicating "beggar," the poor man who drags himself from door to door seeking alms, which, combined with the sign for "to say," becomes the character for "to ask humbly."

To arrive at the present meaning of "to shout," "to demand loudly," a new character had to be added: that of "mouth." By writing "to say" twice, one above the other, we obtain the word "prosperous," "flourishing." A woman who attracts the attention of strangers by means of her ample physical attributes may be called a "prostitute." Putting something pleasing into the mouth transforms the character for "to say" or "word" into the one for "sweet," in both its affectionate and its culinary sense.

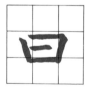

喝	Hè	*to shout*
昌	Chāng	*prosperous*
娼	Chāng	*prostitute*
甘	Gān	*sweet*

GŌNG
TOGETHER

丗

This is a prime example of the way modern script can make the evolution of a character difficult, if not impossible to understand. The radical, when examined in its ancient forms, reveals the drawing of two clasped hands with the clear meaning of "together," "union," "collaboration." All this has disappeared in the radical, which has been reduced to two vertical strokes and a horizontal one. This may explain why the sign has only two derivatives in modern dictionaries.

A man who pools the products of his labour with those of his fellow-men defines the word "common," a term widely used in the political vocabulary of modern China but that basically continues an ancient and well-established Confucian philosophy: the sense of community. If two hands raise the cross-post barring a door, we obtain the character for "to open." The modern character for "weapons" also derives from the sign of two hands, this time clutching a battle-axe. It is also possible to identify the two hands, clutching a halberd, in the character for "to threaten."

一　丿　丨
2　　4　　3
一　十　丗

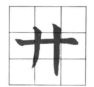

共	Gòng	common
开	Kāi	to open
兵	Bīng	weapons
戒	Jiè	to threaten

ÉR
TO HOLD UP

儿

This radical initially shows a child who first crawls, trying to hold up its body and large head, then stands up, teetering on uncertain legs. In the earliest forms the large head, apart from clearly displaying two pigtails, emphasizes the fact that the fontanelles have still not closed. This explains why the sign is open at the top. In its simplified form, only the legs and the original meaning of "to hold up" survive.

By placing the character for "mouth" on top of the radical we obtain "to shout," "to declaim," "to order." At least, this was the original meaning: it now means "elder brother," the one who has to encourage the younger children, sometimes perhaps even by shouting. By placing the character for "breath" or "breathing" above "to hold up," we form the word "to agree." The drawing showed an upright man expressing his consent by emitting a spiral of smoke from his mouth. If the character for "woman" is placed beside the derivative "son," the word "children," in the sense of both sons and daughters, is created. Next to the character for "song" it means children's songs, nursery rhymes.

丿　乚
4　19

丿　儿

兄　Xiōng　*elder brother*

允　Yǔn　*to agree*

儿女　Ér nǚ　*children*

儿歌　Ér gē　*nursery rhymes*

GĚN
DECISIVE

艮

The meaning "decisive" is a deduction: in the original drawing we can see legs going to the right while the eye is turned towards the left. This strange maneuver may be interpreted as someone averting his or her gaze. Hence the meaning of "to avoid" given by some scholars. Or it may be a decisive turning of the head to fix one's eyes on someone as a sign of mistrust. This is the meaning we have favoured here, partly because it recurs in certain derivatives.

When speaking of leather, this character is used to express "hard," "resistant." All that is needed is a dot above it, which originally probably denoted the sky, everything that lies above man, to change its meaning from "hard" to "good" or "capable." Put the character for "heart" beneath it, however, and it becomes an adverb: "sincerely." Place the sign for "earth" above it and we obtain the word for "drainage," in the sense of the ability to reclaim unproductive land. It is also used to indicate land rescued from the sea. Combined with the characters for "good" and "heart" it means "conscience."

良	Liáng	good
恳	Kěn	sincerely
垦	Kěn	drainage
良心	Liáng xīn	conscience

BǏ
TO CONFRONT

比

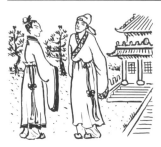

This character is an inverted transcription of the character *cóng*, meaning "to follow." It shows two men who have stopped and are measuring each other up, giving the idea of "to confront" or "to examine," which is the meaning of the radical. In modern dictionaries it also signifies "copy" or "model."

By placing this radical beneath a shelter, a roof, we obtain the word "protection." However, placing the simplified sign for "hand" in front of the radical produces the meaning "to slap," "to criticize." In the first sense the attack is physical, with the hand, while in the second it is verbal. If the character for "sun" is written above the radical, the modern meaning is "children" or "descendants," whereas in the past it meant "a multitude of men." The meaning of "crowd" or "large gathering of people" is obtained by joining the character for "oneself" with this radical. The character for "rice field," when written in front of "to confront," forms the word "beside," "next." Two people whose fields are next to each other are "neighbours."

一 ㇄ ノ ㇄
2 10 4 19

一 ㇄ ㇄ 比

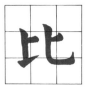

庇	Bì	*protection*
批	Pī	*to slap*
昆	Kūn	*children*
毗	Pí	*neighbour*

SHÌ
TO VENERATE

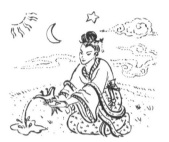

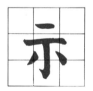

Two transverse lines represent one ancient way of writing the character *shàng*, meaning "superior"; in this radical it stands for "Heaven." The three vertical lines represent the sun, the moon, the stars, whose ever-changing nature reminds man of the presence of a superior being. In modern dictionaries it occurs in two different written forms. The first, in simplified script, preserves the earliest meaning of "to venerate," "to offer up sacrifices," to honour Heaven or one's ancestors, and occurs in many composites. The second, written in the same way as shown here, has acquired the meaning of "to notify," "to demonstrate," "to instruct."

This radical combined with the character for "foetus" means "to offer up sacrifices," either to the gods or one's ancestors. Next to the sign for "earth" it means "god of the earth" and is used to indicate both his shrines and the sacrifices performed in his honour. When linked with the sign *zǔ* – a type of wooden shelf once used for sacrificial purposes – it means "ancestor." Together with the sign for "ancient," ten generations back, it becomes "blessing."

祀	Sì	*to offer up sacrifices*
社	Shè	*god of the earth*
祖	Zǔ	*ancestor*
祐	Hù	*blessing*

BǓ
TO DIVINE

卜

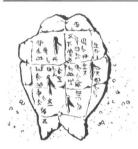

卜 卜 卜 卜 卜

This is certainly the best-known radical and also one of the most ancient. It became famous at the end of the last century when a certain Mr Wāng discovered a number of mysterious signs, which he sensed were the earliest known examples of Chinese characters, on some ancient "dragon's bones" or "oracle bones." They were some 4,000 years old, dating from the time of the Shāng dynasty, and are the predecessors of modern Chinese writing. This radical is a representation of the cracks created by the action of fire on the bones or tortoise shells used for divination.

By placing the character for "mouth" beneath this radical we obtain the word "prophecy," practising the art of divination, foretelling the future. Placing the sign for "trigram" in front of the radical produces the character for "divining symbols," meaning those eight signs we find in the *Yì Jīng* that are used to foretell the future. By putting the character for "shell" (the earliest Chinese coin) below the radical we obtain the payment given to the shaman, whom nobody dared to gainsay. For this reason it now means "loyal," "faithful."

占	Zhān	*prophecy*
卦	Guà	*divining symbols*
占 卦	Zhān guà	*divination*
贞	Zhēn	*faithful*

YÒNG
TO USE

用

＃ ＃ 用 用

丿 乛 一 一 丨
4 17 2 2 3

丿 冂 月 月 用

Originally a drawing of a bronze vase, this later became the sign for an *ex voto* offered to one's ancestors. Subsequently the character came to retain only the meaning of "to use" or "utilization."

In this sense there developed the composite that means "basket," "cask" or "bucket," which is formed of this radical combined with the one for "tree" and, above, the sign for "hook" to denote the handle. The simplified sign for "man" placed before the radical creates the verb "to take on," which reflects the idea of someone using another person to work for him. However, placing the character for "strength" above the radical makes the meaning more complex: it can signify either "horn" or "angle." This character was also the name of the patron of the sect known as "devil worshippers" that infested Fújiàn in the twelfth century and in 1840 led to the formation of the Taoist "Yellow Turban" sect. The same character, but with a different phonetic structure, indicates a Chinese drinking cup, generally of bronze, used for drinking hot wine or for pouring wine during sacrificial libations.

桶	Tōng	bucket
佣	Yòng	to take on
角	Jiāo	horn
角	Jué	drinking cup

TŌU
TO SHELTER

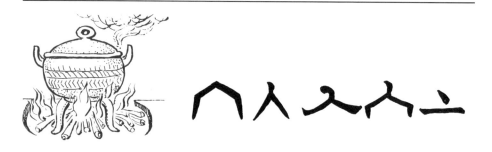

This character represents a rather simplified drawing of a lid with a round handle.

If we place this radical above the character for "field" or "rice field," the result is the word *mū*, a unit of measure equivalent to 0.0667 hectares (*c.* 325 square yards). Placed above the sign for "stool," however, it forms the word "high," but if you add the simplified sign for "man" to this composite, the meaning becomes "couple," "man and wife," two people who shelter under the same roof and sit at the same table. Place a mouth and a child under the radical and we obtain the word "to rejoice."

Although the idea of a cover or lid is often used to portray a sign of protection, and therefore linked to the concept of the family, it also takes on the meaning of "wealth," "well-being." Jars often had great riches hidden beneath their lids: coins, jewels, precious jades, rare medicines. One of the most famous lids is the one discovered in Jiāngsú, in Xūyí county, on 10 February 1982: of solid gold, it dates from the eighth century B.C. and contains 9.2 kg (20 lb) of fine gold.

1 2

亩	Mū	*unit of measure*
亢	Kàng	*high*
伉	Kàng	*man and wife*
享	Xiāng	*to rejoice*

PŪ
TO BEAT

支

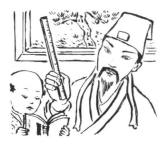

Although as a radical this design has now been modified and appears only in composite characters, its origins are clear – it shows a hand gripping a stick or rod: a symbol of both authority and punishment.

We find it, for example, in the character meaning "to teach," where we see a teacher dealing with his pupils (the character for "son"), rod in hand. This teaching method has a long history in China, where it is endorsed by the classic work *The Three Characters*, which states: "masters who are not strict in carrying out their duties are useless masters." The word "government" also follows the same pattern: in fact, it is formed of the character for "firmness" together with the one for "to beat," reflecting the idea of laws being firmly and decisively applied for the common good. Even though the Chinese realize that "animals hate nets and people hate governments," they are well aware that "a people is not governed by virtue and law alone." A shepherd is the man who controls his flock with a stick. The word for "political opponent" comprises the signs for "government" and "enemy."

支

教	Jiāo	*to teach*
政	Zhèng	*government*
牧人	Mù rén	*shepherd*
政敌	Zhèng dí	*political opponent*

ZHÌ
TO REACH

至

𝟕 𝟕 𝟕 至 至

一 ㇏ 一 丨 一
2 14 1 2 3 2
一 工 云 至 至 至

The pictograph represents a bird that, having spied its prey on the ground, launches itself downward, beak first, to reach it. The radical has few derivatives, but its meaning returns in composites with other radicals in the new dictionaries.

"To reach" a friend's house, to sit with him, implies a feeling of closeness, of having a close friend. By placing the character next to the one for "small" we obtain the word "smallest," in the sense of the worst possible result, the least possible achievement. Replace "small" by "above" and the new composite means "supreme" or "highest." The character of a reclining man when placed above this radical forms the word "house," with the precise meaning of the place that the man reaches in order to stretch out and rest. There is a Chinese saying that wisely advises "before you build a house, discover everything you can about the neighbourhood," so as to avoid any unpleasant surprises about the area when it is too late to remedy them. On the subject of friends, there is a saying: "A single enemy is too much, a hundred friends too few."

至 交	Zhì jiāo	*close friend*
至 少	Zhì shǎo	*smallest*
至 上	Zhì shàng	*supreme*
屋	Wū	*house*

QIÀN
EXHAUSTED

欠

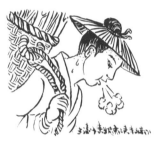

丿 ㇇ 八
4 7 4 5

丿 ㇇ ㇇ 欠

Popular language often contains words that are incorrectly used but have a precise meaning. This is the case with the radical being discussed here. The pictograph, later wrongly interpreted by scribes, shows a man breathing with difficulty. He is breathless, as is shown by the drawing with its three wavy lines in the upper part of the sign.

To understand why "exhausted" or "breathless" has come to mean "to be a debtor," "to owe someone money," we have to take into account the idea of air as a synonym for wealth. Another modern meaning is that of "insufficient." In ancient times, when sealing a pact or a sworn agreement, the participants would dip a finger into the blood of the sacrifice and stain their lips with it. An extract from the *Annals* reports: "We have only just made a pact with the other state and the blood has still not dried on our lips, how can we think of breaking our oath?" The character indicating the verb "to suck" is also a derivative of this radical and written next to the character for "blood" it means "to swear."

歃	Shà	*to suck*
歃血	Shà xuè	*to swear*
欠户	Qiàn hù	*to be a debtor*
欠伸	Qiàn shēn	*to yawn*

ZHǏ
TO EMBROIDER

黹

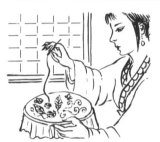

The art of embroidery began in China some 4,000 years ago. The costumes worn by ancient nobles gave ample scope for this typically feminine skill. Old paintings and costumes show that it was the men whose religious, civil and military robes displayed the best embroidery. This was the case right up until the beginning of this century, when the Chīng dynasty was in power. Embroidery was one of the subjects taught to young girls who hoped to make a good match, and was one of the favourite pastimes of the imperial concubines.

This radical is composed in its upper part by the character for "leaves" and in its lower part by the one for "material": material marked out in preparation for an appliqué of leaves, possibly the first embroidered motifs. There are very few characters derived from this radical, and all of them are related to court usage: for example, the square of embroidered material found on the lower part of a mandarins' robes, both in front and behind. The same composite often means "the flowers of five colours": the embroidered silk band with which personal seals were attached to the belt.

| 黹 | | | | |

丶丶丶丶一丿八丶丨丁
3 3 1 4 2 4 1 3 17
丿丿丿丿丷丷丷丷丷
丨丨丨
3 3 3
黹 黹 黹

黹

黻	Fú	*embroidered square*
黼	Fū	*silk band*
针黹	Zhēn zhǐ	*to sew*

84

RÙ
TO ENTER

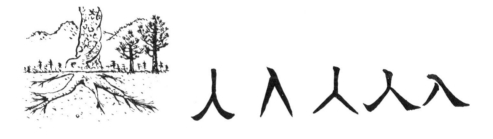

This sign should not be confused with the one for "man," although they are very similar. It derives from the drawing of a tree, a plant that spreads its roots through the soil. It therefore denotes "determination," striving to make headway.

By writing the character for "ear" after this radical we obtain the word "pleasant," meaning something that willingly enters the ear – not only in the sense of harmonious and musical, but also delicate and gentle. Placing the sign for "door" after the radical creates the meaning "to cross the threshold." The thresholds of villas, temples and imperial palaces always had a step, some higher than others, which required a certain amount of effort to overcome. To pass over this step meant to overcome the initial obstacles encountered in any enterprise. As well as meaning to enter the first phase of a project, it also means knowing how to cope with any problems arising in the early stages. By placing the character for "water" beneath this radical and then juxtaposing the one for "son," we obtain *cuān zī*, a small cylindrical pot that is placed in the fire to boil food quickly.

丿　乀
4　5

丿　入

入耳	Rù ěr	pleasant
入门	Rù mén	to cross the threshold
汆	Cuān	to boil quickly
汆子	Cuān zī	pot

毋

Born under an unfavourable sign, this radical has had an unhappy life. Omitted from modern dictionaries, its meaning altered, it has had no descendants. Its derivatives have been attributed to other characters. The pictograph portrays, without a shadow of doubt, a woman locked up for bad behaviour. Because women in this position were considered useless and hence isolated, the sense "negative" or "useless" was created, giving rise to its modern meaning.

Strangely if, instead of the vertical line that divides the radical, two points are placed in both central sections, we have the character for "mother": the two points represent nipples and indicate a suckling mother. The female breast was rarely portrayed in ancient China, and always in the context of motherhood. The word for "sea" or "ocean" derives from the character for "mother" with, on top, the character for "always" and, beside it, the one for "liquid." The character for "sea" plus the one for "armed" gives "navy."

毋	Mǔ	mother
海	Hǎi	sea
上海	Shàng hǎi	Shanghai
海军	Hǎi jūn	navy

GĀN
TO OFFEND

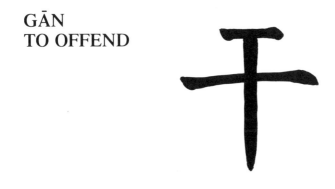

Some scholars see this sign as the representation of a pestle, which beats, crushes and grinds the contents of the mortar, while others derive it from the portrayal of a shield. The first explanation suggests the physical act of striking and implies an offensive act or injury, both meanings still expressed by the sign. The second explanation produces the sense of "to defend" or "protect" and, by extension, the modern meaning of dry, empty or dried, as in "dried food," food that has to be protected from germs and mildew. With the character for "hand" to its left, we obtain the word "to insert," "to thrust in," "to place inside." With the character for "sun" above it, we obtain "scorching heat" or "drought"; even in English we speak of the sun "beating down." At every dinner party the Chinese make a toast that, translated literally, means "to drain the cup," to drink the contents in a single gulp. This popular custom is very far removed from ancient Chinese etiquette, which urged guests to savour their wine and food slowly. By placing this radical next to the character for "ice," we form the word for "dry ice."

一 一 丨
2 2 3

一 二 干

插	Chā	*to insert*
旱	Hàn	*drought*
干杯	Gān bēi	*to drain the cup*
干冰	Gān bīng	*dry ice*

DÒU
TO FIGHT

鬥

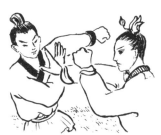

斠 鬥 鬥 鬥 鬥

Two men confronting each other with fists raised immediately convey the idea of fighting, of physically coming to blows or, in the verbal sense, of quarrelling, indulging in heated discussion. Another meaning is that of "to mortise," the method of joining wood using a mortise and tenon joint in carpentry.

When linked with the character for "cock," this radical means "cock fighting," a widespread form of entertainment in China. With the character for "eye" it means "cross-eyed," describing two eyes that cannot agree which way to look. Placed next to the character for "air" or "gas," however, it signifies "to quarrel," to squabble with someone against whom one bears a grudge. It is almost as though the two characters formed an explosive vapour waiting for a spark to detonate it.

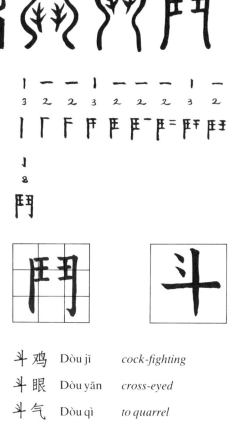

丨 一 一 丨 ⸱ 一 一 一 丨 一
3 2 2 3 2 2 2 3 2

丨 丆 丆 丮 丮 丮 ‾丮 = 丮 鬥

丨
8

鬥

鬥 斗

斗鸡　Dòu jī　*cock-fighting*

斗眼　Dòu yǎn　*cross-eyed*

斗气　Dòu qì　*to quarrel*

XǏ
TO HIDE

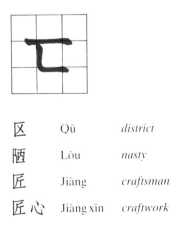

The radical as written here no longer exists, except in the company of other characters. Some people believe that it is a drawing of a trunk or box with a lid, but no front. Hence the meaning "to hide" or "to cover." Other writers believe it shows a roll of cloth or a padded coverlet, which explains the meaning "to enfold."

In the sense of "to contain," this radical with three small squares inside it (now reduced to a cross) means "area," "district," "region." The radical with the sign for "inside," plus "cave dweller," produces the adjective "nasty," "vulgar," "corrupt" – all the qualities one would do well to hide. With the character for "axe" inside, it forms the word "craftsman." In this case the sign conveys the idea of a man building a trunk with blows of his axe. Place beside it the character for "stone" and we have "mason"; replace "stone" with "wood" and we have "carpenter." If, however, the character for "heart" is placed next to the one for "craftsman," this makes "craftwork," a work carried out with intelligence and enthusiasm.

区	Qū	*district*
陋	Lòu	*nasty*
匠	Jiàng	*craftsman*
匠心	Jiàng xīn	*craftwork*

CĂI
TO CHOOSE

In classical dictionaries this radical had a different sound; it was pronounced *biàn* and meant "to mark." Examination of the pictograph reveals the footprint of a fierce animal, showing where its claws have dug into the ground (the four dots) as well as the mark made by its pads. It is probably a tiger, an animal much loved by Chinese artists and writers. This explains the meaning "to mark" or "to make one's mark."

By examining the spoor or tracks of a wild animal, it is possible to identify the creature that has made them: you make a choice or selection. When the character for "wind" is written next to this radical, it means "to collect songs," to record folk songs. In English, the word "air" is often used in a musical context. With the sign "vegetal" placed above the radical, the word "vegetables" is created. By adding the character for "garden" to this composite we obtain the word for "kitchen garden," the garden where vegetables are grown. The inclusion of the character for "heart" beneath the radical gives the meaning "well informed," referring to someone who carefully chooses what he wants to know.

采风	Căi fēng	*to collect songs*
菜	Căi	*vegetables*
菜园	Căi yuán	*kitchen garden*
悉	Xī	*well informed*

MĪ
TO COVER

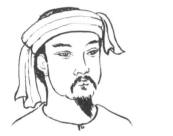

This radical represents that small piece of cloth still used by Chinese peasants to cover their heads, hence the early pictograph, which shows the two ends of the cloth falling either side of the face. It is something used for covering, a meaning that is retained in many of this character's composites.

This radical, together with the ones for "hand" and "head," gives the character for "hat." In China even the poorest people used to cover their heads and feet; removing one's hat was regarded as an act of humiliation, not of deference. Originally, the black hat worn by men of letters was a piece of cloth fixed to the head with a knot on the nape of the neck, later giving rise to two stiff "wings" of material that distinguished the cultural elite. This radical with the one for "rabbit" beneath it means "oppression," "restriction," "injustice," reflecting the idea of forcibly restraining a creature that cannot defend itself – picking on the weak. Place the character for "light" beneath the radical and the word "to darken" is formed. By writing the character for "oppression" next to the one for "house," we create the word "enemy."

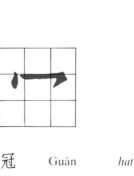

冠	Guān	*hat*
冤	Yuān	*oppression*
冥	Míng	*to darken*
冤家	Yuān jiā	*enemy*

YÁO
TO WEAVE

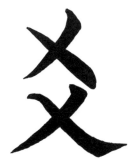

Now a thing of the past, this radical probably contains the origins of the trigram. Composed of eight signs divided into two groups – each comprising three horizontal strokes, either whole or broken – the trigram, if correctly consulted, will allow people to look into the future. The pictograph portrays the interwoven threads on a loom; it gives the meaning of "to weave," "to exchange," "to reciprocate."

This radical, if placed in the middle of two hands, above the character for "to cover" and with the character for "young boy" below, makes the word "to learn." The master uses both hands to remove the darkness of ignorance covering the child. Placed above the character for "cloth," it forms the word "rare" or "scarce," reflecting the gaps left between the interwoven threads. Placed between two trees, with the sign for "large" below, it creates the word "trellis" or "barrier" – a net stretched between two trees to bar the way. The word "brilliant," "dynamic" is obtained by portraying a man with open arms and attaching this radical to each arm; such a man combines words with deeds.

学 Xué *to learn*

希 Xī *rare*

樊 Fán *trellis*

爽 Shuǎng *dynamic*

ÉR
TO ATTACK

而

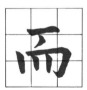

一 ノ 丨 フ 丨 丨
2　4　3　17　3　3

一 丆 广 丙 而 而

At first sight, this ancient sign brings to mind the image of a seedling putting down its roots, spreading them through the soil. It is more likely, however, that it represents a man's beard, firmly attached to his chin; the horizontal line represents the mouth. In view of the full beard and the gesture of the hands, the figure in the drawing is obviously a refined and cultured man.

Combined with the character for "present" it means "at this time." By placing the character for "woman" beneath it, we obtain the word "to recite." In Chinese theater the mask is important because it reveals the character's personality to the audience before any of the action or dialogue has unfolded. Because women were forbidden to appear on stage in imperial China, men had to put on masks and play female parts. Putting on a beard or dressing up as a woman signifies "to recite." By joining this radical to the character for "measure," the word "to control oneself" or "to resist" is created. If we analyse the latter character we can see a hand stroking a beard; a reflective man is a man capable of self-control.

而今	Ér jīn	*at this time*
耍	Shuǎ	*to recite*
耐	Nài	*to resist*
耐心	Nài xīn	*patient*

YÒU
STILL or YET

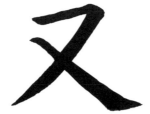

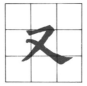

It is difficult to give a precise meaning to this sign. The drawing, however, is clear: a hand about to grasp something. In Chinese characters there are six ways of representing the hand: the right hand in profile, the left one in profile, the hand seen from the front, turned downward, both hands raised and both hands lowered. This radical shows the right hand, as always reduced to only three fingers for practical reasons. With a dot inside it, the character means "pitchfork." The word "fork" is a very recent introduction and is formed by juxtaposing the character for "child" with the one for "pitchfork." Two hands working in the same direction signify "friend," "friendship." The character for "hand" joined with the one for "bird" creates "difficult," "problematical," like the act of trying to catch something that flies and escapes one's grasp. Other scholars, however, maintain that it is the position of the bird clutched in the hand of the hunter that gives the idea of a difficult situation. By writing this character twice, by portraying two hands, the word for "pair," "double" or "twins" is created.

叉	Chā	*pitchfork*
友	Yǒu	*friendship*
难	Nán	*difficult*
双	Shuāng	*double*

94

WÚ
WITHOUT

无

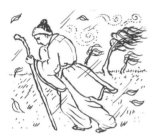

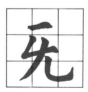

一 乚 丿 乚
2 16 4 19

一 亡 **乒** 无

The drawing shows a man testing his strength against an obstruction, but failing to overcome it. The strain of the man's exertions is emphasized in the way his body leans forward, resting on the right leg. The meaning is a negative one: "without."

By placing this radical with the character for "no," we create the phrase "without exception" or "with the exclusion of nobody," whereas next to the character for "enemy" its meaning becomes "invincible," "unrivalled," "incomparable." When written with the character for "name" it signifies "unknown," "unidentifiable," "indefinable." If, however, we replace "name" with "heart," then for the Chinese an element of will has been introduced and the meaning becomes "not to be in the mood" for doing something, "to feel no desire" or "to have no intention." When referring to an enterprise with no prospects, one that is doomed to failure, the Chinese speak of "cooking a meal without having any rice," or "making bricks and lacking straw." "Envy is like a grain of sand in the eye," a seemingly tiny obstruction that can make men blind and unable to reason.

无 不	Wú bù	*without exception*
无 敌	Wú dí	*incomparable*
无 名	Wú míng	*unknown*
无 心	Wú xīn	*not to be in the mood*

FĒI
WRONG

非

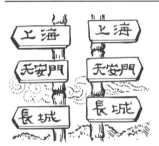

非 非 非 非 非

꜀ ꜀ ― ― ― ― ― ―
4 3 2 2 2 2 2 2

꜀ ꜀ ꜀ 韭 韭 非 非 非

In order to understand this radical, whose form is one of the earliest known, we have to think back to the character for "tree" displayed in two sections: *piàn*, the right half of the trunk – the weak side, of little practical use – and *qiàng*, the left half – strong, tough, and suitable for building a roof. We thus have two contradictory parts designated by opposing signs, with no reference to the tree as found in nature. The radical contains two identical but reversed signs; hence the negative meaning of "mistaken."

When combined with the character for "heart," this radical signifies "suffering," "melancholy," "sadness," which is the opposite of what "heart" normally indicates. By placing the character for "man" after the radical, we obtain the meaning "the wrong person," in the sense of a wrong choice, an unsuitable person. Replace the character for "man" with the one for "law" and we have the adjective "illegal" or "illicit." By placing the character inside the one for "to hide" we create the word "brigand," "kidnapper," or "thief": a man who has done wrong and must hide.

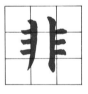

悲	Bēi	sadness
非人	Fēi rén	the wrong person
非法	Fēi fǎ	illegal
匪	Fēi	brigand

Village

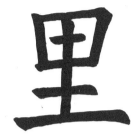

The village lies at the very heart of China, ancient and modern; it is its oldest unit and the guardian of Chinese traditions and civilization. Beside the radical for village *are grouped the terms linked to the environment and clothing. In the verses of Mèng Haorán, a poet of the Táng dynasty (689-740), the village is described as the ideal place for man to commune with nature and with himself:*

> *My friend, you set aside chicken and millet,*
> *you bid me enter your country home.*
> *The trees grow green, thronging the village,*
> *the mountains slope blue behind.*
> *By the window looking over the yard and garden,*
> *we drink wine and speak of hemp and mulberries . . .*

TŬ
EARTH

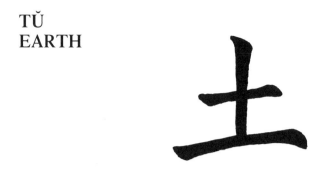

土

土 土 土 土 土

The book *The Three Characters* contains the following lines: "water, fire, wood, metal and earth are called the five elements, to which all things owe their origin." Earth is thus one of the five sources of nature. It is enough to look at the network of fields of modern China to understand how strongly the Chinese feel this link with the earth.

This radical is formed of three strokes: the upper one is the crust of the earth, which can be cultivated; the lower one is the subsoil, stony but fertile; the vertical stroke represents all the things that emerge from the subsoil to the surface, all the fruits of the earth. This radical, with the addition of that for "heart," and the character for "hand" above it, means "strange," "unusual." It used to convey the idea that the hand of the man working the earth transformed it. Combined with the characters for "hand" and "sun," it describes the action of making clay figurines. Originally it symbolized earth worked by man and then left to dry in the sun. This was the way in which the first containers were created. In the *History of the Sòng Dynasty* (960–1279), this radical was used in the sense of "local," "native."

$$\overset{\overline{}}{_2} \quad \overset{|}{_3} \quad \overset{\overline{}}{_2}$$

一 十 土

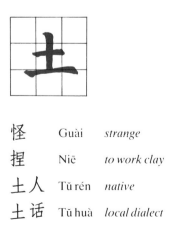

怪	Guài	*strange*
捏	Niē	*to work clay*
土人	Tǔ rén	*native*
土话	Tǔ huà	*local dialect*

SHĀN
MOUNTAIN

山

山 山山 山 山 山

"If you do not climb a high mountain you cannot admire the plain," according to the old saying, and this character, faithful to the pictograph, has been repeating this sentiment for centuries in painting, sculpture and poetry. It is one of the most widely written characters. Even religion has singled it out: since the time of the Shāng dynasty it has meant a place sacred to worship. Classical China has five sacred mountains, one at each of the five cardinal points: north, south, east, west and center, on which splendid temples were erected.

By placing the character for "water" after this radical, we obtain the word "landscape," a classic subject of Chinese painting, with an abundance of mountains, rivers and villages. Shāndōng, the mountainous province of eastern China, takes its name from this radical, a name that recurs in the opaque, loosely woven silk cloth known in English as "shantung." By placing the character for "folksong" after this radical, the word for "mountain songs" is created. By placing the character for "mountain" in front of the one for "tea," however, we obtain "camellia."

丨 ㄴ 丨
3 16 3

丨 屵 山

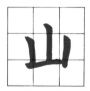

山水	Shān shuī	*landscape*
山东	Shān dōng	*Shandong*
山歌	Shān gē	*mountain songs*
山茶	Shān chá	*camellia*

GŬ
VALLEY

谷

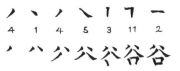

The pictograph shows a cleft in the mountains with water running through it, or perhaps a road whose exit is indicated by the sign for "mouth." It portrays a valley that winds through the peaks before opening out into a plain. In the *Shījīng* (Book of Odes), which dates from the western Zhōu dynasty (1100–771 B.C.) to the Spring and Autumn period (722–481 B.C.), this radical was used in military jargon to indicate a place used by the enemy as a trap where "advance or retreat becomes impossible." When linked to the character for "warehouse" or "storehouse," this radical means "granary," while next to "rain" it indicates the sixth of the twenty-four solar terms into which the Chinese calendar is divided, thus corresponding to 20 April. Placed together with the character for "misfortune" or "destruction," it forms the word "opening," with particular reference to breaches made by the enemy in the walls of a city. Linking it with the character for "garment" gives the word "abundant" or "well-to-do." In China, lengths of cloth were among the most highly appreciated presents.

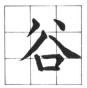

谷仓	Gǔ cāng	*granary*
谷雨	Gǔ yǔ	*sixth term*
豁	Huō	*opening*
裕	Yù	*well-to-do*

CHUĀN
STREAM

There are two ways of writing this character, which indicates two streams flowing through parched land and bringing life to it. There is a saying that underlies the importance of small contributions to an enterprise: "the great river does not spurn the small stream."

Written in front of the character for "money" or "supplies," this radical means "travel expenses": everything needed to tackle a long journey, often by boat. Placed above the character for "city" it means "moat." This character is also used nowadays as a second name for the city of Nánníng, the capital of Guǎngxī-Zhuàng, an important military center in the south for more than 1,600 years. In the past the river Yōng surrounded and protected the center of the city, which is why the character for "moat" has been used as a name for the place. By placing the character for "stream" above the one for "fruit" we get the word "nest," which is the result of a scribe's error. In reality, the pictograph for "nest" did not indicate "water," but three small birds. If the character for "cave" occurs next to "nest" we get the character for "lair."

〈　〈　〈
13　13　13

〈　〈〈　〈〈〈

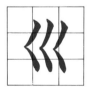

川资	Chuān zī	*travel expenses*
邕	Yōng	*moat*
巢	Cháo	*nest*
巢穴	Cháo xué	*lair*

CHĂNG
SLOPE

厂

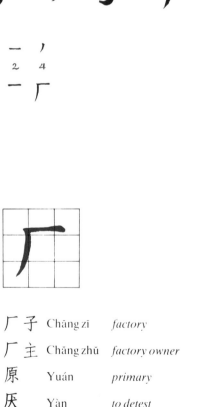

厂 厂 丿 厂 厂

This striking sign has a dual sense. Its upper part expresses the idea of a crag jutting out over an abyss, while its left side conveys the idea of a sheer slope stretching down toward a valley. Both images express a feeling of danger, whether in the rock projecting over a void or in the steepness of the incline. Care should be taken not to confuse it with another radical, similar in shape but not in meaning: *guăng* ("shelter"), which in fact has an extra stroke in its upper part. Many people have made this mistake in the past.

In modern usage this character has acquired the meaning of "factory" or "industrial plant," but it is normally written with the character for "son" beside it. Using the character for "factory" next to the one for "lord" creates the word "factory owner." By writing this radical with the character for "spring" beneath it we obtain the meaning "original," "primary" or "ancient." Placing the character for "dog" beneath it, however, produces "to detest," "to be disgusted": to have sunk so low that either you act like a dog or other people treat you as though you were a dog.

```
 一      丿
 2      4
 一      厂
```

厂

厂子	Chăng zǐ	*factory*
厂主	Chăng zhǔ	*factory owner*
原	Yuán	*primary*
厌	Yàn	*to detest*

FÙ
HILL

阜

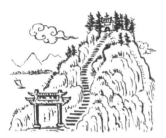

This pictograph was drawn in the same way as the one for "slope," but with three horizontal lines below and three small circles above: the lines indicated the steps allowing people to climb up to where the forest was. This is the classic Chinese hill found in all landscapes: steep and covered in trees. The scribes then upset everything with the arbitrary abbreviation we now find in the radical's composites. Even its original meaning of "hill" has now become "dyke" or "large embankment."

There are two very important derivatives from this radical: one is *yīn*, the other *yáng*. The first indicates the part of the hill in shadow: the cold, lunar, passive, female principle, the night, darkness, the north. The second indicates the part of the hill in sun: the hot, solar, active, male principle, the day, light, the south. For the Chinese these principles, conceived as the ebb and flow of waves, keep alive the sea of reality. Combined with the character for "ten thousand," only in a phonetic role, it gives us "path." The first character in modern dictionaries derives from this radical and is used like our letter "a" in many nouns.

阴	Yīn	*the dark*
阳	Yáng	*the light*
阡	Qiān	*path*
阿	Ā	*a*

KĂN
HOLE

凵

∪∪∪∪∪∪

∟ │
16 3

∟ 凵

This refers to a hole in the road, a hazard for the unwary traveller. For this reason the sign is often associated with the idea of misfortune. In the character *xiōng* there is a cross inside the radical: it indicates a careless person who has fallen headfirst into a hole and means "unfortunate," "unlucky." (Perhaps "absent-minded" would be a fairer description.) This composite next to the one for "spirit" gives "devil": a spirit bringing misfortune could only be a demon. By writing the character for "announcement" next to the one for "unfortunate" we obtain the idea of sad news, generally somebody's death. It can be seen from the examples given here that this radical now occurs only in composites. It does not, however, always have such negative implications. If written with the sign for cultivated field or "rice field" inside it, with the character for "sky" above it, it changes mood and becomes a "drawing," "picture" or "painting" containing a panorama of fields with the sky in the background. When speaking of bad luck and misfortune, the Chinese say: "Many evils are the fault of the mouth."

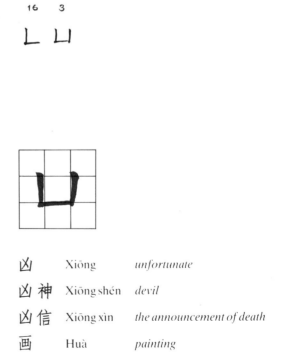

凶	Xiōng	*unfortunate*
凶神	Xiōng shén	*devil*
凶信	Xiōng xìn	*the announcement of death*
画	Huà	*painting*

穴

During the period of the Yǎngsháo culture, which was widespread in Hénán, Shǎnxī, Héběi, Gānsù and Qīnghǎi from 5000 to 2500 B.C., the people lived in caves dug out of clay. These dwellings, cool in summer and warm in winter, represented the best and cheapest housing solution in these regions. The radical, which depicts a roof and two sloping walls, gives an idea of this sort of shelter.

Written next to the character for "to inhabit" it means "to live in caves." Next to the character for "place" it means "acupuncture point," acupuncture being the Chinese healing technique – based on the five elements, five senses, five planets, five colours, five metals and five internal organs – in which the doctor inserts needles at points that will allow balance to be restored to a body in disharmony. With the character for "dog" beneath, it means "suddenly." This refers to what happens when someone enters a cave inhabited by a stray dog: growling followed by headlong flight. Linked to the characters for "hand" and "movement," it corresponds to the verb "to dig."

穴居	Xué jū	to live in caves
穴位	Xué wèi	acupuncture point
突	Tū	suddenly
挖	Wā	to dig

105

GUĂNG
SHELTER

广

个 广 广 广

、 一 ノ
1 2 4
、 亠 广

This radical shows a structure with a triangular roof, open at the front, in which to keep tools, agricultural produce and carts. Originally the sign meant "shelter," "roof" and even "shop," of the type still found in Chinese villages. Today, however, it means "broad," "vast," "extensive."

By placing the character for "cart" beneath this radical we obtain the word "warehouse" or "storehouse." In fact, as the pictograph indicates, it was originally a shelter for carts, which then came to be used for storing grain, vegetables, fruit and all manner of other produce. In this way it ended up acquiring the meaning of "warehouse" and also "shop." The character for "forest" beneath this radical creates the word "hemp." Join the character for "meaning" to it and we obtain the phrase "in the broad sense": i.e. improper, not in strict accordance with the literal meaning. By using the meaning given to this radical in modern dictionaries and by joining it to the character for "to sow," we get "broadcasting": the dissemination of ideas to a vast public, the act of sowing them on the airwaves.

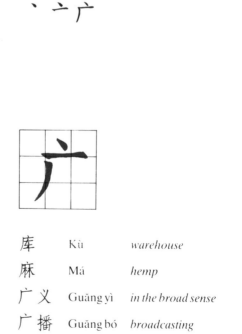

库	Kù	warehouse
麻	Má	hemp
广义	Guāng yì	in the broad sense
广播	Guăng bó	broadcasting

MIĀN
ROOF

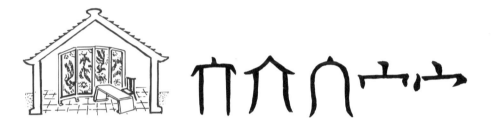

This is another radical with the meaning of "cover"; this time, however, it is a hut in which man lives; a manufactured product, not an accident of nature: the roof as shelter.

If beneath this character we find the one for "fire," we have the word "disaster," "calamity" or "misfortune." In a country where most of the houses were straw huts and the villas and palaces were wooden, fire must have been the most dreaded danger, a total disaster. By placing the old character for "city" beneath this radical, we obtain the word "mandarin" (a word created by Westerners that has no roots in Chinese), in the sense of government official. The word "precious" is formed by placing the character for "jade" beneath "roof"; before this character was simplified it also contained vases and shells as well as jade. The character for "rich," however, shows many things under the roof: a lofty palace and produce from the fields.

灾	Zāi	*disaster*
官	Guān	*mandarin*
宝	Bǎo	*precious*
富	Fù	*rich*

WĂ
TILE

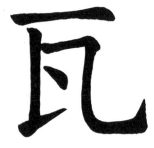

```
一    丨    丶    乙
2     3     1     6    24
一    厂    下    玊    瓦
```

Tiles play an important part in Chinese architecture: they fulfil a decorative role as well as indicating the function of the building or the social status of its occupants. Their shape, which is semicylindrical, may be derived from that of a piece of split bamboo. The earliest terra cotta examples date from the predynastic cultures, but under the Eastern Hàn (25–220) they developed rapidly, and tiles with glazed and coloured surfaces were introduced.

Having undergone a remarkable series of transformations, this radical no longer conveys the idea of two overlapping tiles with the lime that sticks them together at the center. Different characters derived from this radical have extended its meaning to embrace different types of earthenware. Placing the character for "public" above it creates "jar," the terra cotta container found in shops and used to store pickled vegetables. By joining this radical with the character for "container" we obtain "rice bowl." The character for "porcelain" is rather curious: its upper part contains the sign indicating respiratory movement, while the radical for "tile" appears below.

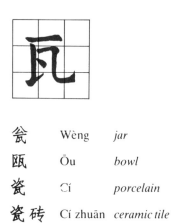

瓮	Wèng	jar
瓯	Ōu	bowl
瓷	Cí	porcelain
瓷砖	Cí zhuān	ceramic tile

108

MÉN
DOOR

門

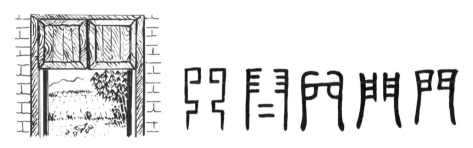

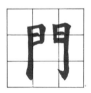

This radical applies to all double doors, whether at the entrance of a house, a palace or a city. It forms part of many composites with a variety of meanings. Its classical shape is clear: it depicts two wings with plenty of space underneath to allow the air to circulate and domestic animals to come and go, while still providing a measure of privacy: the typical door of a peasant's home. In its simplified form it has lost its wings. The most famous gate in China is the Tiānānmén, the Gate of Heavenly Peace that leads into Beijing's Forbidden City.

By placing the character for "pair" after this radical, we obtain the name for the inscriptions expressing New Year's wishes that are placed beside the doors of Chinese houses. The character for "heart" inside it means "melancholic"; replace the "heart" with "mouth" and the verb "to ask" or "to request" is formed. If, however, we find the character for "palace" inside the one for "door," then the meaning becomes "city gate." "Wielding an axe before the door of Lǔ Bān," a mythical carpenter and a contemporary and fellow-citizen of Confucius, means to make a bad impression.

门联	Mén lián	good-wish inscriptions
闷	Mèn	melancholic
问	Wèn	to request
阊	Lú	city gate

109

HÙ
DOORWAY

户

、 丿 フ 一
1 4 11 2

、 丶 丿 户 户

The pictograph shows a drawing of a doorway. This character also means "family" or "home." To indicate the number of families in a village, the tax collector used two characters: the one for "doorway" and the one for "mouth."

"Head of the family" is formed by writing this radical with the character for "lord," in other words, the master of the house. During the feudal period, even the emperor used this form. In fact, the government body concerned with raising taxes and revenue was not known as the finance ministry but simply the "ministry of doors" or, more exactly, "doorways." But the doorway of a house, as well as being a symbol of the family as a social unit, was also a symbol of industriousness. "The hinge of a door does not house many insects," says one proverb, emphasizing the idea that a doorway, because it is in constant use, is not the best place to rest or relax. By placing the character for "dog" below this radical we obtain the word "sin" or "crime," reflecting the idea of a dog, caught misbehaving, which tries to escape punishment by slipping under the door.

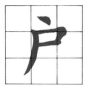

户 口	Hù kōu	*family*
户 主	Hù zhǔ	*head of the family*
户 部	Hù bù	*minister of taxes*
戾	Lì	*crime*

WÉI
ENCLOSURE

Originally this was a circumference drawn by hand. It then became a square, not to be confused with the smaller one for "mouth." It means "enclosure," "boundary."

One well-known derivative of this radical is the character for "nation," composed, in its original form, by "enclosure," "earth," "mouth" and "halberd." The concept is clear: a territory that encloses within it land, men and soldiers. In its simplified version the character contains only the sign for "jade." By writing the character for "enclosure" with the one for "man" inside it, we obtain "prisoner." If, however, we place the character for "woman" or "child" inside, we get "slave girl" or "child slave." That, at least, was the original meaning, but nowadays the character for "slave girl" has acquired the meaning either of "small girl" or "small boy," as though to emphasize the dependence of the young on their parents and also their total obedience. By placing the character for "ancient" inside this radical, the word "solid" is formed. Something ancient is traditional, the result of many generations' experience, a guarantee of solidity.

国	Guó	*nation*
囚	Qiú	*prisoner*
妧	Nān	*small child*
固	Gù	*solid*

LǏ
VILLAGE

里

A small group of houses, each of which – in accordance with ancient law – occupied an eighth of the land, as is indicated in the upper part of the radical, albeit in reduced form. At the center was the common land occupied by the well. Apart from meaning "village," this radical also signifies a measure of length, the *lǐ*, equivalent to about 500 meters (*c.* 540 yards). The Great Wall in Chinese is the "Long wall of the 10,000 *lǐ*." Today it means "internal."

In the sense of "internal," this character, joined to the one for "sea," means "Caspian Sea," the lake bounded by Russia and Iran. It also forms part of the Chinese word for the Italian unit of currency, the *lira*, but only as a phonetic transliteration, with no logical significance. A more precise and inspired derivation occurs in the word formed by this radical, in its sense of "internal," joined to the one for "spine": "fillet," the cut of meat that lies within the lumbar muscles next to the spine. Written next to the character for "hand," it indicates the part of the road to the left of a person driving a left-hand-drive vehicle: i.e. the middle of the road.

里海	Lǐ hǎi	*Caspian Sea*
里拉	Lǐ lā	*Italian lira*
里脊	Lǐ jī	*fillet*
里手	Lǐ shǒu	*to the left*

YÌ
CITY

邑

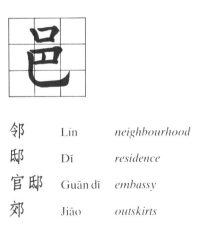

It is not hard to see how this radical derives from the one for "enclosure." It shows a city, surrounded by walls and protected by a moat. The upper part of the pictograph shows a walled city while the lower part, which contains the character for "seal," emphasizes the fact that the city is the seat of imperial authority. Apart from the difficulty of identifying this radical after the process of simplification used in its composites, there is also a danger of confusing it with the one for "hill," which is almost its twin: it should be remembered, however, that "city" always occurs to the right of composites and "hill" to the left.

With the character for "group" or "together," it forms the word "neighbourhood." With the character *Dī*, the name of an ancient Chinese people, which in this case has a purely phonetic function, it becomes "residence," in the sense of the house of someone of high social standing. If the word "official" is added to this composite we obtain the word "official residence," "embassy." The character for "united" combined with this radical produces the word "outskirts.

邻	Lín	neighbourhood
邸	Dī	residence
官邸	Guān dī	embassy
郊	Jiāo	outskirts

113

TIÁN
RICE FIELD

田

田 ... (ancient forms)

A plot of cultivated land or perhaps, more correctly, a rice field with low banks separating the flooded sections and forming raised paths along which the farmer can walk. The peasant is tied to his land and respects the adage: "never leave your field in spring or your house in winter."

By placing "heart" beneath this radical we get the word "to think," "to decide": for the peasant, the rice field is an object of much thought, a determining factor in all the decisions he makes. Write this radical above the character for "limit" and we obtain the word "boundary," which was very expressive in its ancient form: three horizontal lines separating two rice fields. Nowadays the field appears with two lines beneath it. By combining the composite "boundary" with the character for "stone," we create the word "boundary stone." There is one rather curious formation: the character for "frog" is formed by linking the radical for "rice field" with the character for "hen." Perhaps the poor peasants who raised poultry for other, richer men consoled themselves by eating frogs, which they called "rice-field chicken."

丨 一 一 丨 一
3 11 2 3 2

丨 冂 日 用 田

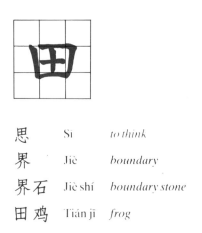

思	Sī	to think
界	Jiè	boundary
界石	Jiè shí	boundary stone
田鸡	Tián jī	frog

JIŌNG
COUNTRYSIDE

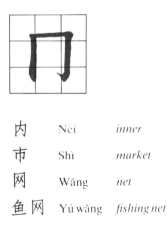

An open space bounded by vertical lines, with the distance denoted by a horizontal line: this is the countryside as opposed to the city. This meaning no longer exists, but the radical forms part of a variety of composites, even though these have often lost the original sense.

By writing the character for "to enter" inside this radical we obtain the word "inner," "within": to penetrate an empty space. It is strange that the famous Kāng Xī dictionary lists the character for "market," a derivative of this radical, under another radical, the one for "napkin" (jīn). The present form is identical, but the pictograph is very different. The design of the character for "market" shows the radical enclosing the character for "grass," together with the one for "necessary things": it thus reveals an empty space where grass grows and that people visit to find what they need. The significance of the character for "net" is immediately clear: it shows an empty space filled with mesh. If we write the character for "fish" before "net" we obtain "fishing net."

内	Nèi	inner
市	Shì	market
网	Wăng	net
鱼网	Yú wăng	fishing net

SĪ
THREAD

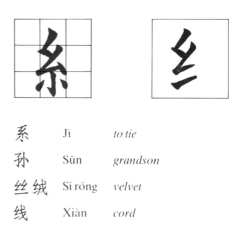

Legend attributes the discovery of silk to the wife of the Yellow Emperor (2698 B.C.); we know it already existed before the Shāng dynasty (16th–11th century B.C.) because the character for "silk," later to become "thread," occurs on oracle bones. It was not until around A.D. 550 that two monks, sent by the Emperor Justinian I, stole silkworms from China, giving the Eastern Roman Empire an important economic resource. The radical in the pictograph portrays two cocoons, one above the other, with three interweaving threads below.

Today the character has lost much of its imagery. The character for "hand" above the one for "thread" gives the words "to tie," "to tighten," "series," "succession" – a reflection of the work carried out by the person unwinding the strands from the cocoons, tying them and fixing them to the loom in order to obtain a continuous thread. By joining the character for "son" to the one for "thread" we obtain the word for "grandson," the child who represents the continuation of the family name and line. The character for "silk" next to the one for "fine hair" forms the word "velvet."

系	Jì	to tie
孙	Sūn	grandson
丝绒	Sī róng	velvet
线	Xiàn	cord

YĪ
GARMENT

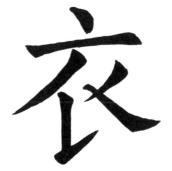

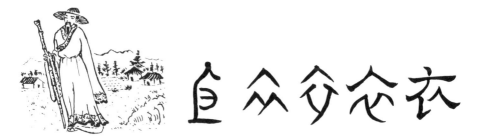

This radical, which occurs in two forms in modern dictionaries, shows a long-sleeved Chinese tunic with a billowing skirt.

"At first" is translated in Chinese by the character for "garment" with the one for "knife," because to make a garment you must first cut the cloth. The character "to mourn" is formed of the one for "roof" with "mouth" and "garment" below; it recalls the old custom, still performed today, of going to the house of the departed wearing a long white robe to lament their passing. A combination of "roof," "center" and this radical produces the word "feelings," "emotion." Originally the character indicated an undergarment to be worn beneath one's clothing and thus, by extension, something that comes from within, from one's innermost self. The silverfish, an insect that eats – among other things – the glue used in bookbinding, is called by the Chinese the "clothed fish," perhaps because of its covering of silver scales. Its name is formed from this radical and the character for "fish." "Clothes are worth more the newer they are, whereas friendship is worth more the older it is."

`、 一 ノ レ ノ 丶`
`1 2 4 10 4 5`
`、 亠 宁 衣 衣 衣`

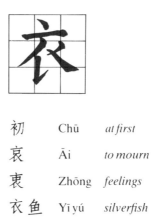

初	Chū	*at first*
哀	Āi	*to mourn*
衷	Zhōng	*feelings*
衣鱼	Yī yú	*silverfish*

JĪN
NAPKIN

巾

巾 巾 巾 巾 巾

We have already discussed the radical *mī* (to cover), but this is the character on which its design is based. It shows a small piece of cloth of the sort used by peasants for countless different purposes, such as for dusting, for wiping sweat from their hands or foreheads and for washing themselves. A trace of this use still remains – as a sign of respect for one's ancestors – in the imperial dress used for ceremonial occasions, which includes a sort of apron tied around the waist. The radical shows the napkin tucked into a belt, from which it hangs in two equal lengths.

By adding this radical to that for "abundance" the word "sheet" is obtained: a large napkin. With the character for "divination," this radical forms three different words: "submissive," "invitation card" and a "book on calligraphy or painting." All three have the same sound and the same character, but a different tone.

丨 乛 丨
3 17 3

丨 冂 巾

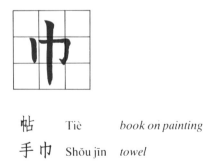

| 帖 | Tiè | *book on painting* |
| 手巾 | Shǒu jīn | *towel* |

PÍ
ROLL

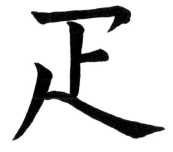

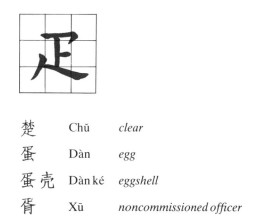

This radical, very similar to the one for "foot," is another typical example of *zhuǎn zhū*, using an existing character in an extended, metaphorical sense. In its earliest design, this character seems to recall the bands of material (which could only be black or white) that the poorest people used to wind round their legs because they could not afford felt or leather boots.

When the character for "wood" or "forest" is placed above this radical, the meaning is "clear" or "clean." When the character for "insect" is linked to it, it forms the word "egg," "oval" or "egg-shaped." The idea originated in the small ball of dung in which the sacred scarab beetle wraps itself. By writing the character for "egg" after the one for "shell," the word "eggshell" is created. Finally, by placing the character for "hair" below (and not above, as would seem logical) the radical for "roll" we get the phrase "noncommissioned officer." This is either because this grade of officer was a subordinate one or because his social status was such as to allow him to wear puttees and a helmet.

楚	Chǔ	*clear*
蛋	Dàn	*egg*
蛋壳	Dàn ké	*eggshell*
胥	Xū	*noncommissioned officer*

119

Paintbrush

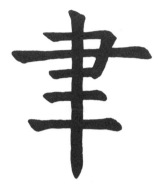

Of all the tools employed by man, there is one that stands out above the rest as a symbol of art and beauty: the paintbrush. It is the paintbrush that allows man to communicate and express his dreams and thoughts. The radical for paintbrush, *a positive sign of strength, lies at the center of the ones for those other instruments that can become symbols of either peace or war, such as the sickle, which can cut grain in time of peace and is an instrument of death in time of war.*

DǑU
BUSHEL

斗

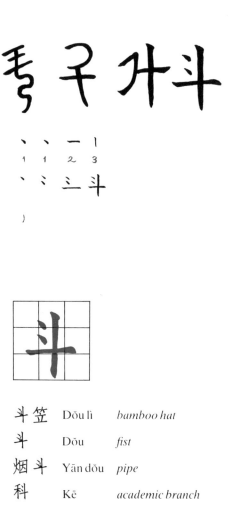

This is an ancient measuring vessel used for cereals. There is a famous one in bronze, of elliptical shape, dating from the Qín dynasty (221 B.C.), on which are inscribed two imperial edicts – that of the 26th year of Qín Shīhuángdì, which says: "Any irregularities or frauds in weights or measures must be clarified and regularized" and that of Èrshí, his successor. The ancient character was formed of a *sháo*, a measure equivalent to a scoop, linked to the character for "ten": it therefore equals ten scoops of grain.

Among its composites are the ones for "bamboo hat," formed of the radical (a concave object) and the character for "upright," with the one for "bamboo" above. The same radical, but with a different tone, means "fist" or "fight." This, however, is incorrect since its pictograph shows two hands, not a measure. The character for "smoke" with this radical produces "pipe," which could be defined as a container for smoke. When juxtaposed with the character for "wheat," this radical forms the word "academic branch": a development that is not easily explained.

斗笠	Dōu lì	*bamboo hat*
斗	Dōu	*fist*
烟斗	Yān dōu	*pipe*
科	Kē	*academic branch*

MĬN
CONTAINER

This sign represents a container for food. Recent archaeological excavations have shown that terra cotta containers were already being used at the beginning of the Neolithic period (8000 B.C.). Among the items that have been unearthed are beautifully made basins, bowls and jars from the Péilĭgāng, Hémŭdù and Yăngsháo cultures that flourished between 7900 and 7000 B.C. Their invention has been attributed to the legendary emperor Shén Nóng, while the Yellow Emperor is believed to have appointed the first official in charge of potters. Another legendary figure is the potter Níng Fēng who, in order to supervise the firing of his wares, used to enter the kiln to control the temperature.

This radical preceded by the character for "utensil" forms the word "vessel for food." A composite of "water," "sun" and "container" produces the adjective "tepid." With the sign for "drop" above the radical we get the word "blood," which recalls the blood poured from a cup during sacrifices. The sign for "son" above and after the radical gives the name of the famous philosopher Mencius.

｜	７	｜	｜	一
3	11	3	3	2

｜　冂　冂　皿　皿

器皿	Qì mǐn	*vessel for food*
温	Wēn	*tepid*
血	Xiě	*blood*
孟子	Mèng zǐ	*Mencius*

FŎU
JAR

Another term indicating a terra cotta container, this time with a lid. Initially it was a simple kitchen container for food or wine (made from fermenting different types of grain, despite the fact that the Chinese were vine-growers). Under Buddhism it became a cult object: it was used as a cinerary urn in which were preserved the remains of Buddhist saints or the ashes of their priests. In modern usage, it means "idiophone," a percussion instrument made of terra cotta.

If this radical is placed below the one for "to envelop" it forms "kiln," the place where clay is baked. Today, this composite with the addition of the character for "hand" means "to extract," "to pull out," "to pick pockets." With the character for "workman" the radical becomes "vat"; a man has to work before a jar can be filled with wine. The composite of "vat" with the character for "boy" produces "bowl" or "soup plate." In the past, peasants used bowls for both eating and drinking; everybody had their own bowl, which they guarded jealously and even took with them when travelling.

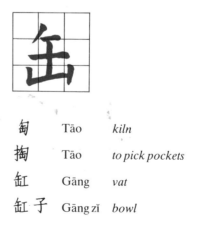

匋	Tāo	kiln
掏	Tāo	to pick pockets
缸	Gāng	vat
缸子	Gāng zǐ	bowl

124

YŎU
AMPHORA

酉

This radical closely resembles the form of a Greek or Roman amphora, of bulging shape with a narrow mouth, tapering base and two handles. The Chinese were the first to discover the function of the barycenter when used with the amphora. They thus invented containers which, when plunged into the river, sank and then, when almost full of water, righted themselves.

Today this radical indicates the eleventh of the twelve "earthly branches" of the solar calendar, i.e. the hours between five and seven in the evening. With two drops above it, this radical forms the word "chieftain," a man chosen after a lengthy selection process; the comparison is with the product obtained by fermentation and the way in which the dregs (the two drops) fall to the bottom of the amphora. This composite, together with the character for "thief" or "brigand," produces "bandit leader": in this case the dregs have floated to the top. In order to create the modern word for "liquor," all we have to do is add the character for "water" to the radical. The character for "soldier" added to the one for "amphora" produces "drunk."

一 ｜ ７ ノ し 一 一
2　3　11　4　19　2　2
一 厂 斤 丙 两 酉 酉

酉	Qiú	chieftain
匪酉	Fěi qiú	bandit leader
酒	Jiǔ	liquor
醉	Zuì	drunk

125

DĬNG
TRIPOD

鼎

This type of vase, originally made of terra cotta, became the classic three- or four-legged bronze vessel used for cooking food or, later, for preparing sacrifices to one's ancestors. It is equipped with handles, originally intended to prevent the holder from burning his fingers, making it easier to use in rituals. The annals known as *The Bamboo Books* (296 B.C.) describe the demise of Duke Âi, of Qí state, who was boiled alive in a *dǐng* by King Yī (Zhōu dynasty) in front of the whole court to punish him for his third attempt at dethroning the king.

With the character for "to boil" after this radical, the verb "to grumble" is formed, reflecting the noise made by a boiling pot. By linking "tripod" to the character "upright," we create the expression "triple confrontation," like the three legs of the upright container that face each other. Combined with the character for "flourishing" or "prosperous," the radical creates the "zenith of an era," which represents power, splendour and prosperity. Place the character for "foot" after this radical and we get the word for "triple rivalry."

		丨	丁	一	一	一	丨	丨	ㄴ	一
		3	11	2	2	2	3	3	12	2

鼎 沸	Dīng fèi	*to grumble*
鼎 立	Dīng lì	*triple confrontation*
鼎 盛	Dīng shèng	*zenith of an era*
鼎 足	Dīng zú	*triple rivalry*

LÌ
COOKING POT

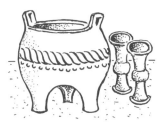

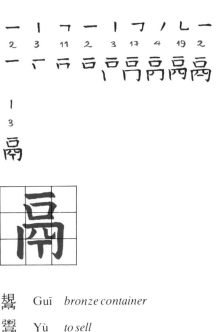

This shows a ritual bronze whose shape can still be recognized in the modern character. It derives from a terra cotta pot with a domelike base that was placed directly on the fire. We find it among the bronzes used in ancient ceremonies, displayed in temples, in the chambers of ancestors and in tombs as part of the funerary goods. Together with the *dīng* and the *yán*, it belongs to the group of pots used for cooking food. Its three legs are hollow in order to heat liquids more quickly. The strokes of the character depict the three legs, the container and also its lid. There are very few derivatives.

By placing the character for "norm" or "rule" – which only plays a phonetic role – above the radical, we form the word *guī*, the most widespread food container: made of bronze, with handles and a hollow rectangular base on which the bellied body rests. In 1978 a *guī* was discovered that was 59 centimeters (*c.* 23 in) high and weighed 60 kilos (132 lb). The character for "rice soup," indicated by the sign for "steam" at either side and the one for "rice" in the center, above this radical gives us "to sell."

Guī *bronze container*

Yù *to sell*

BǏ
SPOON

七

古 亻 亻 𠤎 𠤎 七

```
ノ      ㄣ
4       19
ノ      七
```

This is the only Chinese eating utensil familiar to Westerners, given the Chinese habit of using chopsticks and cutting up food into very small pieces. Their spoons are always made of porcelain, with a short handle. A larger, serving spoon is placed next to the soup tureen. Yet the original sign has been lost in the pictograph, where it must have represented a scraper or something similar to a ladle. The present sign is derived from the one for "man" written backwards.

The composite for "north" contains this radical, in its old sense of "man," together with its reversed form: two men turning their backs on each other. The north conveys the idea of evil and cold, and it is better to turn away from it. Stalls in the theater, thrones and the doors of houses always face south; the magnetic needle in Chinese compasses points toward the south. The word "north" with the character for "capital" forms Beijing, the northern capital. With the character for "head" after this radical, the word "dagger" is created; this may be a reference to the handle.

七

北 Běi *north*
北京 Běi jīng *Beijing (Peking)*
匕首 Bǐ shǒu *dagger*

DĀO
KNIFE

刀

⼃ ⼅ ⼆ ⼄ ⼏ 刀

Rather than an item of cutlery, this represents a working tool; it is often used to mean "sword." The pictograph shows the handle in its upper part, with a curved blade in the lower part. It should not be confused with the radical for "strength," in which the left-hand stroke crosses over the transverse one. It is now found in two forms.

With the character for "mouth" after this radical, the word for the "tip" of the blade is created, but also with the meaning "the right point": to hit the bull's-eye. With the character for "son" next to it, it means "penknife." By combining the sign for "drop" with the radical we obtain the word "blade," the sharp part of the knife that causes bleeding. The same character is also used in the sense "to stab to death," "to kill." By placing the character for "blade" above the one for "heart" we obtain the verb "to tolerate pain," to withstand difficulties and suffering. "Abandoning the butcher's knife and suddenly becoming a Buddha" means to undergo a sudden and unexpected conversion. A person referred to as "a knife and an axe," however, is not subtle by nature.

```
フ    ノ
17   4

フ    刀
```

刀口	Dāo kǒu	*the right point*
刀子	Dāo zǐ	*penknife*
刃	Rèn	*blade*
忍	Rěn	*to tolerate*

XĪA
LID

西

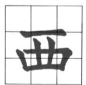

一 丨 フ 丨 丨 一
2 3 11 3 3 2

一 丆 両 両 西

In open-air restaurants in China you will see small upturned saucers being used as lids to keep food warm. The pictograph refers to this practice. In the modern version it is written differently (*xī*) and means "west" rather than "lid."

The ancient capital of the Silk Road, Cháng Ān, is now called Xī Ān (Western Peace). By placing the character for "woman" beneath this radical we obtain the character for "to force," "to constrain": it reflects the idea of a woman being kept down by means of violence and abuse. The same character, but with a different tone, becomes "important," "essential" or "to desire." The ancient writing of the character emphasized the sides of the woman instead of the lid, thus conveying the feeling of "desire." By placing the character for "tree" beneath the radical we form the word for "chestnut tree," whose fruits seem to be contained within two small lids. With the character for "shell" beneath the one for "lid" the word "merchant" is created: a man who can cover the price of anything is able to buy and sell.

西

西安	Xī Ān	*Xian*
要	Yāo	*to force*
栗	Lì	*chestnut tree*
贾	Gǔ	*merchant*

JIÙ
MORTAR

臼

凵 凵 凵 囟 臼

丿 丨 𠃌 一 一 一
4 3 11 2 2 2

丿 亻 亻 𠂤 𠂤 臼

It was common practice among ancient peoples to create a mortar by making a hole in the ground. Later it was made from a tree trunk or block of stone, ultimately being cast in bronze. In fact, this radical does also mean "hole," "opening in the ground."

Placed next to the character for "tooth" it means "molar," the tooth used for grinding food. With the character for "masculine" written beneath it, it means "mother's brother" or "wife's brother." This character also contains a sense of importance: just as a mortar is important for the family, so are the family links represented by the uncle and brother-in-law. With the simplified character for "hill" to the left and the one for "man" above, the word "pitfall" is created. The image is of a steep slope and a man falling into a hole. By placing the sign for "hand" above this radical we obtain "to empty," "to turn out" or "to pour," all of them operations carried out using a hand or scoop to remove the substance that has been pounded in the mortar.

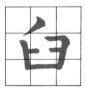

臼齿	Jiù chĭ	*molar*
舅	Jiù	*uncle, brother-in-law*
陷	Xiàn	*pitfall*
舀	Yǎo	*to empty*

MÁO
LANCE

矛

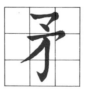

```
フ  丶  フ  ﾉ  ﾉ
マ  ﾏ  ﾏ  ﾅ  矛
```

We now enter the world of weapons, all with precise names, which have since vanished, leaving numerous characters behind them, some with obscure meanings. This pictograph gives the idea of a long-shafted lance, of the type used by the terra cotta army of Qín Shǐhuángdì: it was the only weapon with iron components.

The character for "lance," when linked with the one meaning "hour," forms the word "compassion." This character originally denoted a lance being presented with its tip facing away from the recipient: an act of surrender and submission performed by vanquished soldiers. By writing the character for "head" after this radical, we get the word for the "tip" or "head" of the weapon. With the sign for "tree" or "wood" written below, it means "flexible," "soft," "gentle." This composite, when combined with the character for "hand," forms the verb "to knead," an action that calls for strength as well as a light touch and is carried out by women. "To await dawn with a lance for a pillow" means being impatient to attack the enemy.

矜	Jīn	*compassion*
矛头	Máo tóu	*tip of the lance*
柔	Róu	*flexible*
揉	Róu	*to knead*

132

SHŪ
STICK

妥

卜 妥 妥 妥 妥

丿 乙 フ ㇏
4 24 15 5

丿 几 쓰 妥

An ancient bamboo weapon, later equipped with a curved handle for use as an instrument for carrying things. The earliest design reveals, in its lower part, a hand carrying out irregular, sporadic movements; hence the meaning "to stroke," an action normally carried out with a stick. By writing this radical together with the characters for "mortar" and "work," we obtain "to destroy," "to ruin": a vivid image for people who used this implement every day. By joining this to the sign for "plant fibers," the word "section" or "segment" is created. Once again the reference is to the beating operation used to reduce certain plants to a fiber. One rather curious character is formed by the sign for "meat" linked to this radical. During the feudal period mandarins made extensive use of the stick to inflict punishment: they beat their employees on the buttocks, which allowed them to maintain discipline without damaging the employees' ability to work. Today the character means "thigh" or "part." The character for "part" linked to the one for "gold" means a part of the capital, "a share," as in stocks and shares.

毁	Huǐ	*to destroy*
段	Duàn	*section*
股	Gǔ	*thigh*
股金	Gǔ jīn	*share*

GĒ
HALBERD

戈

先 先 戈 戈 戈

一 乀 丿 丶
2 3 4 1

一 弋 戈 戈

Apart from the terra cotta army, more than 10,000 weapons have been unearthed in the tomb of Qín Shīhuángdì, among them a number of halberds. These consist of a lethal combination of lance, axe and club attached to the end of a wooden shaft. The ancient character describes the halberd.

By linking the simplified character for "man" with this radical we obtain the verb "to cut" or "to fell": although this is now used to describe the work of a lumberjack, the pictograph originally represented a man struck on the back by a halberd. The meaning of the character that used to signify "city" or "center of population" is somewhat contrived: it is formed of a halberd with, beneath it, an enclosure and an area of land indicated by a horizontal stroke. A landowner who defended his territory with soldiers recalled the idea of a settlement; today it means "perhaps," "maybe." This radical linked to the character for "knife" means "to delimit," "to assign," a process that was established and enforced by means of arms. Joining it to the character formed by two hands gives "to warn," "to put someone on his guard."

伐	Fá	*to cut down*
或	Huò	*maybe*
划	Huà	*to delimit*
戒	Jiè	*to put someone on his guard*

SHǏ
ARROW

矢

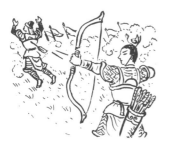

The radical for "arrow" is formed of a pointed tip, a shaft and a flight. However, there is also a horizontal stroke halfway along the shaft in which some scholars see the transfixed body of a man. This would explain its abstract meaning of an "irrevocable action."

For the Chinese, illness strikes man down like an arrow. The character for "illness" is formed from the character for "bad" with the one for "arrow" beneath. But "arrow" is also used to express the cure, since the word "to cure" is formed of three characters: "quiver," "to strike" and "arrow." Because disease is caused by malignant spirits, it was necessary to take an arrow from the quiver, shoot it at the evil spirits and then restore oneself with a drop of wine. Today, the character shows only the arrow in its holder and means "cure" as well as "doctor." By linking this composite to the character for "existence" or "life" we obtain "doctor of medicine" – the doctor as the person who restores life. This radical with the character for "mouth" forms the word "to know," meaning to discover quickly, to know in a flash.

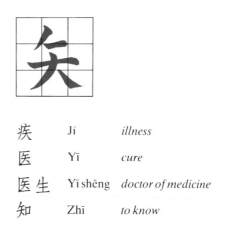

疾	Jí	illness
医	Yī	cure
医生	Yī shēng	doctor of medicine
知	Zhī	to know

GŌNG
BOW

弓

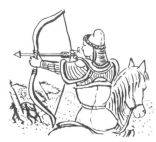

彐 弓 弓 弓 弓

```
コ  一  ㄅ
11  2  21
コ  コ  弓
```

Another weapon of war, with a long range, whose radical conveys the idea of the bowstring being drawn back by an indentation in the graphic sign.

However, by writing the character for "young boy" after this radical we change this lethal sort of bow into the kind used for playing stringed instruments. Linked to the character for "ear" it becomes "to remove," "to eliminate." In order to shoot an arrow, the hand pulling the bowstring comes close to the ear; hence the meaning "to decide to strike." The character linked to the one for "thread" becomes "string," applied both to the weapon and to musical instruments. By joining the character for "to pull," composed of the radical plus a vertical stroke, to the one for "to throw," we obtain the verb "to begin." "Drawing the bow and unloosing the arrow" corresponds to the biblical concept of casting the first stone. A piece of advice is contained in this warning issued by a Chinese philosopher to his prince: "draw your bow, if you must, but do not let fly the arrow." An enemy aware of your strength will "fly away like a bird at the sight of the bow."

弓子	Gōng zǐ	*musical bow*
弭	Mǐ	*to remove*
弦	Xián	*string*
引发	Yīn fā	*to begin*

YÌ
ARROW

弋

猖夔羊弋弋

一 乚 丶
2 3 1
一 弋 弋

This weapon had the advantage of being recoverable: a thin length of twine was tied in front of the flight, which allowed both prey and arrow to be retrieved. It was used mainly for hunting in inaccessible places where it would have been very difficult for the hunter to retrieve his prey. Some people maintain that the radical represents a hook.

This radical with the character for "man" means "to replace," "to substitute." It may reflect the idea of someone being withdrawn or removed. By including two small lines and the character for "shell" below, we obtain "profit": laying out money to get twice the amount back. Today, however, it means only "two" and is used on banknotes to prevent the easy forgery of the Chinese prime cardinal numbers. If the latter character is joined with the one for "imperial office," the word "opportunist" or "turncoat" is created. This referred to those officials who had supported the emperor of an overthrown dynasty but remained in the service of the new one.

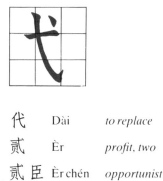

代 Dài *to replace*
貳 Èr *profit, two*
貳臣 Èr chén *opportunist*

FĀNG
TRUNK

In new dictionaries this appears with another radical, the one for "to hide." Its classical form was written differently, with no break between the upper stroke and the vertical. The derivatives of the two radicals have now become mixed. The character appears to owe its origins to the representation of a tree trunk that has been hollowed out to make a canoe. Since being written horizontally, however, the character has changed its meaning and now signifies "basket," "trunk" or "box."

With the character for "napkin" inside it, it becomes "circle" or "circumference." By placing the sign for "child" inside the radical we obtain "equal," "half" or "even." The new character in fact lacks the right side that would make it complete: hence the meaning of equal to the other half. By writing the character for "king" inside, the word "correct" or "rectified" is formed. In the old character this indicated a job that had been commissioned, one that was carried out to order. With the old character for "helmet," which now has the meaning "hard surface," it becomes a box with a lid.

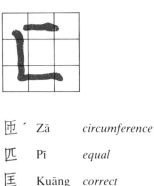

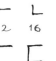

帀	Zā	circumference
匹	Pī	equal
匡	Kuāng	correct
匣	Xiá	box

PÁN
FIREWOOD

爿

爿 爿 爿 爿 爿

This represents the left part of a tree trunk split vertically in two, being hacked by an axe near the middle. It used to be pronounced *qiāng* and indicated the strongest part of the trunk, suitable for use in carpentry; it also signified "bed," which for the Chinese meant a board with a mat laid on top of it. It is now pronounced *pàn* and means "firewood" or "bamboo strip."

The simplified radical juxtaposed with the character for "sage" creates the word "strong," "robust": a man as strong as oak, a man of imposing appearance. By replacing "sage" with "woman," however, it means "to make oneself up." Once it indicated a woman who gave herself airs, who pretended to be strong when she was not: a woman who disguised her true self. Nowadays it means a woman who wants to make an impression, to get herself noticed. By writing the character for "halberd" after this radical we obtain the word "to kill." In this case the weapon has done to a man what the axe has done to the wood. The composite for "strong" next to the character for "sage" makes "warrior," a man who must be resilient, but also astute.

```
乚   一   丿   丨
16   2    4    3
乚   乚   爿   爿
```

壮	Zhuàng	*strong*
妆	Zhuāng	*to make oneself up*
戕	Qiāng	*to kill*
壮士	Zhuàng shì	*warrior*

139

JĪ
SMALL TABLE

几

几几几几几

ノ 乙
4 24

ノ 几

This item of furniture is found in wealthy households. Born of practical necessity, its function is now purely decorative to support a vase or plant. Under the Táng dynasty (618–907) some very fine examples were produced using expensive woods and the process of inlaying. Later on they were utilized as worktables and writing desks. Finally, matching sets were made in nests of three or five small tables fitting one into another.

When preceded by the character for "tea," this radical gives "small tea table," one of the most widely used pieces of Chinese furniture. Two mouths above the radical forms the word "spell": it appears to show a seated shaman speaking and receiving messages from the spirit he has invoked. The character for "capital," wrongly written in this composite, when placed above the radical means "clear," "luminous." In reality it meant that a government official – indicated by the small table – who has been sent from the capital had clearer ideas than the local imperial representative.

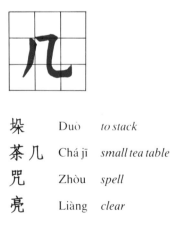

垛	Duò	*to stack*
茶几	Chá jī	*small tea table*
咒	Zhòu	*spell*
亮	Liàng	*clear*

LĚI
HARROW

耒

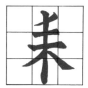

ノ 一 一 丨 八
4 2 2 3 4 5

ノ ㇏ 三 丰 耒 耒

A frame of small wooden crossbars, arranged in a grid and with a large number of metal spikes: this is the harrow, an agricultural implement used to break up the surface of the earth and make it easier to sow seeds. In the past it was drawn by buffalo, but more often than not poor peasants had the back-breaking task of dragging their own harrows. The radical has the sign for "wood" below, while the horizontal strokes divided by the vertical, above, indicate the metal spikes.

Written with the character for "well," it signifies "to plough." This composite with the character for "ox" becomes "farm animal" and suggests land ploughed using oxen. This radical with the character for "handle" and "to grasp" (which has now, however, lost its hand) means "harrowing": the work of breaking up the clods, flattening the ground and spreading seeds and manure carried out using this implement. Place the character for "feather" next to the one for "harrow" and you form the word "cost" or "consumption." If birds arrived during the harrowing and ate the seeds, it cost the peasant dearly.

耒

耕	Gēng	to plough
耕牛	Gēng niú	farm animal
耙	Bà	harrowing
耗	Hào	consumption

YǏ
SICKLE

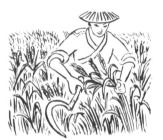

乙
24

乙

This radical is the subject of much controversy: we prefer the idea that it represents a sickle, an implement used extensively in what is primarily an agricultural country. Its design appears to reproduce the gently curving blade, with a short wooden handle, still found in country districts. It could, however, be a green shoot laboriously making its twisting way up through the soil. Hence the idea of germination as a fascinating phenomenon, and the extended meaning of "effort" or "movement" becomes logical. The new dictionary is no help: the composite derivatives do not appear with either meaning. The first of these composites is the number "nine," obtained by means of a vertical stroke. A number sacred to literature, art and architecture, it is the number of circles forming the sky, a symbol offering no explanation. When joined to the character for "district" it creates the poetical name for China: Country of Nine Districts. The radical is also used in many chemical products: with the character for "good wine" it becomes "ethanol."

九	Jiŭ	nine
九州	Jiŭ zhōu	China
乙醇	Yǐ chún	ethanol

YÙ
PAINTBRUSH

聿

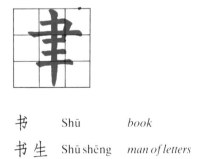

For the Chinese, the artistic beauty of the written word is equal to that of a painting. The instrument is the same: the paintbrush. Never has the word "calligraphy" been so appropriately used as in the case of Chinese writing. The brush is also responsible for the alteration and evolution of characters: it allows the writer to use thin or thick lines, straight or curving ones; to create dots, drops and flicks: the whole range of devices that forms classical writing.

By writing this radical – formed of a hand grasping a stylus with a writing-tablet below – and adding the character for "mouth" with a word inside it, we obtain the word "book": transferring the spoken word onto paper. By following this composite by the character for "to give birth" we create the phrase "man of letters" or "cultured man": the person who knows how to grasp the meaning of books. The oldest academy of which we have positive proof dates from A.D. 759 and was called "The Forest of Brushes." Having high-flown literary ambitions is described as "dreaming that a flower will bloom on the tip of the brush."

| 书 | Shū | book |
| 书生 | Shū shēng | man of letters |

JUĒ
HOOK

In the days when a hollow straw with a reservoir above it was used for writing, characters were composed of straight, uniform lines. The same thing happened when wooden brushes with a fibrous tip were used: except that the lines were more square. The introduction of brushes made of animal hair changed writing completely. This character is the result of this innovation: a softer form of a vertical stroke. It is a false radical. Later it became "hook," a meaning derived from its shape. Placed between two lines it means "small." The line reduces and splits something into two equal sections. Written to the left of the character for "vegetation" ("earth" plus "shoot"), it gives the meaning "to give birth." By placing the character for "woman" in front of this composite, the word "surname" is created. There was a time when babies took the family name of their mothers in accordance with the matriarchal system. This radical, combined with all that is left of the character for "hand" plus the sign for "ten," makes shēng, a measure for cereals. A shēng was ten handfuls of grain. This character now also means "to raise."

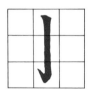

小	Xiǎo	*small*
生	Shēng	*to give birth*
姓	Xìng	*surname*
升	Shēng	*to raise*

WĂNG
NET

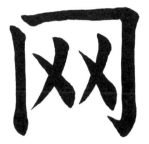

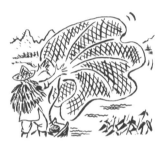

This pictograph, complicated and confused by scribes over the years, was restored to its original form a few decades ago. Its composition is now clear and readily visible: a mesh contained within a framework.

Add the character for "sieve" to this radical and we obtain the word that describes the fine-mesh net used for trapping birds that had been attracted by seeds scattered on the ground. By writing the radical after the character for "electricity," the phrase "electricity grid" is created. By placing the character for "ball" or "globe" after it, however, we create the word for "tennis," a sport in which a ball is hit over a net. One day the king of Táng saw a hunter setting up a net and shouting, "Birds that fly from all directions, come into my net." The king, convinced that this would mean the end of all winged creatures, immediately issued an edict obliging all hunters to leave their nets open on three sides, keeping only one closed. From then, "leaving three sides of a net open" meant to carry freedom too far. Finding oneself between "the cobweb of Heaven and the net of Earth" means having no way out.

丨 𠃌 丿 丶 丿 丶
3 17 4 1 4 1

丨 冂 冈 冈 网 网

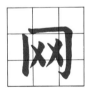

罗	Luó	*net for trapping birds*
网罗	Wăng luó	*trap*
电网	Diàn wăng	*electricity grid*
网球	Wăng qiú	*tennis*

145

ZHŌU
BOAT

舟

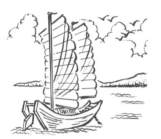

闲 亚 肖 丹 舟

ノ ノ ㄱ 丶 一 丶
4 4 17 1 2 1
ノ ｊ 冂 月 舟 舟

The pictograph shows a long boat with a raised prow, an oar at the front and a rudder with a stern that is open to indicate that the rudder is located on the outside. One anecdote tells of a government official in the state of Chǔ who lost his sword while crossing a river. He made a notch on the edge of the boat, believing that in this way he could mark the place where his weapon had sunk and then fish it up when he returned.

This radical together with the character for "coast," used in a phonetic role, creates the modern word for "boat." Placing this composite after the one for "tail" produces the word for "stern." Replace "tail" with "older" or "senior" and we obtain the word for "captain," who for the Chinese is the person on board with the most experience. Replacing the character for "senior" with that of "personnel" (a mouth with a shell below) gives us "crew," reflecting the idea that the shipowner regards sailors as being just so many mouths to feed.

船	Chuán	*boat*
船尾	Chuán wěi	*stern*
船长	Chuán zhǎng	*captain*
船员	Chuán yuán	*crew*

CHĒ
CART

車

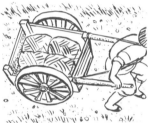

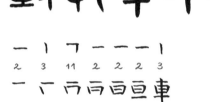

The cart is shown from above, in a bird's-eye view. The pictograph – not the simplification – shows the central rectangular body, the cross-axle and the two wheels.

This radical with the simplified character for "to envelop" forms the word "army": it is the soldiers who surround the carts, as in the terra cotta army of Xiān. The character written after the one for "army" produces "chariot." By placing the character for "man" after the one for "army" we obtain the word "soldier." The character for "vapour," formed of those for "water" and "gas," combined with this radical produces "car." This would mean an engine running on a mixture of air and water, which is too good to be true, and cars in China do in fact burn "vapours produced from oil," as is indicated by other strokes added to the character. "Driving a light cart on a familiar road" means being able to find an easy solution to every situation, to have great ability and experience, to cope successfully even with the unforeseen.

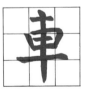 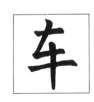

军	Jūn	army
军车	Jūn chē	chariot
军人	Jūn rén	soldier
汽车	Qì chē	cars

147

YUÈ
FLUTE

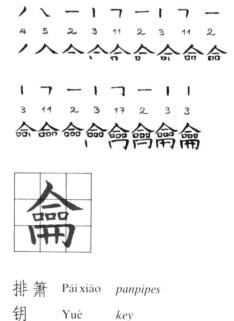

Music would also appear to have been invented by Fú Xī, but it was the emperor Shùn (2317–2208 B.C.) who introduced the *shāo*, a wind instrument. The Chinese divide musical instruments into eight categories according to the material they are made of: stone, metal, silk (string), bamboo, wood, dried gourd, leather and clay. There were no fewer than 72 different types, many of which are no longer in existence. This radical has also been omitted from modern dictionaries, but it originally portrayed the panpipes: at the base appears its row of bamboo pipes, with the apertures in the middle (the three mouths) and the sign for "assembly" (the triangle) above. Another flute is the *pái xiāo*, whose two characters mean "to arrange" and "vertical flute." Together they mean "panpipes": a group of vertical flutes arranged in a special order. The characters for "metal" and "flute," both in simplified form, produce the word "key." A mouth next to the simplified radical creates the verb "to implore," a memory of the instrument's ritual use in ceremonies of invocation.

排 箫	Pái xiāo	*panpipes*	
钥	Yuè	*key*	
吁	Yù	*to implore*	

GŬ
DRUM

鼓

鼓 鼓 鼓 鼓 鼓

一 丨 一 丨 丁 一 丶 丿 一
2 3 2 3 11 2 1 4 2

一 十 士 圭 壹 壴 壴 壴 壴

一 丨 コ 乀
2 3 15 5

壴 壴 鼓 鼓

鼓

A man grasping a piece of wood and beating something from which sounds emerge: such is the image brought to mind by this pictograph. The earliest drums were made of terra cotta, filled with husks and covered in animal skins. They were used in battle to urge on the soldiers and scare the enemy. In times of peace they marked the hour: night and day men were paid to beat the drum, which became the clock of the day. In temples there are drum towers to tell people when to work and when to rest, and bell towers to indicate the hours of prayer and liturgical ceremony. *

This radical followed by the sign for "hand" creates the word "drummer." Next to the character for "palace" it makes "drum tower." In fact, the instrument was housed in a tall building so that it could be heard from far away. Place the radical after the character for "to strike" and the expression "to beat the drum" is created: every movement of the army was marked by the rhythm of this instrument. If the character for "palm of the hand" is written with this radical, the word "applause" is formed.

鼓手　Gū shǒu　*tambourine*

鼓楼　Gū lóu　*drum tower*

打鼓　Dǎ gū　*to beat the drum*

鼓掌　Gū zhǎng　*applause*

Dragon

龍

The dragon *is king of the animal world. He protects man from evil, from fire, from malevolent spirits; he represents the emperor, the Son of Heaven, and with his nine sons he is kept alive in music and literature. Other animals are loved or feared in the same way as they are in the West – the noble horse, the sacred tortoise, the faithful dog, the useful pig – but it is the dragon that symbolizes Chinese culture and to which the Chinese attribute positive values totally unknown to Western civilization.*

QUĂN
DOG

犬

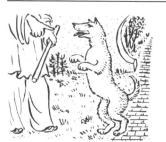

Confucius greatly admired the pictograph for "dog" because it very accurately expressed the nature of this animal, which was quite rare in his day. The dog is shown standing on its hind legs, with its mouth open, greeting its master. The animal appears in Chinese mythology and also occurs on religious artefacts. The emperor Líng Dì, of the Eastern Hàn dynasty (168–189), decorated his favourite dog with the highest literary rank.

By placing the character for "mouth" in front of this radical we obtain the verb "to bark." Put the character for "word" between the radical, written in two forms, and the word "prison" is created. Two dogs fighting recalls two people hurling accusations at one another in court, and thus, by extension, gives rise to the word "prison." Placing the character for "mouth" twice above the radical forms "to cry," "to moan," "to complain," like whining dogs. The radical with the character for "bud" gives an idea of the damage a dog can do to a flowerbed and creates the word "to transgress," "to offend." The dog is the eleventh animal of the Chinese calendar.

犬

吠	Fèi	*to bark*
獄	Yù	*prison*
哭	Kū	*to cry*
犯	Fàn	*to transgress*

MǍ
HORSE

馬

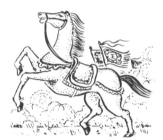

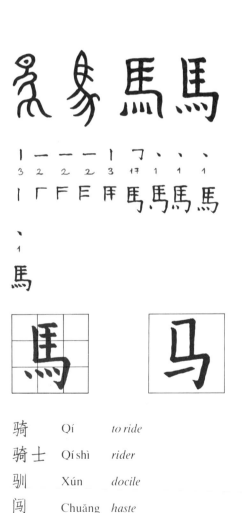

The pictograph shows the horse's head, the mane, the hooves and the tail. It occupies the seventh place in the Chinese calendar. Twenty-four sections of the *Běn Cǎo* (*Medical Matter*, 1596) are devoted to the horse, some of which deal with the pharmaceutical use of various parts of the animal. Its heart, for example, when dried and powdered and added to Chinese wine, restores the memory; sleeping with a horse's skull as a pillow will cure insomnia.

By joining the character for "strange" or "marvellous" – in a phonetic role – with this radical, the word "to ride" is created. Riding a horse is a marvellous experience, but a strange one for those who have never tried it before. With the character for "sage" after this composite we get the word "rider": a wise man on horseback. By joining this radical to the character for "stream," the word "docile" is obtained: a well-ridden horse is as docile as a flowing stream. With this radical inside the one for "door," the word "haste" or "rush" is formed, reflecting the impetuosity of a horse leaving its stable.

骑	Qí	*to ride*
骑士	Qí shì	*rider*
驯	Xún	*docile*
闯	Chuǎng	*haste*

153

NIÚ
OX

牛

A symbol of spring and agriculture, the ox is the second animal of the Chinese calendar. The pictograph shows its head, horns and two of its legs. There are many characters to indicate cattle, one for each of the first seven years. The water buffalo is part of the same family, sharing its pain and glory. At Beijing, on the banks of Lake Kūnmíng, there is a bronze buffalo on whose back is inscribed a poem by the emperor Qián Lōng (1736–1796), a token of his gratitude toward this patient beast.

By linking this radical to the one for "horse" we obtain "beasts of burden," a term also applied in the past to peasants. Juxtaposed with the character for "strength," the one for "ox" produces "great strength," "great stamina," while with the word for "meat" it produces "beef," as it appears on the table. The character for "half" derives from the butcher's habit of cutting the carcass of the ox in two. In classical writing the character for "to divide" appeared above the one for "ox," but the modern simplification has made this composite incomprehensible.

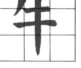

牛马	Niú mǎ	*beast of burden*
牛劲	Niú jìn	*great strength*
牛肉	Niú ròu	*beef*
半	Bàn	*half*

SHĬ
PIG

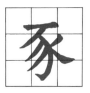

一 丿 丨 丿 丿 八
2 4 8 4 4 5

一 丆 丂 丂 豸 豸 豕

An animal as precious, useful and profitable as it is unfortunate. Every part of the pig is used by man, and yet it is a creature of ill repute, considered fat, stupid and dirty. In the Chinese calendar it is the twelfth and final animal of the cycle. The pictograph shows its snout, head, legs and tail. *Shĭ* is the animal's classical and literary name; the common name is *zhū*, while the radical forms part of many composites. In China it was believed that a stray pig entering a house would bring the family bad luck, perhaps because of the pig's reputation for being greedy and lazy.

This radical with the character for "roof" above it creates the word "family." In order to be able to marry, a man should have a house and at least one pig (productive capital). By writing the character for "garden" after the one for "family," the word "birthplace," "fatherland" is created: a romantic image of a house set amidst trees and flowers. Place the character for "utensil" after the one for "family" and you form the word "furniture." Replace "utensil" with "aged" and we have "parents," the "firstborn" of the family.

家	Jiā	*family*
家园	Jiā yuán	*birthplace*
家具	Jiā jù	*furniture*
家长	Jiā zhǎng	*parents*

YÁNG
SHEEP

羊

丫 丫 ⩑ 羊 羊 羊

、 ノ 一 一 一 丨
ㄑ ㄑ 2 2 2 3
、 丷 丷 丷 丷 羊

The eighth animal of the Chinese calendar, the sheep is shown in its male form, a ram, the shape of whose horns, mouth and ears is clearly visible. A beard (the sign of a goat), legs and tail were added later. Used in ancestral sacrifices, it symbolizes meekness and filial piety because of the way in which the young kneel down when being suckled by their mother. Canton (Guǎngzhōu) is the city of the five goats. Legend tells of five magicians, clothed in five different colours and riding five goats, who brought with them five heads of grain. Southern China became the granary of the empire.

This radical with the character for "hair" gives "wool": the hair of the sheep. The characters for "fish" and "sheep" together create the word "fresh." In the past, meat was salted, smoked or dried, while the composite indicates that fish and mutton were preferred fresh. This radical with the addition of "great" produces "beautiful," and if this composite is combined with "complete" or "total," the word "happy" is obtained. Beauty as an amalgam of pleasing qualities brings with it joy.

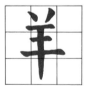

羊毛	Yáng máo	*sheep's wool*
鲜	Xiān	*fresh*
美	Měi	*beautiful*
美满	Měi mǎn	*happy*

156

LÙ
DEER

鹿

Branching antlers, slim body and four legs: this is how the pictograph portrays a deer. According to legend, deer use yaks as guides, watching the movements of their tails. For this reason yak tails are still used by Tibetan lamas to brush off the dust and drive off the flies. Deer are a symbol of longevity and occupy an important place in Chinese medicine. Their antlers are cut into thin slivers and sold at exorbitant prices as a preparation to enhance virility and to prolong life.

By writing the character for "meat" after this radical we obtain the word "game," of which venison is an excellent example. With the character for "male" before the radical, the word "buck" is created. Replacing "male" with "small" gives us "fawn": the young of the deer. With the character for "small" above the one for "earth" we obtain the word "dust." The classic character depicts three deer raising dust with their hooves as they run: simplification has now reduced the character to three grains of sand rising up from the ground.

、　一　ノ　フ　丨　丨　一　一　レ
1　2　4　11　3　3　2　2　10

、　二　广　户　庁　庑　庙　鹿　鹿

ノ　し
4　19

鹿鹿

鹿肉	Lù ròu	*game*
公鹿	Gōng lù	*buck*
小鹿	Xiǎo lù	*fawn*
尘	Chén	*dust*

SHǓ
RAT

鼠

ノ 丨 コ 一 一 一 丶 丶 丶
4 3 11 2 2 2 10 1 1

ノ 亻 亻 亇 臼 臼 臼 臼 臼

丶 丶 丶 乚
10 1 1 9

鼠 鼠 鼠 鼠

鼠

A head, whiskers, a rather plump body and a long tail: this is the rat as it appears in the pictograph. The first animal in the Chinese calendar, it is a symbol of timidity and mischief but also of industriousness and prosperity. There has always been a love-hate relationship between the rat and the Chinese people, on whom this rodent has inflicted misery as a plague carrier.

The character for "epidemic" placed after this radical creates the word "plague," the infectious disease spread by rats. By joining the radical with the word for "people" or "group," we create the adjective "evil" or "wicked": like a horde of starving rats. Before its simplification, the character meaning "to flee" or "to hide oneself" derived from this radical with the character for "hole" above it: a rat seeking refuge in a hole to escape the cat. The radical with the character for "to hide oneself" gives the idea of a stampede. In spring the rat turns itself into a quail, according to the *Imperial Annals*, but in the eighth month it returns as a rodent. Among the peoples of southern China, dried rat is used as a cure for baldness.

鼠疫	Shǔ yì	*plague*
鼠輩	Shǔ bèi	*wicked*
竄	Cuàn	*to flee*
鼠竄	Shǔ cuàn	*stampede*

NIǍO
BIRD

鳥

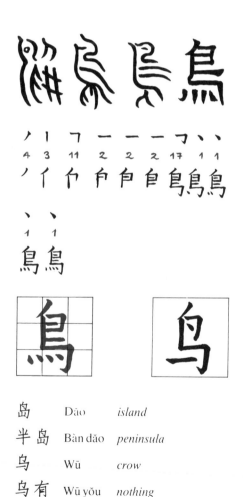

Chinese naturalists divided the animal kingdom into five great families: feathered, furry, naked, scaled and shell-bearing. The feathered family was further divided into short-tailed and long-tailed birds. This radical represents a long-tailed species. The pictograph clearly shows its open wings, legs, beak and eye. Birds appear in many paintings, sculptures and ceramics as symbolic elements: the empress, for example, was represented by the phoenix.

By placing the character for "mountain" beneath the radical we obtain the word for "island": many sea-birds nest on the rocks jutting out of the sea. Place the character for "island" in front of the one for "half" and the word "peninsula" is created: coastal land that is partially an island and partially attached to the mainland. "Crows do not roost with phoenixes" is a social comment that may explain why the character for "crow" is the same as the one for "bird," but without the eye. Or perhaps it is simply because a black eye in a black bird is invisible. The character for "crow" with the verb "to have" means "nothing," which is what hunters get if they bring one down.

岛	Dǎo	*island*
半岛	Bàn dǎo	*peninsula*
乌	Wū	*crow*
乌有	Wū yǒu	*nothing*

159

ZHUĪ
BIRD

This is not a repetition of the preceding character, since we are dealing here with short-tailed birds. This radical is now almost obsolete. The ancient character represents a small tailless bird with open wings and legs stretched out as though poised to land.

By writing the character for "small" above this radical we obtain "sparrow," the most common small bird, once persecuted as a devourer of seeds but now protected as a destroyer of pests. By placing the character for "tree" beneath it, we obtain the word for "assembly." Originally the character had three birds above the tree, giving the idea of a gathering. Writing the simplified character for hands twice creates the word "two" or "pair." This is a modern monstrosity: the classical character contained the character for "bird" twice above the one for "hand"; a pair of birds perched on a hand conveyed the poetic idea of "two." The word "to advance" was formed by this radical with the one for "movement"; the meaning becomes clear when one bears in mind that birds cannot walk backward. In the reduced form of the character it is hard to make out the shape of the bird.

雀	Què	*sparrow*
集	Jí	*assembly*
双	Shuāng	*two*
进	Jìn	*to advance*

GUĪ
TORTOISE

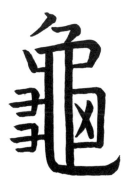

The first design showed the shell of the tortoise depicted with several strokes: the head and tail were barely hinted at. Later the head and legs, complete with claws, were portrayed. According to the *Lǐ Jì (Book of Rites)*, the tortoise, together with the unicorn, the phoenix and the dragon, is one of the four sacred animals: it is a symbol of strength and perseverance.

In common usage, however, the tortoise is a symbol of female infidelity and sexual activity. In China, "son of a tortoise" means "illegitimate son," while the tortoise's head is called the "glans." The tortoise represents the north and the winter, perhaps because it goes into hibernation during cold weather and falls into a deep sleep. Among many ancient peoples it is a symbol of the universe. According to these traditions, the earth rests on the shell of one or more tortoises bobbing up and down on the waters. The ventral part of its shell or "plastron" (the radical plus the character for "table") was used in oracular answers. It is to the tortoise that we owe the most ancient ideographs (*gǔ wén*), from which many of the modern ones are derived.

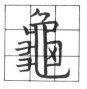

龟头	Guī tóu	*glans*
龟板	Guī bǎn	*plastron*
龟甲	Guī jiǎ	*tortoiseshell*
龟缩	Guī suō	*to retire*

MǏN
TOAD

黽

A reading of the Chinese classics does not give the impression that any clear distinction was drawn between toads and frogs. They merely relate how the toad's eggs fall from the sky with the dew and are used in medicine. The warty shape of the creature has given rise to various legends: it is a three-legged toad, for example, which eats the moon during an eclipse. The legendary warrior Hòu Ì (2500 B.C.) is said to have obtained the elixir of eternal life from Xī Wángmǔ, but his faithless wife drank it and fled to the moon. Here she was punished by the gods and turned into a toad. Líu Hǎi, the prime minister, freed the world of a pestilential toad by luring the creature out of a well with gold coins and then killing it. The pictograph shows a toad at the tadpole stage, with gills and a tail.

The character for the Chinese alligator has the simplified form of "beast" in its upper part, with this radical below. The alligator resembles a toad the size of a beast of burden. With the character for *yuán* – in a purely phonetic capacity – placed above the radical, the word "turtle" is created.

鼉 Tuó *alligator*

黿 Yuán *turtle*

LÓNG
DRAGON

龍

龍 龍 龍 龍 龍

` ﹣ ﹨ ノ ﹨ ノ ﹁ ﹣
1 2 1 4 2 4 17 2 2

﹨ ﹂ 亠 亠 立 立 产 竒 竒
3 11 2 2 2 19 2 2 2

竒 竒 竒 竒 龍 龍 龍 龍

龍 龙

... image of the
... n the classical
... ut the wings to
... dy below left.
... in the simpli-
... gon, the fifth
... a good and
... us with "im-
... re are three
... dragon (*lóng*),
... the sea dragon
... he marsh dragon
... ad of a camel, the
... of a rabbit, the ears
... erpent, the belly of a
... carp, the claws of a
haw... tiger. It is deaf, which
is why the ... efer to people who do
not listen as "dragons."

By writing the character for "well" after
this radical we obtain the name of the best
tea in China, "dragon well" tea. With the
character for "crayfish" after the one for
"dragon," the word "lobster" is formed.
Link the character for "boat" with the
radical and you have the "dragon boat"
used in celebrating ancient rituals.

龙井 Lóng jīng *dragon well*

龙虾 Lóng xiā *lobster*

龙舟 Lóng zhōu *dragon boat*

HŬ
TIGER

虎

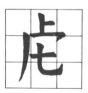

ノ一ノ一一し
3 2 4 ㇆ 2 19

丨卜广卢卢虍

The radical represents only the stripes on the coat of this cat, which the Chinese regarded as the king of wild animals. The common word for "tiger," in fact, includes the sign for "legs" below the character, thus showing the tiger rearing up. It was a symbol of dignity, of the relentless nature of the magistracy, of courage, of military fierceness. The tiger's head was carved on shields, on the gates of cities, on the bows carried by tax-gatherers, and embroidered on the robes of certain mandarins of military rank, and its whiskers are regarded as an excellent cure for toothache. It is the third animal of the Chinese calendar.

By placing the character for "mouth" after this radical, we create the phrase "jaws of death": very few people escape from the jaws of the tiger. Next to the character for "general" it forms the word "courageous" or "fearless." In ancient times the emperors would authorize troop movements by sending their generals a plaque in the shape of a tiger. The radical and the character for "plaque" create the name for this order. "Nine oxen and two tigers" signifies Herculean strength.

虎

虎	Hŭ	*tiger*
虎口	Hŭ kŏu	*jaws of death*
虎将	Hŭ jiàng	*fearless*
虎符	Hŭ fú	*tiger plaque*

YÚ
FISH

魚

In its archaic form, this radical portrayed the scaly body of a fish. Then the head, the fins and the tail, later reduced to four small strokes, were added; these small strokes also indicated tongues of flame. The Chinese saw the fish as a symbol of riches and abundance. It also had a place in Chinese marriages, an association born of a desire for fertility and serenity. The reproductive capacity of fish and the tranquillity of their life symbolized the wish for many sons and for conjugal harmony. Later, fish came to symbolize a couple's fidelity. There is still a saying: "as faithful as a fish."

By placing the character for "to speak" beneath this radical, we obtain the word "stupid," which originally contained the character for "nose." A curious fish that does not see the hook is a stupid creature. A combination of the characters for "fish" and "water" creates the verb "to fish." Placing the character for "fin" after this radical gives us the word for a Chinese delicacy: "shark's fin." Put the character for "thunder," the voice of lightning, after the radical and you have the word for the "electric ray": the fish that defends itself by electric shocks.

鲁	Lǔ	*stupid*
渔	Yú	*to fish*
鱼翅	Yú chì	*shark's fin*
鱼雷	Yú léi	*electric ray*

CHÓNG
INSECT

虫

ζ ζ ໔ ໔ 虫

```
丨 フ 一 丨 一 丶
3  11  2  3  2  1
丶 冖 口 中 虫 虫
```

There is still doubt as to whether the pictograph represents a wriggling worm or a cobra, with its head swollen, rearing up and about to strike. The fact that this radical is applied to both insects and snakes does not help to solve this problem. The Chinese believed that insects or their poisons were the cause of many illnesses whose origins they did not understand.

By joining this radical with the simplified character for "just" we obtain the word for "ant," a social insect that obeys the laws of organization, builds cities and possesses armies. The character for "insect" combined with the one for "to make one's way through bushes," in a phonetic role, produces "wasp": the insect that can cope with difficulties and is ready to lay down its life by stinging its enemies. By writing the composite of "life" and "tree" after this radical we create "butterfly," the insect whose colours mirror the life cycle of leaves. With the character for "down" or "beneath," this radical produces "crayfish," whose old character represented this crustacean as an insect with a double skin, in reference to its hard casing.

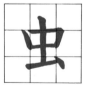

蚁	Yǐ	*ant*
蜂	Fēng	*wasp*
蝶	Dié	*butterfly*
虾	Xiā	*crayfish*

166

RÒU
MEAT

肉

夕 ⺈ 冈 肉 肉

丨 ⺈ ノ 丶 八
3 11 4 1 4 1

丨 冂 内 内 肉 肉

There was an old custom of paying teachers with thinly cut slices of dried meat. This type of meat is still sold, in tins, and makes a very acceptable present. Examination of the character reveals a container with neatly arranged slices of meat inside it. When someone is said "to receive payment in dried meat," it means he is a teacher.

By joining the character for "earth" with the one for "meat" we obtain the word "stomach." In the past this character also meant "memory," which gave rise to the idea that the Chinese believed that intelligence (memory) derived from the stomach. By writing the character for "meat" twice, in its simplified form, we create "friend": someone who is like one's own flesh and blood. In the word for "lips," this radical indicated the flags and strips of material used by soldiers to convey messages or orders: they are strips of flesh. Following the reform of the Chinese language, however, the character is now written with the sign for "mouth" instead of the one for "meat."

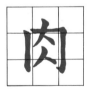

肚　Dù　*stomach*
朋　Péng　*friends*
吻　Wěn　*lips*

167

XIĚ
BLOOD

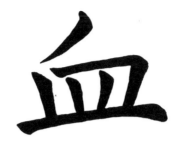

A drop above the character for "vase" produces the sign for "blood." The pictograph clearly shows the receptacle containing the blood of sacrificial victims. On the death of someone close; to propitiate the gods or one's ancestors; to ask for a good harvest or to discover the outcome of a journey, a business transaction or a marriage, it was the custom to sacrifice animals, whose blood, collected in ritual vases, was then poured onto the ground in honour of the ancestor or the deity whose name had been invoked. By writing the character for "dizziness" after this radical we obtain the word "bruise," the result of a fall. However, by placing it before the character for "sea" we create the phrase "sea of blood," the outcome of a battle. With the character for "air" or "spirit," this radical forms the term "animal life," distinguished by the act of breathing. It is also used in the sense of "vigorous" or "courageous." The radical with the character for "type" or "model" forms "blood group." Although the Chinese knew about the way blood pumped through the body, they had no knowledge about its composition.

ノ 丨 フ 丨 丨 一
4 3 11 3 3 2

丷 灬 血 血 血

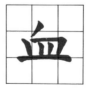

血晕	Xiě yùn	*bruises*
血海	Xiě hǎi	*sea of blood*
血气	Xiě qì	*animal life*
血型	Xiě xíng	*blood group*

GǓ
BONE

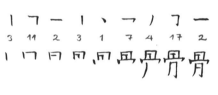

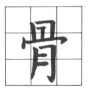

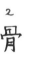

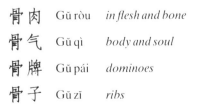

What seems logical to us may not always seem so to the Chinese. This pictograph places the flesh beneath the skeletal structure, whereas in reality it is above and around the bones. The character, however, respects the latter idea even though it represents a relatively recent alteration. The earliest designs showed only a framework of bones with no meat on them; it was not until later that scribes began to confuse and complicate matters.

Even though the Chinese use the phrase "in flesh and bone," they write it "in bone and flesh." To express moral integrity or kinship, they use the expression "bone and spirit," which equates roughly with our own "body and soul." By placing the character for "playing cards" after this radical we obtain "dominoes," a game played with counters or "cards" that are often made of bone or ivory. The character for "young boy" placed after the one for "bone" creates the word for "ribs," which the Chinese regard as small bones. There is a Chinese proverb that says "you cannot get fat from a dry bone," equivalent to our saying "you cannot squeeze blood out of a stone."

骨 肉	Gǔ ròu	*in flesh and bone*
骨 气	Gǔ qì	*body and soul*
骨 牌	Gǔ pái	*dominoes*
骨 子	Gǔ zī	*ribs*

PÍ
SKIN

皮

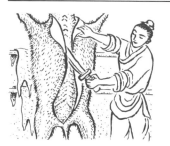

皮 皮 皮 皮 皮

ノ フ l 八
4 7 3 15 5

ノ 厂 广 皮 皮

"When a man dies he leaves behind his name; a tiger leaves his skin" – this saying seems to describe the pictograph aptly. In the lower part there is a hand with a knife above and to the left an open animal skin: a man with a knife has just skinned the dead animal. In China, when a child is naughty, they say "What a skin!" meaning "What a rascal!"

By placing the character for "egg" after the radical we obtain the "thousand-year-old egg," a duck's egg that is treated in such a way that the white turns emerald green and the yolk becomes dark green. Mothers displaying new babies to their friends for the first time will offer them slices of ginger and one of these eggs to celebrate the event. With the character for "yellow" after this radical we obtain the abbreviated form of *Pí huáng*, which stands for *Xīpí* and *Èrhuáng*, two types of traditional Chinese opera. It also means Peking Opera. The character for "false" is formed of the one for "man" with this radical repeated twice: someone with two skins. The radical with the character for "to think" gives "imagination": creating another skin for oneself with the mind.

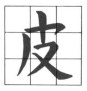

皮蛋	Pí dàn	*pickled egg*
皮黄	Pí huáng	*Peking Opera*
假	Jiǎ	*false*
假想	Jiǎ xiǎng	*imagination*

170

YÁ
TOOTH

牙

牙 身 身 牙 牙

一 乚 丿 丿
2 12 8 4
一 匚 牙 牙

The pictograph and character for "tooth" show two sharp canines closing onto their prey. From the pointed shape of the canines we can deduce that they belong to a carnivore, the group to which man also belongs.

Placing the character for "mouth" after this radical gives us the word "age," which is assessed by examining the state of dental development. Before buying an animal, the purchaser should take a look inside the mouth: the teeth will indicate both the age and health of the creature. By writing the radical twice we obtain the verb "to stammer," to fall over one's words to such an extent that they seem to be entangled in one's teeth. The person who acts as middleman in a business transaction, or arranges a meeting or marriage, is called a "son of the tooth," meaning that he acts as a link. Combining the radical for "man" with the one for "tooth" forms "child": a familiar pet-name for a child is "little tooth." The Chinese way of saying "Those whom the gods love best die young" is "Once the tooth has gone the tongue remains."

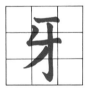

牙口 Yá kǒu *age*

牙牙 Yá yá *to stutter*

牙子 Yá zī *mediator*

伢 Yá *child*

JIĂO
HORN

角

角 角 角 角 角

丿 フ 丿 フ 一 一 丨
4 11 4 17 2 3 2

丿 ⺈ ⺈ 冄 角 角 角

The present character resembles the stylized portrayal of a crinkled cow's horn, as shown in the pictograph. It may be a combination of the character for "strength" above and the one for "meat" below, as though to indicate something strong emerging from the flesh that surrounds and supports it.

It also indicates the tenth part of a *yuán*, the basic unit of Chinese currency: ten *fēn* or ten hundredths, a small part. With the character for "building of several storeys" after the radical, the word for a "corner tower," as found in city walls, is created. This radical plus the character for "shark" gives the name of a shark commonly found in the seas of China: *Heterodontus japonicus*, which has two dorsal spines similar to horns; hence its popular name of "horned" or "spiny shark." By placing the character for "insect" after this radical we obtain the verb "to touch" or the noun "contact." It derives from the bump left by an insect sting on the skin: an irritating protuberance, sensitive to the touch. "Horns on a hair and hair on a tortoise" means a fantastic concept.

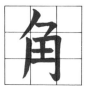

角	Jiǎo	*ten hundredths or ten fēn*
角楼	Jiǎo lóu	*corner tower*
角鲨	Jiǎo shā	*spiny shark*
触	Chù	*to touch*

MÁO
HAIR

毛

卉 禾 乎 毛 毛

丿 一 一 乚
4 2 2 19
丿 二 三 毛

The hairs that cover different parts of the body are tiny elements; this is why this character also means "small" or "of little value." In fact, people in China prefer to call the ten-*fēn* piece by the name *máo* rather than *jiǎo*, underlining the fact that the coin is a small one of little value.

This radical with the one for napkin creates "hair dryer." By placing the character for "clothing" after the radical we obtain "woollen sweater," a garment made out of animal fleece. By writing the character for "wings" followed by the one for "hair" we create "feather": the birds' equivalent of hair. "Raining hairs" is the literal translation of "drizzle" or "fine rain": when it drizzles, such a minute amount of water comes down that to the Chinese people it seems as though countless hairs are falling out of the sky. They, too, interpret "hair standing up on end" as a sign of terror or panic. "So angry that your hair stands up and makes your hat fly off" is the worst that can happen to an enraged Chinese.

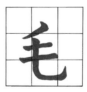

毛巾	Máo jīn	*hair dryer*
毛衣	Máo yī	*woollen sweater*
羽毛	Yǔ máo	*feather*
毛雨	Máo yǔ	*drizzle*

173

YǓ
FEATHER

羽

舫舫 羿羽羽

ㄱ 丶 ノ ㄱ 丶 ノ
17 1 6 17 1 6

ㄱ 习 习 羽 羽 羽

The pictograph contains a realistic representation of two wings, and though stylized they are still visible in the character for "feather." As we have already seen, the modern transliteration of this word favours the addition of the character for "hair" to the one for "feather."

If we place the character for "doorway" in the upper part of this radical we obtain "fan": the rotating movement of the door on its hinge and the feathers together give an idea of this useful item, widespread in the East in many different forms and often decorated by the brush of famous painters or poets. The most precious fans were made from the feathers of exotic birds. With the character for "ream," the radical creates the word "goose quill" or "tail feather": the idea of a ream of paper is given by the vane of thin barbs whose arrangement recalls a pile of sheets of paper seen from the side. This latter character, with the one for "child," gives *líng zǐ*, the feather from a peacock's tail inserted in the back of the hat of a mandarin of the third civil grade, or the very long pheasant's plume placed in the helmets of warriors in the Peking Opera.

羽毛	Yǔ máo	*feather*
扇	Shàn	*fan*
翎	Líng	*quill*
翎子	Líng zǐ	*pheasant's plume*

ZHǍO
CLAWS

The drawing shows either an open right hand resting on its palm or a bird's foot with three claws outstretched: the meaning is "claw" or "animal's foot." It repeats the familiar character for "hand," but this time turned downward, as in the pictographs.

This radical linked to the character for "tooth" gives the phrase "tooth and claw," which, during the time of the foreign domination of China, meant "arrogant lackey of the Europeans." By combining the two characters for "claw" and "boa" (a short, broad snake found in southern China), we obtain the verb "to crawl," "to creep," a slow and laborious method of progress that almost gives the idea of clutching at the ground. This composite with the character for "insect" gives the word "reptile." Once again the ancient Chinese have grouped snakes and insects together, continuing to ignore their different origins. Joined to the character for "to look," this radical forms the verb "to give chase," "to pursue": to seek someone in order to grab hold of them. Write this radical after the one for "mountain" and we have the verb "to climb."

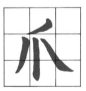

爪牙	Zhǎo yá	*lackey*
爬	Pá	*to crawl*
爬虫	Pá chóng	*reptile*
觅	Mì	*to give chase*

JÌ
SNOUT

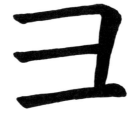

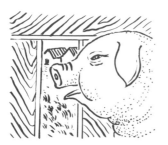

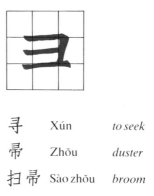

There is a curious Chinese name for the pig, still used today: "long-nosed general." This radical portrays the snout of this animal, particularly the nose with its highly developed sense of smell.

If we join the character for "measure" (in the pictograph it was a hand) with this radical we obtain the verb "to seek," "to uncover": a hand holding a pig on a leash and a highly sensitive nose rummaging among the leaves. This brings us to another erroneous transcription by scribes: in the word "duster" they wrote the character for "napkin" twice below this radical. The logical deduction is that it represents a pig's snout looking for slops and old cleaning rags, but the pictograph showed a hand holding a rag, giving the exact meaning of "to dust." This character linked to the one formed of "hand" and "snout," in a phonetic role, reinforces the idea of cleaning and means "broom." One curious derivation is the Chinese word for "comet," which is literally a "star flying on the broom" and is formed of the character for "star" placed after the two preceding characters.

寻	Xún	*to seek*
帚	Zhǒu	*duster*
扫帚	Sào zhǒu	*broom*

176

BÈI
SHELL

貝

From the time of the primitive societies (before 2100 B.C.) the *Cypraea* shell was used as money in China. Under the Shāng dynasty (1766–1122 B.C.) the first bronze coins appeared, but they still reproduced the shape of the seashell. This lasted until the Spring and Autumn period (770–476 B.C.).

The pictograph portrays the mollusc's shell and antennae. Placed beneath the character for "presence," the radical forms the verb "to desire," "to yearn" and, by extension, "venal" or "corrupt." With the character for "jade," the radical produces "jewel," a gemstone of great value. A precious stone with money: objects of great value. The character for "lance" (in ancient times there were two) combined with "shell" gives the meaning "valueless," "of little account." Breaking shells signifies the destruction of money or valuable objects. By placing the character meaning "in place of" above the radical we obtain the word "loan," which reflects the idea of a person intervening with his or her own money in place of someone else who has none.

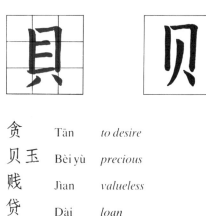

贪	Tān	*to desire*
贝玉	Bèi yù	*precious*
贱	Jiàn	*valueless*
贷	Dài	*loan*

GÉ
HIDE

革

There are two radicals to indicate leather, the tanned hide of an animal. This is the most widely used and has many composites; the other has only four. The distinction between the two is hard to justify nowadays, but it was not always so. The pictograph shows the skin of an animal (a sheep) stretched (the two horizontal lines) between two hands that are scraping it. Originally, the radical did not indicate a tanned hide. It also described a demoted government official who, apart from losing his post, had to pay a fine as well.

Today, the word "to demote" is written with the character for "office" next to this radical. With the character for "strength," however, it creates the verb "to brake." The reins, made of strips of leather, were used to steer but also, by using one's strength, for braking and stopping. The radical linked to the character for "sign," in a phonetic capacity, produces "target": in the past, soldiers used to practice firing arrows or throwing javelins at targets covered in hide or hides filled with straw. With the character for "peace," in a phonetic role, the word "saddle" is formed.

革 草 茜 革 革

一 丨 丨 一 丨 フ 一 一 丨
2 3 3 2 3 11 2 2 3
一 十 サ サ 革 革 苎 茸 革

革职	Gé zhí	to demote
勒	Lè	to brake
靶	Bǎ	target
鞍	Ān	saddle

178

WÉI
LEATHER

韋

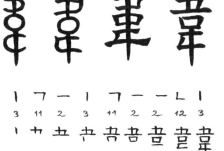

The pictograph shows a stylized drawing of two men, in accordance with recognized formulae, who are pulling a round object in different directions. From this it can be deduced that we are dealing with a tanned hide being pulled over the object to be covered. As for the way in which the character is used, this radical and the one for "hide" represent, in their composites, the products made from tanned hide.

With the character for "to extract" or "to pull out" this radical forms "sheath" or "holder," the bag from which the bow is taken out when going to war or on a hunt. The character also means "to hide," and we find it linked to the one for "plan" or "scheme" to form "military strategy," the art of hiding one's plans from the enemy. The character for "blade" joined to this radical forms the word "tough," "pliable yet strong," like leather. By using this composite with the character for "ribbon" we obtain "ligament," the tough, flexible fiber that attaches the muscle to the bone like the strips of leather that attach the harness to the horse.

韜	Tāo	*bow holder*
韜略	Tāo lüè	*military strategy*
韌	Rèn	*pliable yet strong*
韌帶	Rèn dài	*ligament*

179

ZHÌ
FELINE

豸

No animal like the cat has ever formed part of the Chinese calendar. Perhaps cats were not common in China at the time, even though the pictograph does appear to be an accurate representation of one, standing up on its back legs, baring its teeth and arching its back, with a long tail behind.

The character for "cat" is formed of this radical with the one for "shoot." This animal has to catch mice among the fruits of the rice and wheat fields: in the granaries. It was also called the "domestic wolf." It is regarded as the protector of silkworms because it keeps away mice, which are notoriously fond of them: this popular name is obtained by writing the character for "cat" with the one for "silkworm." By joining the character for "cat" with the one for "bear," we obtain "panda," the world's largest and most appealing "cat." This radical with the character for "talent" or "strength" creates "wolf" (nowadays "jackal"). The ancient Chinese, although fearing the wolf, held it in high esteem because of its characteristic strength, tenacity and sense of social organization.

猫	Māo	cat
蚕猫	Cán māo	protector of silkworms
猫熊	Māo xióng	panda
豺	Chái	wolf

FĒI
TO FLY

Just by looking at the pictograph we can see the origins of this character, already complicated by classical writing, which clearly showed two open wings. The ancient sign represented the flight of the crane as it took off with its long neck folded. Between the drawing and the classical character, the crane's profile was altered and came to be shown in migratory flight, flying with open wings. Simplification has certainly made this character easier to write, but it has plucked the crane and reduced its wings to two drops. As a radical it no longer appears in modern dictionaries.

This character with the one for "white" forms the word given to a style of calligraphy that leaves blank spaces in the characters, as though the brush had been flying. With the character for "insect" it means "winged insect." With the one for "motor" or "machine," however, it creates "aeroplane": a flying machine. Joined to the character for "sky" it forms the word for *Apsaras*, the graceful spirits of Buddhism: female beauties that hover in the air. There are some famous ones painted in the Dūn Huáng caves of Gānsù province.

飞白	Fēi bái	*(calligraphic style)*
飞虫	Fēi chóng	*winged insect*
飞机	Fēi jī	*aeroplane*
飞天	Fēi tiān	*Apsaras*

181

Jade

The radicals linked to nature include those representing bamboo, rice, gold and other elements that recall the world of the Orient, but none occupies a place as important as jade. *Jade is a symbol of nobility, opulence and beauty. It is Nature's most precious secret, the fruit of Mother Earth, which protects man from misfortune and illness. For this reason a pierced disc of jade is hung around babies' necks and newlyweds are each given bracelets of jade on their wedding day.*

RÌ
SUN

日

0 0 0 0 0 日

The ancient Chinese believed the sun had a diameter of 1,000 *lǐ* (500 km/310 miles), a circumference of 3,000 *lǐ* (1,500 km/930 miles) and was suspended under the arch of the firmament at a height of 7,000 *lǐ* (3,500 km/2,173 miles). It was round, whereas the earth was square, as can be seen in the pictograph; only later did it become square, for practical reasons, and then rectangular. This radical also means "day."

The character, together with the one for "chronicle" or "account," forms "daily newspaper": an account of the day's events. Next to the character for "moon," it means "life": everything that happens during the day and night. Placing the character for "sun" below the one for "tree" creates the verb "to disappear": it once meant "sunset," the time when the sun disappeared behind the trees. By joining the character for "sun" to the one for "to eat," we obtain the word for the solar eclipse that happens when the three-legged toad tries to eat it. "The dogs of Sìchuān bark at the sun" refers to a person marvelling at something out of ignorance or inexperience.

丨 ㄱ 一 一
3 11 2 2
丨 冂 日 日

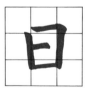

日报	Rì bào	*daily newspaper*
日月	Rì yuè	*life*
杳	Yǎo	*to disappear*
日食	Rì shí	*solar eclipse*

YUÈ
MOON

月

The pictograph and the ensuing characters show the crescent moon which, as it changes, turns toward the earth with beneficial influences. A female symbol in nature, it is inhabited by different characters from Chinese mythology. At the foot of a cassia-bark tree a hare prepares the elixir of immortality. The thieving wife of Cháng Ōu, transformed into a three-legged toad, awaits the eclipse. Yuè Lǎo, the god of matrimony, ties invisible red threads and creates weddings. Poor Wú Gāng, the Chinese Sisyphus, tries in vain to cut down a tree with blows from his axe, but it immediately grows back.

This radical with the character for "cake" forms "moon-cake," a special sweet prepared to celebrate the mid-autumn festival. By placing the character for "moon" before the one for "musical instrument," we obtain the "moon guitar," an instrument with a circular sound box and four strings. The characters for "sun" and "moon" together form "brightness," the combination of sunlight and moonlight. If we add the character for "white" to the one for "light" we obtain "shining."

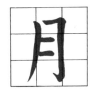

月饼	Yuè bīng	*moon-cake*
月琴	Yuè qín	*moon guitar*
明	Míng	*brightness*
明白	Míng bái	*shining*

XĪ
EVENING

夕

ﾉ ﾌ ﾟ ﾞ ﾟ ﾂ ﾞ ﾀ

The start of night is indicated by the moon peering out from behind the mountains: the pictograph shows a crescent moon, with its lower half in shadow and its visible half lighting up the sky. It thus conveys the meaning of "to grow dark." By placing the character for "mouth" beneath this radical we obtain the word "surname" or "proper noun." When people came to the door in the evening, the only way they could identify themselves was to say their own name. The phrase "common noun" is created by adding the composite of a boy under a roof, meaning "word" or "character," to "surname": this indicates the name given to a child born in that house or, more simply, the character denominating a person. By doubling this radical we obtain "much" or "many": the character indicates the passing of time as evening follows evening, but also what can be done in a certain period. It is the work completed by a man at the end of the day that will yield many results. Joining the character for "many" with the one for "a few" gives us "price," which conveys the idea of asking whether something costs a lot or a little.

ﾉ ﾌ ﾞ
4 15 1
ﾉ ﾜ 夕

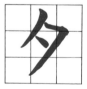

名	Míng	surname
名 字	Míng zī	noun
多	Duō	a lot
多 少	Duō shăo	price

HUǑ
FIRE

火

业 岹 火 火 火

丶 丿 丶 丶
1 4 4 5

丶 丷 少 火

A flame flickering upward with two sparks at either side: this is the image clearly portrayed in both the pictograph and the character. Fire, the symbol of warmth, strength, danger and anger, plays a part in every aspect of our lives, like good and bad luck. In the past, when a young bride entered the house of her husband for the first time, she was passed over a burning brazier. This ritual was thought to guarantee her survival of childbirth.

Writing the character for "flower" after this radical forms the word "spark," which the Chinese imagination has poetically transformed into a fire flower. By placing this radical before the one for "mountain" we obtain "volcano": a mountain that burns, a fiery mountain. With the character for "cart," this radical creates "train": an engine that needs fire in order to run. When juxtaposed with the character for "air," it forms "anger" or "wrath": like a mixture of flames and wind, there is nothing more unpredictable or dangerous. "To climb a mountain of swords and dive into a sea of flames" means to be prepared to overcome any difficulty.

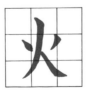

火花　Huǒ huā　*spark*

火山　Huǒ shān　*volcano*

火车　Huǒ chē　*train*

火气　Huǒ qì　*anger*

QÌ
STEAM

气

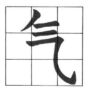

ノ 一 一 乁
4 2 2 24
ノ 仁 气

In its ancient form this character represented sun and fire, the sources of steam. Later – as a result of daily experience – these two elements were replaced by rice, which, as it boils in the water, creates clouds of steam. Its smell would bring great happiness to the houses of the poor, whose dream was to have at least one steaming bowl of rice each day. Modifications have eliminated the rice from the character, but the steam remains. It also now indicates "air," "vapour" and "breath."

This radical with the character for "strength" means "force" or "energy" – an unconscious but precise forecast of the way in which man would later use steam as a source of kinetic power. The character for "ability" or "exercise" after this radical forms *qì gōng*: a type of therapeutic gymnastics consisting of deep-breathing exercises. By writing the radical for "gate" after this one we obtain "air valve": the device used to regulate the flow of air in and out, a pneumatic "gate." The character for "sphere" after the one for "steam" creates "aerostat": a balloon inflated with hot air.

气

气力	Qì lì	*energy*
气功	Qì gōng	*deep-breathing gymnastics*
气门	Qì mén	*air valve*
气球	Qì qiú	*aerostat*

YǓ
RAIN

雨

雨雨雨雨雨

一 丨 コ 丨 丶 丶 丶 丶
2 3 17 3 1 1 1 1

一 ㄏ ㄇ 雨 雨 雨 雨 雨

This character, which has stayed very close to its pictograph, shows four drops falling vertically out of clouds (represented by the open-ended container) suspended in the sky (the horizontal line in the upper part) – a simple yet effective image of a phenomenon that controls the rhythm of life. Not everyone, however, regards rainfall in the same way: "the peasant desires rain, the wayfarer fine weather," says one old proverb.

By placing the character for "clothing" after this radical we obtain "raincoat": the garment that protects its wearer from the rain. Writing the character for "rice field" beneath it creates the word "thunderclap." This reflects the experience of the peasant caught out in the fields during the summer by black clouds that rumble and then unleash rain. In fact, by writing the character for "rain" after the one for "thunderclap," we obtain "thunderstorm." The character for "frog" after the radical produces "tree frog," whose croaking announces that rain is on its way. The subject of many poems, rain plays an important part in Chinese folk songs.

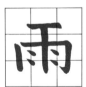

雨衣	Yǔ yī	raincoat
雷	Léi	thunderclap
雷雨	Léi yǔ	thunderstorm
雨蛙	Yǔ wā	tree frog

189

FĒNG
WIND

風

凮凮�風風

ノ	乙	ノ	l	フ	一	l	一	、
4	24	4	3	11	2	3	2	1

ノ 几 凡 凡 风 凤 風 風 風

There is an ancient Chinese tradition that insects were born as a result of the influence of the wind and earthly vapours. This explains the original composition of this character, which contains three elements: sun, movement and expansion. Its simplification, in which even the insects have been eliminated, retains a square sail swollen by the rain.

This radical, when linked to the one for "water," forms *fēng shuī* which, freely translated, denotes a suitable place for building a house or tomb so that the fortunes of the family and the peace of the departed will be ensured. Wind and water, as denoted by the characters, are the two elements of Chinese geomancy. By placing the character for "bell" after the one for "wind" we obtain "wind chimes," the small bells placed at the tips of pagoda or temple roofs, which tinkle in the breeze. With the character for "cart," this radical forms "windmill": in this case the word "cart" is used in the sense of "wheel." When juxtaposed with the character for "light" it forms "panorama," a view enjoyed when the air has been cleared by the wind.

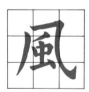

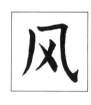

风水	Fēng shuī	*wind and water*
风铃	Fēng líng	*wind chimes*
风车	Fēng chē	*windmill*
风光	Fēng guāng	*panorama*

SHUĬ
WATER

水

Whereas in the character for "fire" the flames leap upward, in the one for "water" the movement is downward. Its pictograph shows the eddies produced by the water. As well as the central current, the character also depicts the drops of water caused by the spray at its edge. A basic element of life, water, a symbol of peace and prosperity, influences where communities settle, as indicated by geomancers. This radical forms part of many composites and occurs in two different styles of writing, the classical form and the reduced form, in which it consists of two drops with a vertical stroke between.

With the radical for "hand," this character forms the word "sailor," one of the hands on deck. Linked to the character for "disaster," it produces "flood." Written next to the character for "flower," it creates the word "spray": a spray of perfumed water. Juxtaposed with the character for "alcohol," this radical gives "modest little wine," the polite way of offering to one's guests a wine that is really of excellent quality. Etiquette demands that one present it almost as though it were water.

丿 フ 丿 乀
8 15 4 5

丨 刁 朩 水

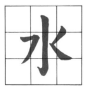

水手　Shuĭ shŏu　*sailor*

水灾　Shuĭ zāi　*flood*

水花　Shuĭ huā　*spray*

水酒　Shuĭ jiŭ　*modest little wine*

BĪNG
ICE

When water freezes, vein-like lines form on the surface; ice crystals take the form of small, star-shaped clusters of needles; when its surface splits, cracks form. It is possible that the observation of these three phenomena gave rise to the pictograph. The ancient character shows small lines next to the water, which were later reduced to a stunted icicle.

With the character for "mountain," this radical produces "iceberg," a mountain of floating ice. With the word "river," however, it creates "glacier," a river of ice flowing down a valley. By placing the character for "box" after this radical we obtain "refrigerator" or "icebox." If, however, the character for "knife" occurs after the radical, we have the word for "skates": shoes with steel blades on their soles to glide over the ice. "More than one cold day is needed to freeze a deep river" means that difficulties can arise despite lengthy warning. "Ice is formed of water, but it is colder than water" indicates that sometimes a pupil can outstrip his teacher.

冰山　Bīng shān　*iceberg*

冰川　Bīng chuān　*glacier*

冰箱　Bīng xiāng　*refrigerator*

冰刀　Bīng dāo　*skates*

CHĒ
SHOOT

屮

屮 Ψ Ψ Ψ 屮 屮

L I ノ
12 3 4

L ㄩ 屮

"From the grassy ground she brought me a flower / most beautiful, rare; lovable but not the shoot / given to me by a girl who is my love." This is the translation of an ancient poem from the *Book of Odes*: it recalls the spring festivals when the young went out to find their soul mates. The pictograph, too, shows a seed bursting with life, which in springtime pushes the young shoot through the soil.

Nowadays – when written twice, one above the other – this radical has the meaning "to go out," "to produce," "to publish." With the character for "nation" the radical forms the expression "to go abroad," "to leave one's own country." With the character for "shameful," however, it means "to play the fool," behaviour of which later one feels ashamed. Place the character for "to go out" after the one for "door" and we obtain the expression "to be far from home." The saying "a small patch of green makes one think of spring" does not refer solely to nature but means that a small sign of gratitude from their children will repay parents for their years of effort and sacrifice.

出	Chū	*to produce*
出国	Chū guó	*to go abroad*
出丑	Chū chǒu	*to play the fool*
出门	Chū mén	*far from home*

CĂO
GRASS

艸

屮屮 屮屮 屮屮 屮屮 屮屮

Two shoots, one next to the other, convey the idea of grass. These two signs occur in a large number of characters linked to vegetation.

The Chinese also had their Robin Hoods, outlaws who lived in the forest and protected the poor. The feudal lords, the victims of their trickery, called them "thieves of the forest," because they lurked in the undergrowth. The character for "head covering" placed after the radical creates "straw hat," a hat made from dried grass. Next to the character for "to write" or "style," the radical forms the word indicating a particular style of rapid writing known as "grass characters": a soft, swift and original style that came into use during the 4th century. When linked to the character for "fish," this radical forms the word "carp" – more accurately the so-called "grass carp." In fact, the fish belongs to another subfamily, but the Chinese called it the "grass carp" because of its diet. To convey that one should never despair because Providence will always intervene, the Chinese say "every blade of grass receives its drop of dew."

L I ノ L I I
12　3　4　12　3　3

L Ц 屮 屮L 屮Ц屮

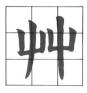

草寇　Căo kòu　　*"thieves of the forest"*

草帽　Căo mào　　*straw hat*

草书　Căo shū　　*grass characters*

草鱼　Căo yú　　*grass carp*

MÙ
TREE

木

米 米 米 木 林

一 丨 丿 乀
2 3 4 5
一 十 才 木

This character shows a trunk emerging from the ground (the horizontal line), solidly anchored by its roots. In its earliest versions the pictograph also portrayed branches extending from the upper part of the trunk, thus forming a mirror image.

By writing the character for "young boy" beneath the radical we obtain "plum tree," which, because of the abundance and sweetness of its fruits, is called the "young boys' tree." Naturally, the fruit of the tree is the plum, the child of the plum tree. The character for "plum tree" after the one for "to travel" forms "suitcase," which was once a wooden trunk. Writing the character for "fish" after the radical for "tree" gives us "wooden fish," a percussion instrument carved from a single block of wood, which Buddhist monks use to accompany the singing of sacred texts. Its name derives from the two fish carved on the wooden drum rather than from its shape. The character for "melon" or "gourd" after the radical creates "papaya," the gourd that, according to popular Chinese imagination, grows from a tree.

李　　Lǐ　　*plum tree*

行李　Xíng lǐ　*suitcase*

木鱼　Mù yú　*wooden fish*

木瓜　Mù guā　*papaya*

ZHÚ
BAMBOO

The bamboo is the most loved, most painted, most sung-about plant in China. The pictograph shows two tufts of leaves pointing downward. The people call it "China's friend" because they use every part: its shoots are used in cooking, its pulped wood in paper-making, its stems make pipes and brushes, its trunk is used for making furniture, tools and scaffolding, its leaves for packing and making roofs, and its seeds and roots in medicine. On top of this, it is a symbol of longevity because it is evergreen and long-lasting.

With the character for "strip" this radical indicates "ancient books," which were written on strips of bamboo. By placing the character for "bud" after the one for "bamboo," we obtain "bamboo shoot," a vital part of any Chinese meal. These shoots grow at an incredible rate following the warm spring rains: in a single night they can form a whitish cone some 40 cm (16 in) high. A bamboo cane between the legs of a child becomes a "hobbyhorse." The character for "woodland" after the radical gives us "bamboo forest," where the pandas live.

竹简	Zhú jiǎn	*bamboo strips*
竹笋	Zhú sǔn	*bamboo shoot*
竹马	Zhú mǎ	*hobbyhorse*
竹林	Zhú lín	*bamboo forest*

196

GÙN
STICK

This is an elemental sign, now used only in composites. It probably originated in the representation of a branch stripped of leaves, later depicting a walking stick or an offensive and defensive weapon. In this capacity it forms part of many characters with a variety of meanings, often unrelated to its original one.

In the composite for "center" it represents an arrow, which in the past had a metal tip and wooden shaft, as it hits the bull's-eye. In the character of "to stretch" it represents the taut, stretched bowstring. In the verb "to tie," however, it is a stylized bobbin linking two objects, running between the threads of the loom to form the weft. Today, the character for "stick" is written in conjunction with those for "tree" and "boy." This brings to mind the old Chinese adage "a bamboo rod ensures children are well brought up," the equivalent of "spare the rod and spoil the child." It should be added that in modern China this proverb has become a metaphorical reference to educational systems based on discipline.

3

中	Zhōng	center
引	Yīn	to stretch
串	Chuàn	to tie
棍	Gùn	stick

MĬ
RICE

米

米 米 米 米

（stroke order diagram）
1 2 3 4 5
丶 丶 一 丨 八
丶 丶 丷 半 米

This character shows a rice seedling complete with roots, leaves and grains. The pictograph, however, first depicts nine grains of rice, a sign of abundance, then divides them by a cross, with one grain at each of the four corners. This is a clear reference to the idea of the grains of rice being dispersed during threshing. The radical applies solely to rice that has been separated from the husk.

By placing the character for "food" after this radical, we obtain "steamed rice," the staple food of China. Next to the character for "dust," it creates "rice flour." Juxtaposing the character for "alcohol" with the one for "rice" gives us the so-called "rice wine." The most famous of these alcoholic beverages is *Máo Tái*, but it is definitely not the best: it owes its reputation to the fact that Máo Zédōng offered it to President Nixon when toasting Sino-American friendship. One strange feature is the Chinese word for "metric system," whose characters literally mean "rice system": it is probably the result of a Chinese attempt to reproduce the pronunciation of the English word "meter."

米饭	Mǐ fàn	*steamed rice*
米粉	Mǐ fěn	*rice flour*
米酒	Mǐ jiǔ	*rice wine*
米制	Mǐ zhì	*metric system*

HÉ
CEREALS

禾

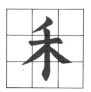

"The richer the ear in grain, the more the head bends." This observation, self-evident to any peasant, contains an important message: the richer a man is in ideas (intelligence and learning), the more humble his behaviour should be. The pictograph represents a plant with its spike weighed down by grain, its leaves and its roots. This character is used for cereal plants in general even though each has a specific character to identify it.

This radical with the character for "open space" creates "threshing-floor," the place where the peasants gathered not only to thresh grain but also to hold parties. The small plants used in transplanting are indicated by the radical plus another character formed by shoots sprouting out of the rice field. When juxtaposed, the characters for "cereal" and "insect" provide the name of the grain weevil that eats its way through granaries. With the character for "fire" after this radical, we have the word "autumn": this reflects either the idea of the grain being harvested after ripening under the scorching summer sun or of the stubble being burned in the autumn.

禾场	Hé chǎng	*threshing-floor*
禾苗	Hé miáo	*small plants*
禾虫	Hé chóng	*grain weevils*
秋	Qiū	*autumn*

199

DÒU
LEGUMES

豆

豆𣅊𣅊豆豆豆

一 丨 フ 一 丶 丿 一
2　3　11　2　1　4　2

一 一 一 一 豆 豆 豆

This radical could well have been included in the chapter incorporating utensils, but because of its original concept and its modern usage we have preferred to insert it here. Nowadays used to indicate legumes, whose seeds are contained in pods, originally it depicted a bowl resting on a pedestal, as shown in the pictograph. The design for the bowl was inspired by the shape of the legumes' seed pods, hence the character's modern meaning.

By writing this character next to the one for "wrap," we create "sweet bread," a steamed bun, made of cereal flour, with a sweet filling. When written before the character for "stale" or "fermented," the radical creates "bean curd," sometimes wrongly called "soy cheese." This consists of soybean flour mixed with water to form a firm white paste. By replacing the character for "fermented" with the one for "oil" we obtain soy oil, the most common ingredient in Chinese cooking. Placed before the character for "young boy," this radical creates the word for "peas."

豆包　Dòu bāo　*sweet bread*

豆腐　Dòu fū　*bean curd*

豆油　Dòu yóu　*soy oil*

豆子　Dòu zǐ　*peas*

GUĀ
GOURD

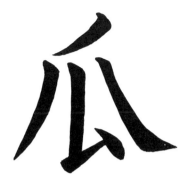

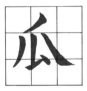

ノ　ノ　レ　ヽ　乁
4　4　10　1　5

ノ　厂　瓜　瓜　瓜

The picture conjured up in Western minds of a robust, climbing ivy is also apparent in the Chinese interpretation of the melon and gourd: the former is somewhat romantic, the latter rather more pragmatic. The pictograph shows a gourd, with the fruit at the center, hanging from a branch, with leaves or tendrils at the sides. The essential lines of this basic idea also survive in the character. The radical, when followed by the character for "component," creates the verb "to divide." The presence of a knife in the additional character gives the idea of a melon cut into slices: segments that make up the whole fruit. The character for "son" after the radical produces "melon seeds." The fox is certainly a mysterious animal, much feared by the Chinese, who believe that it has the power to turn itself into a human being in order to carry out malicious acts with stealth and cruelty. For this reason it was respected and venerated, but that still does not explain its character, which is formed of those for "dog" and "gourd." With the character for "vain," together with the one for "son" and this radical, we obtain "baby marrow."

瓜分	Guē fēn	*to divide*
瓜子	Guā zī	*melon seeds*
狐	Hú	*fox*
瓠子	Hù zī	*baby marrow*

MÁ
HEMP

麻

A herbaceous annual cultivated in China since the third millennium B.C. for its fibers, which are used in the manufacture of ropes, carpets, sacks, mats and cloth. The sign represents two bundles (or sheaves) of stems, hanging out to dry in a shelter. In 1973, at Jīnguān, fragments of paper made from hemp fibers from the Western Hàn dynasty (206 B.C.–A.D.24), were discovered. This reveals an unusual use for the plant.

Placing the character for "irritated" after this radical creates "annoying," "inconvenient": the two characters indicate the trouble taken in preparing the hemp and the irritation caused by any holdups in the process. By linking the character for "general" to the one for "hemp" we obtain the name of a game, a very popular pastime in China: *má jiàng*, a sort of dominoes. The character for "oil" after the radical creates "sesame-seed oil," even though this plant in fact belongs to another family. With the character for "stone" below the radical we obtain the verb "to grind," reflecting the pounding to which the plant is subjected in order to break it down into fibers.

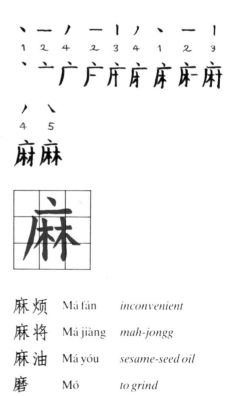

麻烦	Má fán	*inconvenient*
麻将	Má jiàng	*mah-jongg*
麻油	Má yóu	*sesame-seed oil*
磨	Mó	*to grind*

JIǓ
GARLIC

According to the Chinese Herodotus, Sīmǎ Qiān (145–87 B.C.), garlic was imported into China by the imperial official Zhāng Qiān after an arduous mission undertaken on the orders of the Emperor Wǔ Dì in 119 B.C. In reality, garlic (*Allium scorodoprasum*), together with coriander, the cucumber and the fig, was introduced into China from Central Asia between the third and seventh centuries. Chinese garlic differs from its European counterpart (*Allium sativum*) in its sparse flowers and its bulb composed of violet, pedunculate and highly scented bulbils. The pictograph shows two small plants with their typically lanceolate leaves. In modern dictionaries it is associated with another radical and has few composites.

Linked to the character for "vegetables" it creates "green garlic," a small, very pungent plant. It can also be used to mean "spring onion." With the character for "yellow," it means "yellow spring onion," a vegetable that grows on manure heaps. With the character for "juice" we obtain "crushed garlic," while with the character for "green" it forms "garlic shoot."

韭菜	Jiǔ cài	*green garlic*
韭黄	Jiǔ huáng	*yellow spring onion*
韭汁	Jiǔ zhī	*crushed garlic*
青韭	Qīng jiǔ	*garlic shoot*

203

MÀI
WHEAT

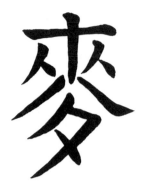

China is the world's third largest grower of wheat. The rich alluvial loess of northern China is ideal for growing wheat, millet, kaoliang, barley and beans, making it one of the most agriculturally productive areas of the country. The pictograph is formed in two parts: above, the shafts bending under the weight of the plump grain and, below, the character for "to advance." The reference is to ripening grain. This radical is also used for "barley."

With the character for "skin" or "bark" it forms "bran": the coarsely ground husk of the grain. With the character for "autumn" we obtain a phrase used to mean "school holidays": in fact the expression refers to the autumn harvest, when the village schools remain closed to allow the children to help in the fields. To create the word for "harvest," all we need to do is add the character for "to accept" or "to put away" to the radical. If, however, we place the character for "shoot" after the radical we obtain the word "malt," the product of dried barley.

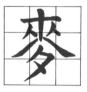

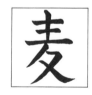

麦麸	Mài fū	bran
麦秋	Mài qiū	autumn harvest
麦收	Mài shōu	harvest
麦芽	Mài yá	malt

SHǓ
MILLET

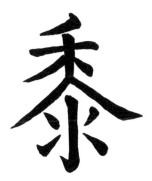

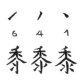

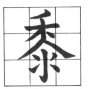

The radical shows a grasslike plant, as indicated by the character for "cereal," with the one for "water" below: the latter is intended to represent the plant's stickiness. In the pictograph we can see drops of liquid falling from the leaves. Millet seeds still form an important part of the local diet: they are spread on sandwiches, sweets and even pork crackling. Millet grain is also used in the production of alcoholic beverages and as a food supplement for domestic animals.

This radical with the character for "to hold back" means "glutinous," "sticky," the viscosity of the plant giving the idea of something that cannot be removed. By combining the radical with the character for "spoon" we obtain "multitude": a mass of millet seeds in the ladle. By a strange process of distortion the word "fragrant" or "aromatic," derived from this radical, has had its lower section replaced by the character for "sweet"; perhaps this is a reference to millet cakes. When juxtaposed with the character for "fire" the radical creates "joss stick," the fragrant stick of incense burned in houses and temples.

黏	Nián	*glutinous*
黎	Lí	*multitude*
香	Xiāng	*aromatic*
香火	Xiāng huǒ	*joss stick*

ZHĪ
BRANCH

支

This character shows a hand removing a branch from a tree for use as a walking stick: it is similar to the one for "stick" but derives from a different pictograph. It has many meanings nowadays: "to emerge," "to sustain," "to give out money," "to take back money," "a branch" (of either a bank or a post office) and, finally, the twelfth "heavenly stem" of the calendar.

Joined to the character for "tree," it forms the modern word for "branch." The character for "to go out" or "to disburse," when linked to this radical, creates the word "expenses." Juxtaposed with the character for "work," this radical produces the expression "industrial subsidy," financial support to an important economic sector. With the character for "pole" after the radical, we obtain the word "column," "pilaster": an element – normally made of wood, as indicated by the character – used to support a building. "He who plants trees should remember that others will enjoy the shade of their branches": some important enterprises will be of use not only to the person who carries them out but also to many others.

攱 鑫 筝 攴 支

一 丨 フ 乀
2　3　15　5
一 十 方 支

枝	Zhī	branch
支出	Zhī chū	expenses
支工	Zhī gōng	industrial subsidy
支柱	Zhī zhù	column

PIÀN
PLANK

片

片 片 片 片 片

ノ 丨 一 フ
4 3 2 1

ノ 丿 广 片

This is the other part of the vertically bisected tree trunk whose left side we have already seen in the radical for "wood." The pictograph is a mirror-image of the latter character. It is the less sturdy part of the trunk: a thin, weak piece of wood. Today, its meaning has been extended to include "slice," "tablet," and "moment."

With the character for "pharmaceutical preparation" after the radical we obtain "lozenge," "pastille." By writing "son" after it we create the word "visiting card." There was a time when important personages, scholars, mandarins and professional men, who had passed state exams and possessed official qualifications, had the right to hang a wooden board above the entrance to their homes bearing their name, title and profession: a visiting card is a miniature board. This radical with a different tone, when linked to the character for "box," creates the word "cartridge," used for loading cameras: it recalls the light-sensitive plates of older models of camera. The same character with the one for "son" forms the word for "reel" or "film": like a small cartridge.

片 剂 Piàn jì *pastille*

片 子 Piàn zǐ *visiting card*

片 盒 Piān hé *cartridge*

片 子 Piān zǐ *reel*

SHÍ
STONE

石

石 后 石 石 石

```
一  丿  丨  フ  一
2  4  3  11  2
```

一 丁 ᄌ 石 石

A boulder falling from an outcrop of rock: this image, clearly discernible in the pictograph, was gradually altered until the boulder became a mouth.

This character with the one for "cinder," composed of a shelter with a fire burning beneath it, forms the word for "slaked lime," which is produced by heating limestone. There are still furnaces for this purpose in China. When juxtaposed with the character for "flower" the radical creates "quartz": a crystal or stone flower. By replacing "flower" with "oil" we obtain the word for "mineral oil": the oil extracted from the bowels of the earth, or "oil of stones," as the Chinese call it. The word "pomegranate" is formed by writing the character for "stone" before another whose original meaning was "something found on a tree." This may refer to the hardness of the fruit within its skin or to the fact that the pomegranate-tree grows in arid, stony ground. "Slander cannot destroy an honest man: once the flood is over the stone reappears" says one proverb; it does not, however, specify whether this happens during his life or after he has died.

石

石灰	Shí huī	slaked lime
石英	Shí yīng	quartz
石油	Shí yóu	mineral oil
石榴	Shí liú	pomegranate

208

LǓ
ROCK SALT

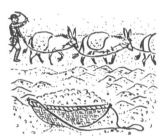

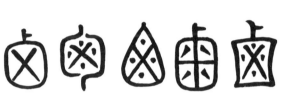

This is another radical that has been eliminated from modern dictionaries, although it has an illustrious past. It refers to salt obtained either from rocks or from evaporated seawater. In 51 B.C. the Western Hàn made its trade a state monopoly. It appears that Marco Polo exercised control over salt taxes as imperial official from 1278 until 1280. At that time salt was also used as currency.

The pictograph represents either a container with grains of salt inside it or the old-style character for "the West," which contains four grains of salt, because that was the direction from which the caravans carrying salt came. Today, the radical means "bitter," "harsh." Juxtaposed with "water," it creates "brine," while with the character for "flavour" it forms the word "stew": a tasty dish, cooked for a long time and, in China, sometimes served cold. The modern character for "salt" is different and rather strange: it is formed of "container" with "earth" and "divination" above it, and possibly reflects some ritual significance. This character with the one for "flower" gives us "pinch of salt."

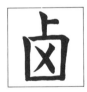

卤水　Lǔ shuǐ　*brine*

卤味　Lǔ wèi　*stew*

盐　　Yán　　*salt*

盐花　Yán huā　*pinch of salt*

YÙ
JADE

玉

Confucius once wrote: "Jades are as delicate, smooth and brilliant as benevolence; as compact, strong and splendid as intelligence, as sharp at the edges, but without inflicting wounds, as justice; as beautiful, even in their flaws, as loyalty." It is the stone that in Chinese eyes represents "the most precious thing in the world." The character indicates three pieces of jade, tied together by a cord. The dot is a modern addition to distinguish it from the character for "king," whose symbol jade was.

With the character for "silk," it signifies "gifts of State," presents given to important guests. Juxtaposed with the character for "belt" it creates "jade girdle," an important accessory to the ceremonial dress worn by high-ranking officials. With the character for "palace" or "temple" it forms "empyrean," the realm of the highest divinities. If we place the character for "imperial seal" after this radical we obtain "jade seal," as used by the emperor to pass laws. Jade was regarded as a living stone – to be worn, to ward off illness, to bring good fortune to the healthy and to preserve the bodies of the dead from decay.

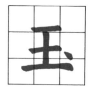

一 一 丨 一 丶
2 2 3 2 1
一 二 干 王 玉

玉

| | | | |
|---|---|---|
| 玉帛 | Yù bó | *gifts of State* |
| 玉带 | Yù dài | *jade girdle* |
| 玉宇 | Yù yū | *empyrean* |
| 玉玺 | Yù xī | *jade seal* |

210

JĪN
GOLD

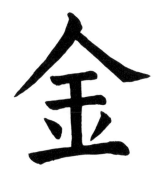

This character signifies both "gold" and "metal." The pictograph indicates the presence of four pieces of gold or four layers of minerals in the earth's core, which was believed by the Chinese to be the matrix of metals: above it is a covering, a roof intended to act as a means of protecting one's treasure and hiding it from others. The transformation and reduction of the character has reduced the nuggets to two.

By placing the character for "writing" after this radical we obtain "characters on bronzes," one of the earliest forms of Chinese writing. The planet Venus is the "star of gold" because of its shimmering reflections; its name is formed of the characters for "gold" and "star." The radical next to the character for "paintbrush" creates "fountain pen": the modern writing implement. The characters for "gold" and "fish" make "goldfish," which many Chinese people keep in their home in the hope that they will bring prosperity and fidelity. "You cannot buy one instant of life, not even with a gold nugget" means that there are certain things that even money cannot buy.

金文	Jīn wén	*characters on bronzes*
金星	Jīn xīng	*Venus*
金笔	Jīn bǐ	*fountain pen*
金鱼	Jīn yú	*goldfish*

CHÀNG
RITUAL ALCOHOL

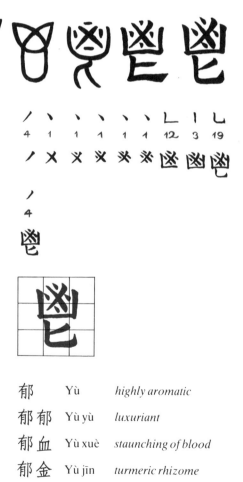

"The emperor, having arrived on the highest platform of the altar, offered up ritual alcohol, first to Heaven, then to Earth and finally to his Ancestors." This extract from the *Chronicle* of the city of Hángzhōu (1280) records the ritual use of aromatic alcohol, sometimes called "wine of happiness." The pictograph shows a vase containing cereals, herbs and spices to make the liquid more acceptable to the spirits. At the base of the vase is the ladle used to transfer the liquid into cups. Now eliminated from dictionaries, this radical has very few composites and even these have been made unrecognizable by modifications and reductions. Combined with the characters for "herbs" and "liquid," in old script, it forms "highly aromatic," as ritual alcohol should be. Written twice, this composite means "luxuriant." A juxtaposition of the character for "blood" with the one for "highly aromatic" produces "the staunching of blood": the idea probably derives from the fermentation of the herbs in the alcohol and from their colour. With the character for "gold," however, it gives the word for turmeric rhizome.

郁	Yù	*highly aromatic*
郁郁	Yù yù	*luxuriant*
郁血	Yù xuè	*staunching of blood*
郁金	Yù jīn	*turmeric rhizome*

Yellow

Colours, smells, weights and measures: all these heterogeneous radicals are gathered together in a single group with rather ill-defined boundaries. There is one radical, however, that stands out from the rest: the one for yellow, *the colour of* yīn, *the female principle in philosophy and Chinese medicine. It is also the colour of loess, the yellow clay soil that fed and nurtured the forefathers of the Hàn, the men of Yuánmóu. Yellow was also the imperial colour during the Qīng dynasty, as witnessed by the roofs of the Forbidden City in Beijing, and Yellow is the name of the great river that has since time immemorial watered the immense plains of Zhōng Guó, the country at the center, China.*

BÁI
WHITE

白

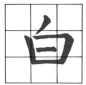

丿 丨 ㄱ 一 一
4 3 11 2 2
丿 亻 白 白 白

The idea of this colour is conveyed by the pictograph, which shows the sun at dawn, as the first shaft of light appears behind the horizon. But it is also the colour of the cardinal point west and is used as the colour of death and mourning. In theatrical masks a white face represents cunning, betrayal and licentiousness.

The character for "face" after this radical gives the name of a character in the Peking Opera: White Face. Together with the character for "vegetal" it produces "Chinese cabbage," a lettuce-like vegetable also known as "Chinese leaves." Written next to the character for "palace" or "temple," this radical forms "White House," the official residence of the president of the United States. With the character for "bone" linked to the one for "white" we obtain the name of a famous character in the 16th-century novel *Pilgrimage to the West*: the witch of the White Skeleton, defeated three times by the Monkey King, Sūn Wù kòng, in his attempts to trick the Buddhist monk Xuān Zàng. A person "unable to tell black from white" cannot tell right from wrong.

白 脸　Bái liǎn　*White Face*

白 菜　Bái cài　*Chinese leaves*

白 宫　Bái gōng　*White House*

白 骨　Bái gǔ　*White Skeleton*

214

QĪNG
GREEN

青

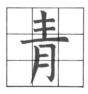

There is a legend, which also occurs in the Peking Opera, that tells of the love between White Snake and a young scholar. The White Lady (the name of the beautiful young girl who has abandoned her serpentine appearance) has a maid of honour, called Blue Snake by some and Green Snake by others. The cause of this disagreement lies with the radical, which can mean "green," "blue," "grey" and even "black"; perhaps its inventor was colour-blind. The sign represents young shoots growing: green is the colour of plants in their early stages of development.

With the character for "copper," the radical forms "bronze." The radicals for "fish" and "green" create a type of carp: the "black carp." With the character for "cloud" we obtain the expression "high position": the composite gives the idea of a lightning-quick rise to the top and of a person standing out like a cloud in a clear sky. As if to clarify this idea, the radical, when juxtaposed with the character for "sky," produces "blue sky." Green was the official colour of the Míng dynasty, which ruled China from 1368 to 1644.

青铜　Qīng tóng　*bronze*

青鱼　Qīng yú　*black carp*

青云　Qīng yún　*high position*

青天　Qīng tiān　*blue sky*

HĒI
BLACK

黑

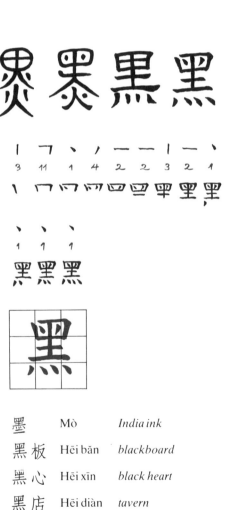

In huts, when a fire was lit, the smoke normally escaped through an opening above the hearth. The pictograph shows a small window blackened by the soot in the smoke: by extension it indicates the colour black. India ink is also made of soot, blended with other substances, hardened and then cut into sticks or blocks. The latter, when rubbed against special "ink stones," produces a fine powder that is then mixed with water to form the black ink used in painting and calligraphy.

The character for "ink" is formed from this radical placed above the one for "earth": black powder. The character for "black" next to the one for "table" forms "blackboard." "Black heart," composed of the radical plus the one for "heart," means an evil, insensitive, black-hearted person. The character for "inn" with this radical creates the word "tavern": a hostelry of the lowest order, frequented by people of ill fame, in the China of days gone by, run by brigands.

墨	Mò	*India ink*
黑板	Hēi bǎn	*blackboard*
黑心	Hēi xīn	*black heart*
黑店	Hēi diàn	*tavern*

HUÁNG
YELLOW

黄

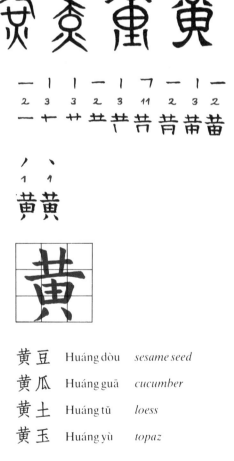

This pictograph is not easy to interpret. It shows a man with a lighted torch and the earth; the yellow of the flame and the soil. The latter may refer to the fertile loess deposited for centuries by the Yellow River on the lands in its basin. It is a warm, bright colour, a vital force. The yellow of the sun and the earth became, under the Qīng dynasty (1644–1911), the colour reserved for the Imperial House, a symbol of the Son of Heaven, who was responsible for the fertility or aridity of the land. There is another, less plausible explanation: that the man holding the torch is a miner searching for the yellow metal, gold.

The radical with the character for "legumes" creates "sesame seed": a bright yellow cereal. With the character for "gourd" it produces "cucumber." The characters for "earth" and "yellow" together form "loess," the alluvial soil that covers the Huáng Hé river valley and has made it into a very fertile area. Juxtaposed with the character for "jade," in the sense of "precious stone," this radical forms "topaz," a stone whose most common type is bright yellow.

黄豆	Huáng dòu	*sesame seed*
黄瓜	Huáng guā	*cucumber*
黄土	Huáng tū	*loess*
黄玉	Huáng yù	*topaz*

赤

During ritual ceremonies the emperor would wear different-coloured robes depending on the power being invoked. To honour, thank or petition the Sky he would wear blue, for the Earth yellow, for the Moon white and for the Sun red. In the theater, a red mask normally indicates a sacred personage. Red symbolizes sincerity, loyalty, courage, good fortune and happiness. It is the colour of the dress and of the veil covering the face of a bride, of the envelopes containing gifts of money, of the clothing to be worn by children for the New Year, and of one of the eight banners of the imperial army. The pictograph shows a man sitting by the fire.

The radical with the character for "way" forms "equator": the red way. With the character for "foot" it means "barefoot," the term used to indicate the paramedics who range through the countryside helping the peasantry: the famous "barefoot doctors." Here the character means "naked." Juxtaposed with the character for "boy," it means "newborn baby," a totally naked creature. With the character for "crockery" it means "terra cotta."

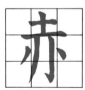

赤道	Chì dào	equator
赤足	Chì zú	barefoot
赤子	Chì zī	newborn baby
赤陶	Chì táo	terra cotta

SÈ
COLOUR

色

ノ フ フ ｜ ｜ 乚
4 11 11 3 2 19

ノ ク ク 名 名 色

According to some writers, the ancient character contains a drawing of a man and a woman, while others see a man and a seal; the latter theory seems to us the more accurate. Just as the stamp reproduces the seal, so the colour of the face reveals the passions and feelings of the heart. The character thus signifies colour in general but also refers to sex, a passionate encounter that heightens facial colour.

Juxtaposed with the character for "passion," this radical creates the word "pornographic" or "sexy." The films that we refer to as "blue" – in the sense of obscene or pornographic – the Chinese call "yellow." When placed before the character for "globe" this radical forms "chromosphere," the red halo of gases surrounding the sun. When linked with the character for "sediment" or "deposit," it creates "crimson," the red colour of iron-rich soil or rice fields with their waters stained by the sunset. With the character for "paper" it produces "coloured paper," on which good wishes are written. In addition it was burnt in religious rituals and offered to the gods or the departed.

色

色情	Sè qíng	*pornographic*
色球	Sè qiú	*chromosphere*
色淀	Sè diàn	*crimson*
色纸	Sè zhǐ	*coloured paper*

YĪN
SOUND

音

咅 帝 苗 咅 音

` 一 丶 丿 一 丨 ㄱ 一 一
1 2 1 4 2 3 11 2 2

丶 一 亠 立 产 音 音 音

This character shows a mouth from which a moving tongue emerges, representing sound and music. The radical for "sound" and the character for "sign" produce "phonetic symbol," a conventional figure indicating the sound and exact pronunciation of a word. The character for "pitchfork" written after the radical gives us "tuning fork": the metal instrument that, when struck, emits the note "la" of the sol-fa scale and acts as a means of tuning musical instruments and giving a choir the correct pitch. Followed by the character for "symbol," the radical produces "musical note." With the character for "to put together," "to combine," the radical creates "transliteration," the process of converting the sounds of Chinese characters into alphabetical form, of reproducing their tones and sounds in syllables. It is also the name Pīn yīn, the system officially adopted in China to translate or transcribe characters into European letters and is the method followed in this book. "A sound to stop the clouds in the sky" refers to an exceptional piece of music or one played with extraordinary skill.

音

音 标	Yīn biāo	*phonetic symbol*
音 叉	Yīn chā	*tuning fork*
音 符	Yīn fú	*musical note*
拼 音	Pīn yīn	*transliteration*

SĪ
PRIVATE

This radical occurs only in composites. From the pictograph we know that it represents a silkworm about to spin its cocoon. By extension, we obtain the adjectives "selfish," "separate," "private," "individual." In modern usage, the word for "private" is formed from the character for "grain" and this radical; in the past, peasants paid their taxes in grain, which thus became the property of the state. The remaining surplus was the property of the farmer and thus represented the private element. The radical with the character for "division" above it gives "public" (as opposed to private) and "impartial," because the total, the private element, is divided into equal parts. The character for "nothing," when followed by the radical, creates "unselfish," the description of someone who has nothing private. The juxtaposition of the characters for "oneself" and "private" forms "egoist," someone who does not think of others. "To spin one's own cocoon and stay imprisoned within it" is the risk run by those who, afraid to open up to others, afraid of having to give, end up finding themselves alone.

私	Sī	private
公	Gōng	public
无私	Wú sī	unselfish
自私	Zì sī	egoist

XĪN
BITTER

辛

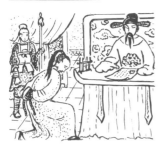

辛 辛 辛 辛 辛

`、 一、 ノ 一 一 丨`
`1 2 1 4 2 2 3`

`、 亠 六 立 立 辛`

In its ancient form this character was composed of two elements: "man" and "above." It refers to a man who has offended his superior and therefore deserves punishment. By extension, we obtain "suffering," "bitter," or "penalty."

By placing the character for "ancient" – in its original meaning of "handed down by ten generations" – above the radical we obtain "crime": a criminal act condemned by many generations that has caused bitterness among multitudes of people. Linked to the character for "suffering," the radical creates "fraught with difficulties," describing a decision or task that is hard to carry out. The character for "diligent," in the sense of "laborious," after the radical gives us "industrious," "hard worker": a person who carries out his work tenaciously and intelligently. With the character for "prince," the man who issued orders before his people, the radical creates the word "law" or "punishment." The prince, as representative of the emperor, would pass sentence on the guilty. Today the character means "to open up a territory," "to start an index."

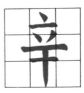

辜	Gū	*crime*
辛苦	Xīn kŭ	*fraught with difficulties*
辛勤	Xīn qín	*industrious*
辟	Pì	*to open*

XĪANG
PERFUME

The contracted sign for "sweet" and the character for "millet," both of which appear in the pictograph, convey the idea of fragrant or perfumed: it is the smell of fermenting millet used to make Chinese liquor. The odours and tastes of the Orient do not always coincide with our own.

With the character for "intestine" written after the radical, we obtain the word for a type of Chinese salami, which the Chinese see as an aromatic parcel with the spiced meat enclosed in a length of intestine. With the character for "dust" this radical forms "face powder": the scented powder used in make-up. By replacing the character for "dust" with the one for "water" we obtain "scent," the perfumed liquid sprayed on the skin. With the character for "broad-leaved plant" it creates "banana," the distinctly scented fruit that grows in the scorching sun on broad-leaved trees. The Chinese word for "cigarette" means literally "perfumed smoke," but the character for "smoke" is accompanied by a prisoner with fire beside him: possibly a reference to a man enslaved by the habit of smoking cigarettes.

香肠	Xiāng cháng	salami
香粉	Xiāng fěn	face powder
香水	Xiāng shuǐ	scent
香蕉	Xiāng jiāo	banana

QÍ
EQUAL

齊

A perspective of three ears of corn, all of equal size, conveys the idea of a mass of identical objects: by extension, we obtain the meaning "uniform," "equal" or "together."

This radical with the character for "name" forms "popular." With the character for "voice" or "tone" after it, it gives "in chorus," "in unison": large numbers of voices singing in harmony, expressing themselves in the same tone. The juxtaposition of "equal" and "heart" means "to express the same idea or opinion," "to be in agreement": to have similar opinions on the same problem. Once again, attention should be drawn to the position of the character for "heart" in the phrase: it represents intelligence and will rather than feelings, as a Westerner would be tempted to interpret it. By placing the character for "to play" after the radical we obtain the phrase "to play in unison": this reflects the idea of musicians working together to produce the same sound with their different instruments to create musical harmony.

〳〳〳 帝 兒 帝 齊

丶 一 丶 丿 丿 丁 丿 丿 乚
1 2 1 4 8 17 4 4 10

丶 亠 ㄧ 宀 亠 亣 亦 斺 斺

丶 丿 一 一 丨
5 4 2 2 3

斺 斺 斺 斺 齊
丿 广 斤 斿

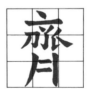

齐名　Qí míng　*popular*

齐声　Qí shēng　*in chorus*

齐心　Qí xīn　*to be in agreement*

齐奏　Qí zòu　*to play in unison*

CHUĂN
OPPOSITION

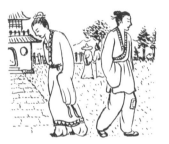

Two inverted shapes, back to back, indicate "opposition," but also "error" or "mistake": this is the idea expressed by the pictograph. The Chinese have always maintained that "if someone begins with a mistake of a few inches he may end up many miles from his goal." However, this was not meant to discourage them, because "one learns by one's mistakes."

Placing the character for "multitude" above this radical gives us "dance": a group of people moving rhythmically in different directions. This reflects a typical Chinese folk dance, with separate groups of men and women. By linking the latter composite with the character for "woman" we obtain "female dancer," a woman who dances professionally. The character for "platform" after the radical creates "stage," the arena on which an actor or politician faces the public. The radical above the character for "tree" once meant "gibbet," the place where criminals were hanged back to back. It then came to mean a "perch" for birds, while it now signifies "eminent person." Sometimes there is more to etymology than meets the eye!

舞	Wŭ	*dance*
舞女	Wŭ nŭ	*female dancer*
舞台	Wŭ tái	*stage*
杰	Jié	*eminent*

GĀN
SWEET

甘

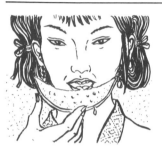

A mouth with something pleasant inside it: something "sweet," even though this is one of the most debatable adjectives in the Chinese language, not only in its grammatical sense but also in its interpretation. According to one proverb, born of many people's experiences, "all food tastes good to the starving man's mouth." In Chinese, the adjective "sweet" is taken in the widest meaning of the word, and is applied to anything that pleases the five senses, not merely something edible with an agreeable taste.

With the radical for "grass" it produces "licorice root": a plant with a sweet taste. The juxtaposition of the radical and the one for "heart" produces "ready," "willing": a disposition that pleases others. The character for "sweet" linked to the one for "bitter" means "in good times and in bad," reflecting the bittersweet nature of human existence. Linked to the character for "oil" it forms "glycerine": an oily substance with a sweetish taste. "Both halves of sugar cane are not always sweet" means that even pleasant circumstances can contain an element of unpleasantness.

一 丨 丨 一 一
2 3 3 2 2

一 十 卄 卄 甘

| | | |
|---|---|
| 甘草 | Gān cǎo | *licorice root* |
| 甘心 | Gān xīn | *willing* |
| 甘苦 | Gān kǔ | *in good times and in bad* |
| 甘油 | Gān yóu | *glycerine* |

DĂI
WICKED

Scattered fragments of a human skeleton: an idea conveyed in the sign for "body" with two lines intersected by a third, horizontal one and thus, by extension, the meaning "death," "misfortune," "bad," "evil," "broken into pieces," "turned to dust." Today, the character is used solely to mean "wicked." Written beside the character for "follower," this radical means "ruffian" or "scoundrel": a hypocrite who tries to procure favours for himself, someone who behaves in a wicked way. With the character for "halberd," written twice, the radical forms the word "to wound," "to damage," but with an underlying sense of malice. This composite with the character for "to continue" forms the adjective "cruel," "pitiless," thereby further underlining the sense of wickedness. Linked to the character for "life" the radical means "the final years," "the remaining years." For many people in the past the final years were spent in misery, haunted by the specters of poverty, illness and hunger as their strength declined. Today things have improved. China offers its old folk years of serenity, respect and affection.

歹徒	Dǎi tú	*ruffian*
残	Cán	*to wound*
残忍	Cán rěn	*cruel*
残生	Cán shēng	*the final years*

XUÁN
DEEP

玄

Two cocoons beneath a shelter: the dark room where the peasants raised silkworms. Alternatively it represents a skein of wool being dyed. It once indicated the colour green, but later, as a result of Taoist theories on colour, it came to mean "black." The character underwent a further modification when the Emperor Kāng Xī (1661–1720), whose name was Aisin-Gioro Xuán Yé, had the upper stroke removed in order to distinguish it from his own name, thus mutilating the radical. After his downfall the stroke was restored.

By linking the character for "deep" to the one for "fantastic," we obtain "mysterious": the fascination of something we do not understand. With the radical for "green" it becomes "deep black": the Chinese appear to perceive and define colours differently from Westerners. With the character for "grandson" the radical creates "great-grandson." With the character for "wisdom" it forms the name of a famous Taoist sect and school of philosophy, active between the years 220 and 420 under the Wèi and Jīn dynasties, called "Obscure Wisdom."

`丶 一 厶 厶 丶`
`1 2 14 14 1`

`丶 亠 玄 玄 玄`

玄 妙	Xuán miào	*mysterious*	
玄 青	Xuán qīng	*deep black*	
玄 孙	Xuán sūn	*great-grandson*	
玄 学	Xuán xué	*"Obscure Wisdom"*	

228

YĀO
TENDER

幺

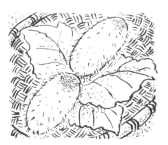

The finest thread, almost invisible to the human eye, is produced by weaving the filaments of two silkworm cocoons; hence the meaning "thin," "soft": today this radical is rarely used, and then only in the meaning of "the youngest" and the number "one." Combined with the character for "strength" the radical forms "young," the struggle of the youth to become a man – a tender shoot, but full of vitality. If we link this composite to the character for "insect" we obtain "larva," the initial tender stage of the insect's development after emerging from the egg. Replace "insect" with "small" and we get the word "immature," describing a creature that, although young, has yet to achieve the proper size for its age. The character for "boy" after this composite gives us "youngest son": the latest offspring of the family. There is a proverb – now obsolete thanks to the new policies on reducing the size of Chinese families and therefore inappropriate for modern couples – which says "A man with much money and few sons is not rich; a man with many sons and little money is not poor."

幼	Yòu	young
幼虫	Yòu chóng	larva
幼小	Yòu xiǎo	immature
幼子	Yòu zǐ	the youngest son

229

WĀNG
LAME

尢

八 尤 尤 尤 尢

一 丿 乚
2 4 19

一 尢 尢

The pictograph shows a man resting on his right leg, with the left one seemingly unable to hold up his weight. A person limping: someone who is lame. In the new dictionary, however, this radical occurs in composites whose characters have nothing to do with either the pictograph or its earliest meaning: errors that already appeared in the *Kāng Xī* dictionary. The character *yóu*, for example, has a dog and not a man in its pictograph: its design shows an animal stopping in its tracks, as though it caught the scent of something unusual; hence the meaning "strange," "extraordinary." This character, when linked to the one used as a pronoun, creates the adverb "specially." Clearly, we have drifted away from the original meaning. The character for "extraordinary" placed beside the one for "man," in its reduced form, provides "excellent," describing a man of singular abilities and virtues. The same character, however, when linked to the one for "heart" – also in its reduced form – means "to be preoccupied": to take a problem to heart or worry about something.

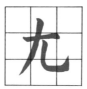

尤	Yóu	*extraordinary*
尤其	Yóu qí	*specially*
优	Yōu	*excellent*
忧	Yōu	*to be preoccupied*

WÉN
CHARACTER

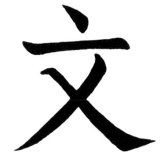

There is a legend that tells how, while the mythical Emperor Fú Xī was meditating on how to write down words and ideas, a splendid dragon-horse bearing strange signs on its back emerged from the waters and presented itself to him. Another legend, however, places these signs on the back of a tortoise and attributes their discovery to another emperor, Yǔ the Great, who lived twenty-two centuries before Christ. The pictograph showed only crisscross lines, or wrinkles; only later did it come to mean "character" or "literary writing."

Juxtaposed with the character for "paintbrush" this radical produces "literary style." With the character for "law" or "rule," it forms "grammar," the rules governing the correct use of characters. By placing the character meaning "to remove from office," "to modify" before this radical we obtain the name for the "Cultural Revolution," which certainly produced changes, not always for the best. With the character for "change" or "transformation" the radical creates "civilization," "culture": changes for the better.

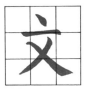

文笔	Wén bǐ	*literary style*
文法	Wén fǎ	*grammar*
文革	Wén gé	*Cultural Revolution*
文化	Wén huà	*culture*

YĪ
ILLNESS

疒

、一丿丶丶
1 2 4 1 6
、亠广广疒

In the radical for "arrow" (*shī*) we noted that the Chinese see illness striking like an unexpected bolt from the blue. The pictograph shows a person lying in bed under a canopy and therefore, by extension, it comes to mean "illness." In the character used nowadays to indicate "illness" the radical has an arrow, the cause of the malady, beneath it. There are many composites derived from this radical, the majority of which are concerned with pathology.

The radical with the character for "complete" creates "recovery": the complete restoring of one's health. The character for "mountain" under the radical forms "hernia": a visible swelling, a small pathological mountain. The character "to know clearly," "to understand" placed after the radical gives us the word "treatment" or "cure." This is rather an optimistic view of medicine, whose task it is to intervene with the appropriate means once the nature of the illness has been identified. By placing the character for "nail" beneath the radical we obtain "boil," an inflammation that pierces the skin.

痊 Quán *recovery*

疝 Shàn *hernia*

疗 Liáo *cure*

疔 Dīng *boil*

232

LǍO
OLD

老

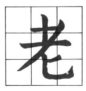

一 丨 一 ノ ノ ㄥ
2　3　2　4　4　19

一 十 土 耂 耂 老

If there is one country in which old people are cherished and treated with care and respect, that country is the China of today, even though this concept is deeply rooted in Confucian teaching. The character for "old" was originally composed of three signs: "hair," "person," "change." When a person's hair changes colour it means he or she has grown old; baldness is rare amongst the Chinese. The modern character is a distorted contraction of the old sign.

By writing the character for "word" after this radical we obtain "proverb," "saying": the word of an old person, the wisdom of the ancients. The character for "family" after the radical creates "birthplace": an old household, in the sense of one's parents' home. By placing the character for "woodland" after the radical we form the expression "virgin forest," an old wood as yet unaffected by the destructive work of man. Linked to the character for "way" the radical gives us "Taoist priest," a man who, if not old in years, is at least old in wisdom, who follows the way or *dào*, the doctrine of Taoism.

老

老话	Lǎo huà	*proverb*
老家	Lǎo jiā	*birthplace*
老林	Lǎo lín	*virgin forest*
老道	Lǎo dào	*Taoist priest*

233

GĀO
HIGH

高

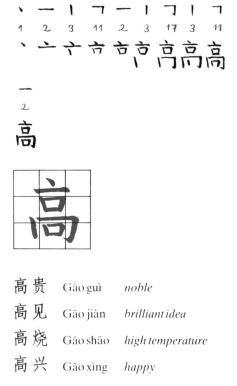

A tower or pavilion built above a palace: this is the idea that the pictograph tries to convey. This gave the idea of "high," but also in the sense of moral superiority. Every so often a pictograph will retain its original message, even in the modern character.

This radical linked with the character for "costly" or "rich" gives "noble," the man who can afford things with a high price. With the character for "to see" or "opinion," the radical creates "brilliant idea," the result of someone thinking on a higher plane than other people, or having a superior intellect. The radical with the character for "to burn" (formed of the elements "fire," "halberd" and "stool," indicating a motionless man struck down by the heat) gives us "high temperature." With the character for "inclination" or "disposition" after the radical we obtain "happy," "contented": the Chinese consider that a happy man is one with above-average abilities at his disposal, who possesses superior qualities and is free from everyday worries.

高贵　Gāo guì　*noble*

高见　Gāo jiàn　*brilliant idea*

高烧　Gāo shāo　*high temperature*

高兴　Gāo xìng　*happy*

FĀNG
SQUARE

方

ㄹ 圬 方 方 方 方

丶 一 丿 フ
1 2 4 17

丶 亠 亍 方

The swastika – now a symbol of infamy – is of Buddhist origin: it represents the wheel of life. The pictograph shows first a square, formed of two right angles, and then the four regions, the four sections enclosed within; hence its meaning of "square" or "rule." Less probable is the idea that it shows two boats tied together to form a square pontoon. There can be no doubt that the concept of the wheel of life has entered the religious and lay culture of China: one famous villa was even built in the shape of a swastika. Today, as well as meaning "square," this character means "religion," "direction," "honest," "puritan."

Juxtaposition of the character for "law" and this radical forms "method": a clearly defined way. With the character for "brief" or "schematic," the radical creates "general plan": the résumé of an entire project expounded in a few lines. Next to the character for "word" it produces "dialect," in the sense of a local language, one spoken in a particular region. By linking the radical to the character for "regular" we obtain "just" or "upright," describing a person who does not act outside the law.

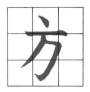

方法	Fāng fǎ	*method*
方格	Fāng gé	*general plan*
方言	Fāng yán	*dialect*
方正	Fāng zhèng	*just*

235

YĪ
ONE

The number "one" symbolizes a thousand different things when included in a character: everything from the sky to the horizon. It is a symbol of unity, but it is also the origin of all beings, all things. In Taoism it is the sign of the absolute. The horizontal line comes from the pictograph, where it represents a hand with its pointing index finger. When it forms part of the composition of other characters, this line changes position as well as meaning.

It appears in the upper part of the character for "rain," where it indicates the sky in which the cloud that unleashes the raindrops is suspended. Placed in the lower part of the character, beneath the sign for "sun," it becomes "horizon," above which the day star appears, giving the character the meaning of "dawn." In the word "sky" it indicates everything that occurs above mankind, including the idea of protection. When placed at the feet of the human figure it gives the character the meaning of "safe," "secure" or "upright." Within the character for "door," it becomes "bar" or "bolt": something that impedes entrance.

雨	Yū	*rain*
旦	Dàn	*dawn*
天	Tiān	*sky*
闩	Shuān	*bolt*

ÈR
TWO

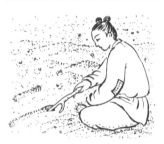

If the number "one" is the symbol of the sky, then "two" is that of the earth. The pictograph shows two lines that can be interpreted as marks in the sand, notches in a piece of wood, lines indicating a numerical system, an inventory or a period of time. This character is also the symbol of *yīn* and *yáng*, the dualistic principle of the Chinese cosmogony: the male and the female.

This radical together with the character for "man," in its reduced form, creates "goodwill," the fundamental virtue of Confucianism: the friendship, tolerance and sympathy that should unite mankind and govern human relationships. When it contains a mouth, a man and a hand it represents "anxiously," "benevolent," "diligently." Its true meaning, however, was of a man who gave his all (his mouth and his hands) to obtain a place between the sky and the earth. Linked to the character for "violin" it forms *èr hú*, a two-stringed violin with a cylindrical soundbox covered in snakeskin and a long, thin neck. Written beside the character for "heart," the radical forms the word "disloyal," the description of a man of both good and ill will.

仁	Rén	goodwill
亟	Jí	diligently
二胡	Èr hú	two-stringed violin
二心	Èr xīn	disloyal

BĀ
EIGHT

八

The sign indicates a division into two parts, a separation. In modern usage the radical represents "eight." Yet this extended meaning is not so far fetched since the ancient Chinese recognized the four-sided square as a unit of calculation. Eight can be exactly divided into two equal parts; the fields were divided into eight equal plots, as we have seen in the radical *tián*. It occurs in many composites, but is often reduced to two drops or dots in the upper part of the character.

The meaning of "to divide," "to separate" is retained in the composite that has the radical for "knife" beneath it. The radical with the character for "treasure" (a jade beneath the roof) creates "eight treasures," the name given to ingredients for special dishes served at a Chinese banquet. Juxtaposed with the character for "section," the radical forms "test in eight parts," a written exam needed to gain entrance into the imperial bureaucracy. By adding the character for "hermit" we obtain the Eight Immortals, the legendary figures whose deeds have fired the imagination of countless Chinese children.

丿 乀
4　5

丿 八

分　　Fēn　　*to divide*

八宝　Bā bǎo　*"the eight treasures"*

八股　Bā gǔ　*"test in eight parts"*

八仙　Bā xiān　the Eight Immortals

SHÍ
TEN

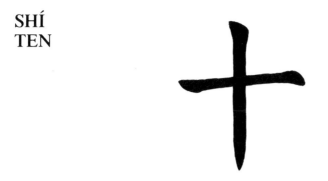

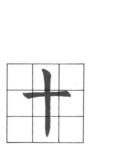

While the prime numbers were indicated by a horizontal line, "ten" was written with a simple vertical line. Later the sign for "one" was joined to the one for "ten," forming a cross, to indicate that this figure contained all the numbers: it was the highest of the decimals. The concept of the two dimensions and of the cardinal points, which for the Chinese number five, was thus added.

This radical with the character for "month" forms "October," literally "tenth month," because the months of the Chinese calendar do not have names, only progressive numbers. With the character for "one," separated by a dot (otherwise it would mean "11"), it means "October the First," the national holiday commemorating the foundation of the Chinese People's Republic on 1 October 1949. Juxtaposed with the character for "foot" it means one hundred per cent"; in this case the radical for "foot" is taken to mean "together," and "ten" means "complete" or "all." With the character for "to talk," in its reduced form, the radical means "to calculate": a person able to count from one to ten is capable of calculating.

十月	Shí yuè	*October*
十.一	Shí yī	*October First*
十足	Shí zú	*one hundred per cent*
计	Jì	*to calculate*

辰

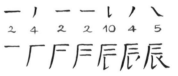

一 丿 一 一 乚 丿 丶
2　4　2　2　10　4　5

一 厂 厂 厂 厂 辰 辰 辰

The pictograph is highly unusual: it shows a woman bending over to hide something embarrassing. Because this cannot be pregnancy, which is indicated by other signs, it must refer to a woman's period, to menstruation. This interpretation is reinforced by the meaning retained in the radical for "period" and in some of its composites, which convey a sense of shame, embarrassment, an unpleasant situation. This is a deflective character, in which a transfer of meaning has occurred. The radical also indicates each of the twelve periods of two hours into which the Chinese day was divided, both day and night. With the character for "period" it indicates the hour between seven and nine in the morning, the "fourth hour." With the character for "sand" the radical forms the word "cinnabar," the mercuric sulfide that occurs in granular masses. The Chinese believed it was one of the key ingredients in the elixir of life. The characters for "time" and "heavenly body" together form "star." Juxtaposed with the character meaning "to be born," it forms "birthday": the time of birth.

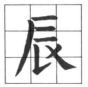

辰时	Chén shí	fourth hour
辰砂	Chén shā	cinnabar
星辰	Xīng chén	star
诞辰	Dàn chén	birthday

CÙN
INCH

寸

In Chinese traditional medicine "diagnosing the pulse" gave a skilled doctor a lot of information on which to base his diagnosis of an illness, and this radical represents the point where the pulse is taken. The pictograph shows a hand with a line drawn at pulse level. This point is about three centimeters (one inch) away from the hand: we thus obtain the *cùn*, equivalent to "inch." By extension, this character means "measure," "rule," "norm" and, in the modern dictionary, "very little," "short" or "small."

Linked to the character for "step" the radical creates the expression "small step" or 'gentle progress." With the radical for "heart" it forms the word for "sentiments," "gratitude." Juxtaposed with *yīn*, the famous female principle in philosophy – here used in the sense of "shadow" – it indicates the movement of a sundial's gnomon: a slight movement, and thus "a short time." Linked to the character for "property" it forms "seal": in the past this character indicated a piece of land granted by the emperor to a vassal, to which agreement the imperial seal was affixed.

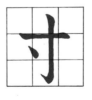

寸 步	Cùn bù	*small step*
寸 心	Cùn xīn	*sentiments*
寸 阴	Cùn yīn	*short time*
封	Fēng	*seal*

241

JĪN
POUND

斤

丿丿一丶
4 4 2 3
丿亻丄斤

The pictograph shows an axe, but it also signifies a measure of weight: the *jīn* or Chinese pound, equivalent to half a kilo (one Western pound). In the past the weight used on scales was in the shape of an axe.

With the character for "two" this radical forms the word "weighty." To weigh something, two weights were needed: the one on the scales and the counterbalance of the goods. Combined with the character for "door," the radical creates the composite for "place": firewood was normally cut in front of the doors of village houses. The same character with the verb "to have" creates the word "possession" or "property": having firewood to cut meant that one had a home to heat. The radical with the character for "hazelnut tree" means "new." At one time judges, in order to extract a confession or to punish the guilty, would have them beaten with fresh hazel twigs. From cutting fresh branches with an axe we get the idea of "new." This composite together with the character for "year," creates "New Year."

斤两	Jīn liǎng	*weight*
所	Suǒ	*place*
新	Xīn	*new*
新年	Xīn nián	*New Year*

DÀ
LARGE

大

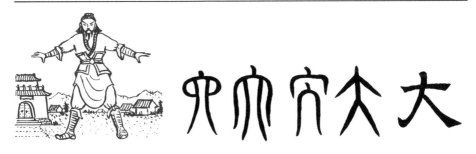

一 丿 乀
2 4 5

一 ナ 大

Together with that for "man," this is one of the best-known characters. It portrays the universal gesture for expressing large proportions: open arms. In this case the radical has remained virtually identical to the pictograph, preserving the legibility of the sign.

If we juxtapose the radical for "large" with the character for "family" we obtain "people" or "everybody": the great family of the nation, of mankind, an ideal concept of universality too often forgotten nowadays. With the character for "man," the radical forms "adult": a man who has grown – and one hopes, not only in stature. Placed next to the character for "school" it means "university": a big school. With the character for "insect," however, it creates the name for one of the fiercest and most fearsome animals known to man: the tiger. This may explain why the Manchurian tiger, which lives in the bamboo woods between Russia and China, is such an enemy of man: a solitary hunter with pitiless jaws, it is constantly trying to extract payment for the insult of being called an insect by shedding the blood of those who thus malign it.

大家 Dà jiā *people*
大人 Dà rén *adult*
大学 Dà xué *university*
大虫 Dà chóng *tiger*

243

XIĂO
SMALL

小

氺 敉 屮 小 小

丿 丶 丶
8 丿 丿

丿 小 小

A vertical line divides two parts in half. An extra line is inserted into the pictograph for "eight," which takes the form of a division into two equal parts, thus conveying the idea of a truly minute segment; hence the meaning "small."

This radical with the character for "to give birth" creates "miscarriage": a creature so small that it cannot survive. The juxtaposition of the radical with the character for "cart" forms "wheelbarrow": a small cart with a single wheel pushed by hand, and a means of transporting goods that is smaller than the one drawn normally by animals. If we place the radical next to the character for "ugly" or "ridiculous" we obtain "fool" or "clown": the ridiculous circus figure who is certainly not known for his looks, but who tries to create amusing situations. Next to the character for "heart" the radical forms the adjective "careful" or "prudent." The Chinese say "clutch your heart" when urging someone to take care, and they write it on signs in public places. As a warning against pickpockets they sometimes write "Clutch your heart, small hand," meaning "Beware of pickpockets!"

小产　Xiǎo chǎn　*miscarriage*

小车　Xiǎo chē　*wheelbarrow*

小丑　Xiǎo chǒu　*clown*

小心　Xiǎo xīn　*careful*

ZHĂNG
LARGER

The pictograph shows hair that is so long it has to be tied up. Later on, a hairpin was also added to the character. All this indicates a grown person, the elder brother, the oldest in a group, but also "to grow," "to develop." Hair is a sign of old age and, as we have already seen, the beard is a sign of wisdom. Yet the classical form of the character and – to an even greater extent – its simplified form are both arbitrary contractions and distortions of the pictograph.

The radical with the character for "motor" forms "captain," the man with most experience on an aeroplane. By linking the radical to the character for "aged" we obtain "abbot," the man best versed in knowledge and virtue amongst the elders of a Buddhist monastery. With the character for "son," the radical forms "elder son," the "firstborn," the one who should have the longest hair. With the character for "near," it creates "progress," conveying the idea of greater development being near at hand.

机长 Jī zhăng *captain*

长老 Zhăng lăo *Buddhist abbot*

长子 Xhăng zī *firstborn*

长进 Zhăng jìn *progress*

BIÉ
PART

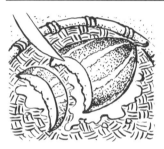

The pictograph consists merely of an oblique line slanting down toward the left. The *Kāng Xī* dictionary erroneously inserted it among its radicals, and this is where it has remained in history and, even worse, in dictionaries.

Nowadays it can indicate a part of the whole, like a knife blade that slices something in two. With the character for "eye" – albeit modified in the present script – it forms "eyebrow": the hairs that adorn and delineate the upper part of the eye. This radical appears twice in the character for "to mow," like two crossed swords: two parts that join together to form a pair of scissors. The Chinese regard death as being primarily a separation of man from the earth: just as a blade of grass dries up and dies when separated from its roots, so a man dies when parted from his natural element. This concept also occurs in Christian iconography of the Middle Ages, which loved to portray Death as the grim reaper. The character for "to kill" is formed of the radical repeated twice ("scissors") above the character for "tree": to cut a tree is an act of violence against life.

别　Bié　*part*

眉　Méi　*eyebrow*

刈　Yì　*to mow*

杀　Shā　*to kill*

DIǍN
DOT

Having started as a round mark, a spot, this later took on the shape of a pear or teardrop as a result of the introduction of a new writing implement. Whereas the stylus, a piece of wood with a rigid tip, made a round mark when dipped into liquid colour, the brush, with its tip of soft hairs (an invention attributed to General Méng Tián), allowed for different lines to be drawn: fat, thin, straight or curved.

In the character for "master" the sign represents the flame of an oil lamp. The master is the man who is born first, who has more experience: he must stand above the common men, he must enlighten them with his knowledge. With the character for "justice," the preceding composite creates "doctrine": the just teachings of a wise man. The character for "master," when followed by the character for "part" or "role," creates "protagonist": the most important figure on the stage. If the dot occurs inside the character it indicates a mineral still in the bowels of the earth, in a mine: "cinnabar," one of the minerals most commonly used by Chinese alchemists in their search for the philosopher's stone.

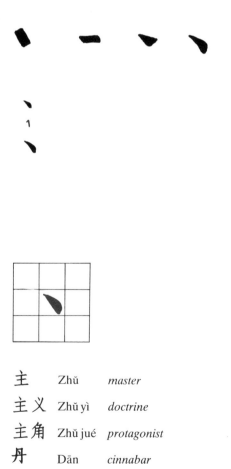

主	Zhǔ	*master*
主义	Zhǔ yì	*doctrine*
主角	Zhǔ jué	*protagonist*
丹	Dān	*cinnabar*

Bibliography

Chang Chengming, *L'écriture chinoise et le geste humain, essai sur la formation de l'écriture chinoise,* Paris 1937

B. Karlgren, *The Chinese Language, an essay on its nature and history*, New York 1949

J. Needham, *Science and Civilisation in China*, Cambridge 1954

L. Wieger, *Chinese Characters*, New York 1965

Kuang Jussu, *Chinese Written Characters, their Wit and Wisdom*, New York 1968

V. Alleton, *L'écriture chinoise*, Paris 1970

B. Karlgren, *Sound and Symbol in Chinese*, Hong Kong 1971

Jièzǐ yuán huàpū (The Mustard Seed Garden; 1679), Shanghai 1982

Index